With

MAY 0 8 2017

P9-DTG-730

Withdrawn/ABCL

3 9075 05038056 4

DOLL PARTS

a memoir

AMANDA LEPORE

with **Thomas Flannery Jr.**

Regan Arts.

NEW YORK

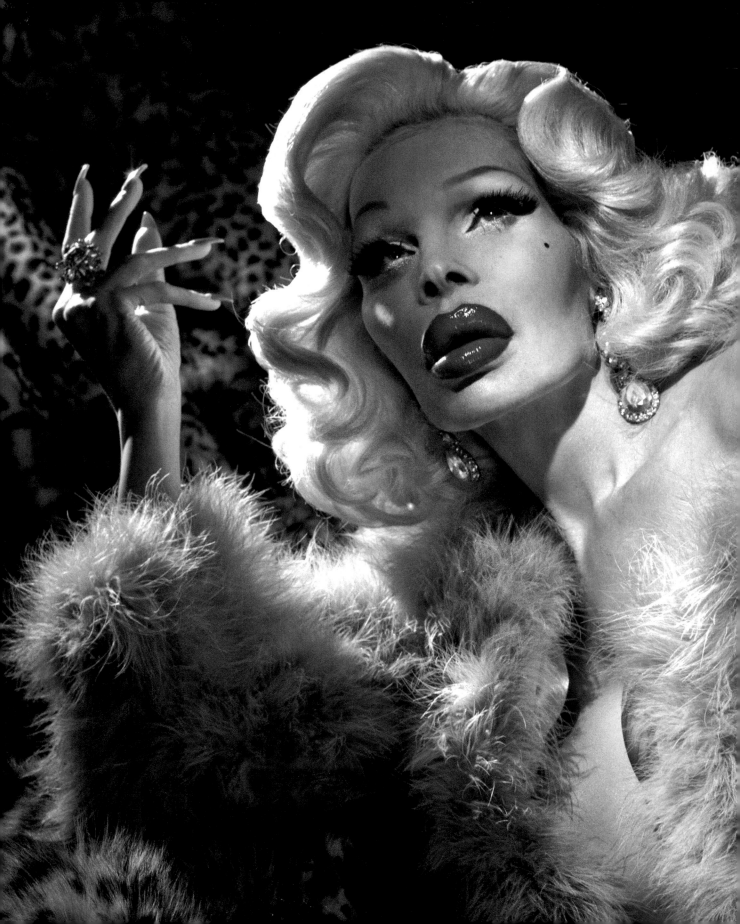

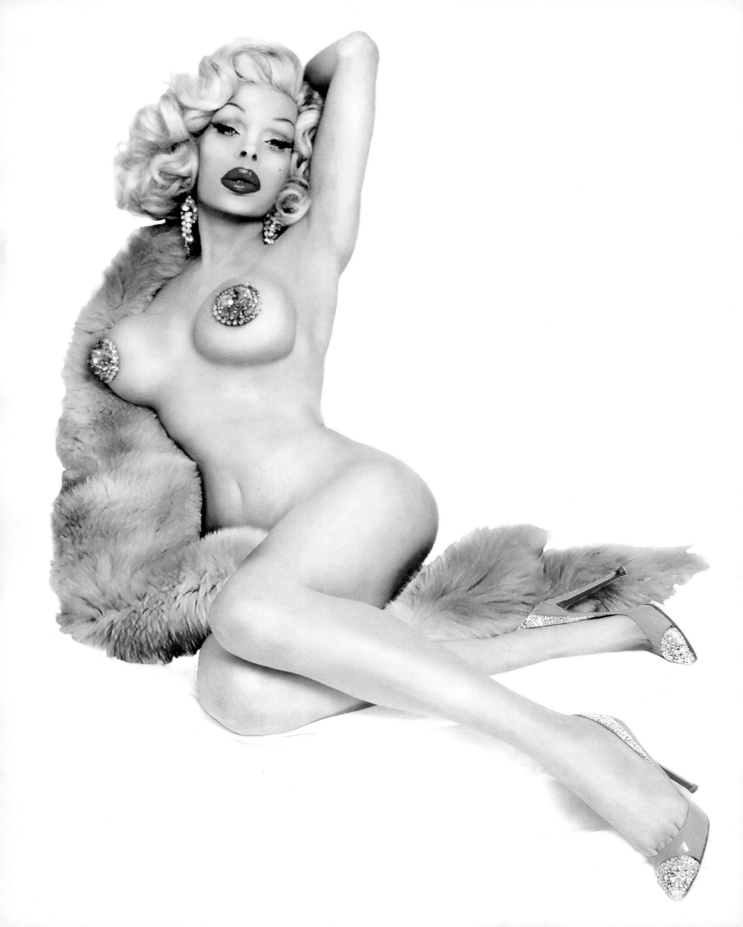

DOLL PARTS

CONTENTS

 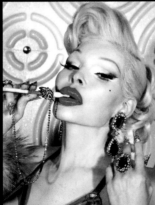 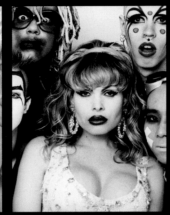 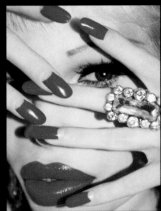

Amanda Lepore is a recording artist, model, rule breaker, international LBGT icon, the reigning queen of NYC nightlife, and a self-made woman. She has been the photographic muse for pop culture visionary David LaChapelle and countless others for decades. *Doll Parts* is her first book.

Regan Arts.

65 Bleecker Street, New York, NY 10012

Copyright © 2017 by Amanda Lepore

All rights reserved, including the right to reproduce this book or portions thereof in any form whatsoever. For information, address Regan Arts Subsidiary Rights Department, 65 Bleecker Street, New York, NY 10012.

Names and identifying details of some of the people, events and places portrayed in this book have been changed, and some characters and events are composites.

First Regan Arts hardcover edition, April 2017. Library of Congress Control Number: 2015958512
ISBN 978-1-942872-85-6

Interior design by Catherine Casalino and Judith Regan, Cover design by Richard Ljoenes
Printed in Hong Kong
10 9 8 7 6 5 4 3 2 1

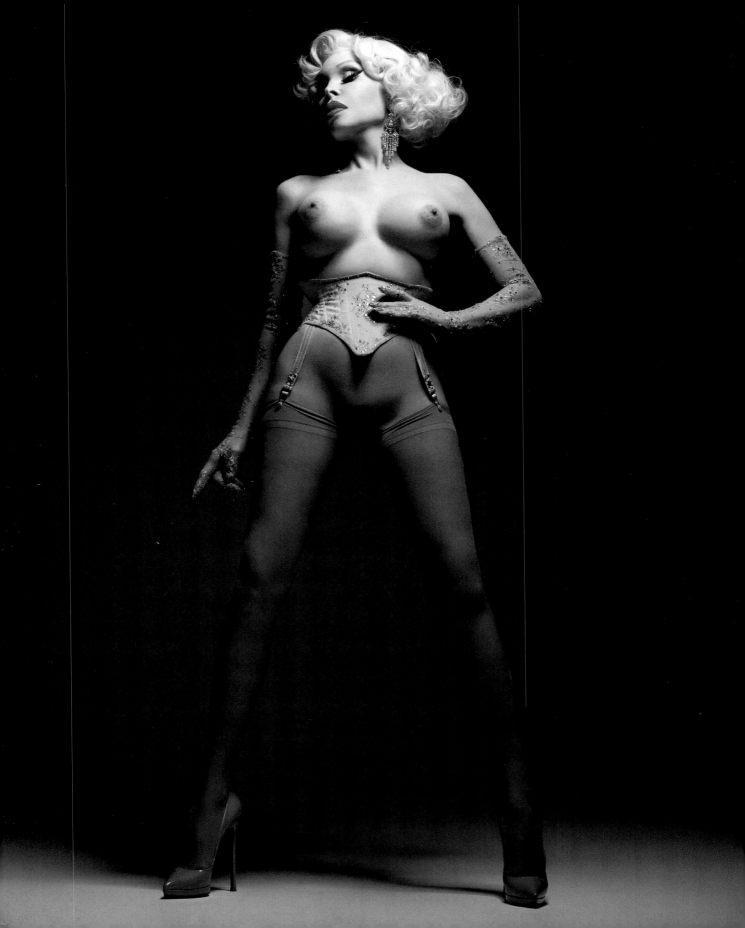

To every girl

who has ever put

effort into

looking good,

And to every man

who has appreciated

those efforts.

LET'S MAKE LOVE

an introduction

Hello, I'm Amanda Lepore, the most expensive body on earth.

Thank you so much for buying my book. If you didn't buy it and are reading this in your local bookstore, make sure the cover is clearly visible to your fellow patrons. You obviously have good taste and I want the whole store to see what you're reading. Trust me: they want to know.

I wrote this entire manuscript longhand, with a feathered pen, on Chanel No. 5 scented paper, in a big pink mansion, just like the one Jayne Mansfield had. I worship Jayne Mansfield. Everything she owned was pink. Except for Mickey Hargitay; that beefcake was Hungarian.

Can you see me sitting at my escritoire, completely naked, coining phrases and reminiscing? Really try and see it. Visuals are so supremely important.

When I'm not writing, or ending world famine (by not eating), or negotiating peace in the Middle East (threesome with an Iranian and an Israeli), I spend my time beautifying. It's 90 percent of what I do. I don't make excuses; I'm very vain. I love my body and I love showing it off. You can get away with almost anything when you look good.

Everyone has their own standard of beauty, for themselves and the people around them. Some people don't like the way I look. I've seen comments posted on my Instagram and the hate and ugliness are pretty powerful. But for every person who says I look like the Mistress of Frankenstein, there's another who thinks I'm gorgeous. I don't give a second thought to the negativity. You can't control what people say about you. You can only control how you choose to react to it.

The reason I have such thick skin (figuratively, physically my skin is basically translucent) is that at the age of seventeen, I got my pussy. It was all I ever wanted out of life, and everything since then has just been a maraschino cherry on top. I'm so happy to be living the life I want in the body I want to have. I don't let little things bother me.

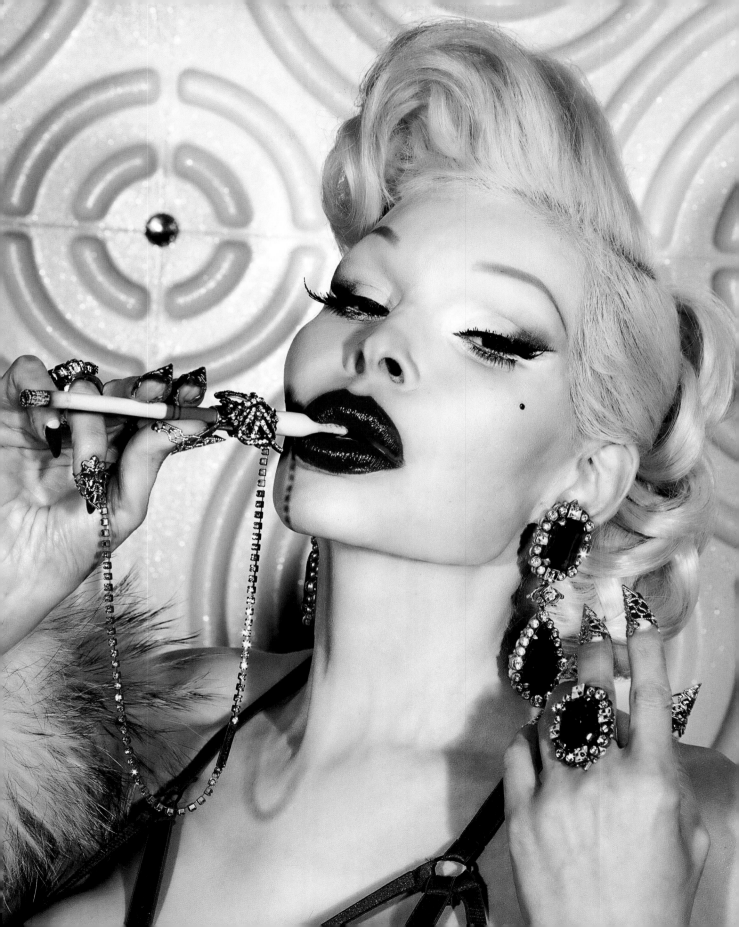

Recently, I met this gorgeous, twenty-one-year-old Jersey boy named Marco. We started chatting and flirting (two things I'm very good at), when a friend of his yelled out to him, "She was a man! What are you doing?"

Marco apologized to me. "You're the most beautiful girl I've ever seen," he said. "I've been staring at you all night. They don't make girls like you in Jersey." He came back to my place and we had great sex (something else I'm good at). If I had let his friend bother me, I would have missed out on a ten-inch dick. I have a sixth sense for big dicks; it's a blessing and a curse.

Many transgender girls are scared, vulnerable, and miserable in their own bodies. They can't speak up for themselves because they're too busy trying not to get clocked. They are focused on blending in and living their lives as naturally born women. I, on the other hand, have no interest in anything "natural." I'd rather look like Jessica Rabbit or Marilyn Monroe. So I always felt it was important to be open about how happy I am to be transsexual, to give a voice to all the girls who don't have one.

Now, times are changing. You have Laverne Cox on the cover of *Time*. Janet Mock is a *New York Times* best-selling author. Carmen Carrera is bringing it to the kids. And Caitlyn Jenner . . . well, she's changed everything. These are strong, proud women who won't hide in the shadows any longer.

The transgender civil rights movement is gathering momentum amazingly quickly. Yet some things are slow to change. Christine Jorgensen was the first transsexual woman to gain national media attention in the 1950s. If you watch videos of her talking to the press, she was very poised, articulate, and polite, but the reporters could be really unintelligent in their questioning. Some sixty years later, trannies are still dealing with much the same thing. Being transgender raises a lot of questions and confusion for some people. Trans-phobic and trans-ignorant are two different things, and I'm so proud of Laverne, Carmen, and all the other girls who are speaking up and quieting ignorance through understanding. Visibility is power.

I wasn't always so Zen. When I was younger, and vulnerable to other people's opinions, I was up in arms over my identity. I was a woman, flat out. If someone used the wrong pronoun I never corrected them. I was too scared to stand up for myself, but on the inside I was angry and sensitive. A lot of young people are angry and sensitive. If you happen to be young and transgender, then you're used to people being hateful towards you when all you want to do is exist. Through all the insanity in my life, there was only one thing I could control: myself. On the outside, obviously, but on the inside too. I focused on not letting other people's opinions have any effect on me whatsoever, and that's how I've lived my life ever since.

I hope this book shows you there are as many different ways to be transgender as there are to be a woman, which is what I am. When you get me alone, which I'm sure some of you reading this (one or two) have, you'll see that deep down there's nothing but woman here, sitting on this pussy, writing these words. Transsexual is only one of a long list of adjectives (I hope my use of the word "adjective" doesn't change your opinion of me

as a sexy blonde bombshell) that describe Amanda Lepore, and it's much farther down the list than words like sexy, beautiful, stunning, perfect . . . not to mention humble.

XOXOXO, *Amanda Lepore* ♡

PS. I didn't really write the book longhand. It's hard enough to sign my name with these stiletto nails, let alone write a whole book. But I love the image, don't you? Let's just go with it.

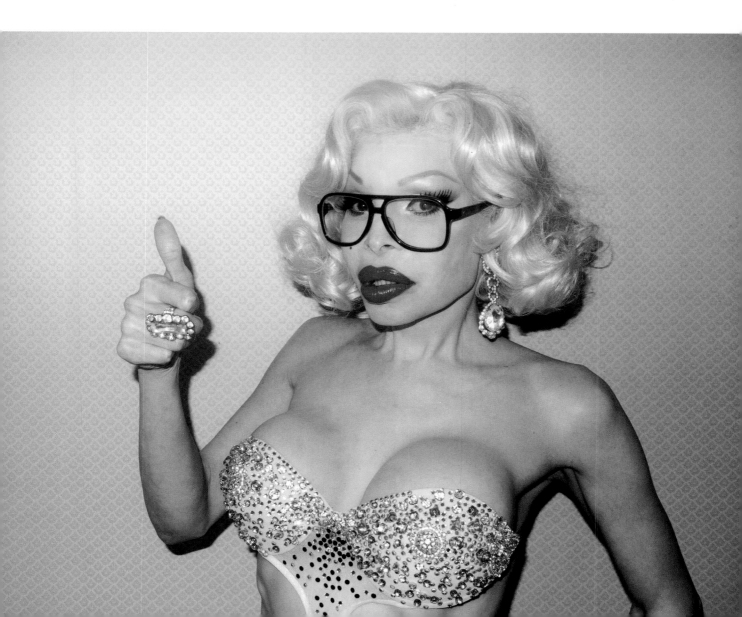

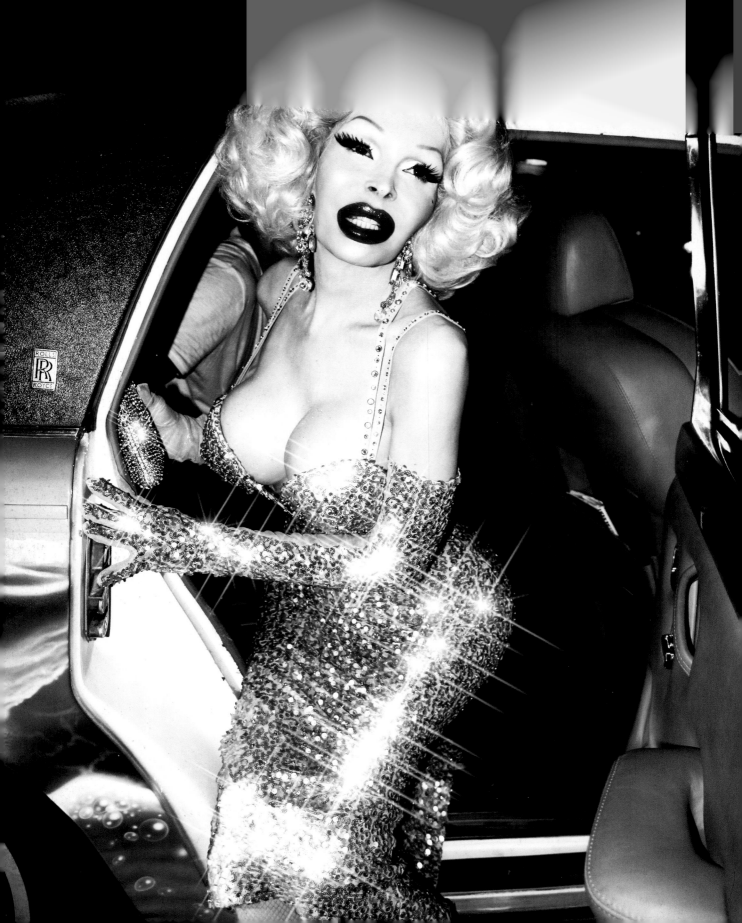

GENTLEMEN PREFER BLONDES

When I was a child, I had a recurring dream. In this dream I was locked in a tower. It was sort of like the fairy tale *Rapunzel,* except there was no witch and no prince. Just me and my yards and yards of perfectly silky, strawberry blonde hair. As I combed, the hair would grow. I'd keep combing and combing, the hair would keep growing and growing, and very quickly the whole room would fill.

Usually it was a great dream; I loved having all that hair. But I'd wake up sad, because in reality my hair was clipped short, like a boy's.

Sometimes the dream would turn dark. My hair would not stop growing. My long locks would pin me down and fill my mouth and nose. I'd wake up out of breath and grabbing at my head, trying to push all that dream hair off my face.

Hair became an issue in my house when I was five. Mine was getting longer and I was so happy, but Dad hated it. He kept telling Mom to take me to the barber, but she never would. One night, he told me he'd take me himself the next day. As Mom put me to bed, I begged her not to let him. She made me a secret promise that I could keep my hair as long as I wanted. I loved my mom very much.

During dinner the next day Dad said he'd take me to the barber as soon as we were done eating. My brother started laughing at me, and just then Mom burnt her arm on the stovetop, real bad. Mom was always graceless in the kitchen. Dad jumped up so fast to help her, his pudgy little legs gave out and he fell backward.

In all the commotion, Dad forgot about the barber.

A week later, Dad had us all pile into his Cadillac, telling us we were going to the mall. Instead, he pulled up in front of a barbershop and turned the engine off.

"Hurry along inside! I'll wait here," he said.

Mom didn't say anything, so neither did I. I had come to terms with my fate; there was no use crying about it now. We walked inside. Mom yelled something to the bald old barber and I sat in his chair. He draped a smock around my neck and I heard clippers buzz on. The chair spun around backward, placing me face to face with Mom, who was holding a pair of scissors and staring at the barber.

"Mom?" She wasn't paying attention. "Mom, you know I'm really a girl, right? I don't want a boy's haircut."

She glanced at me and said, "I know." Then her eyes went right back to the barber. "Don't choke my son," she said.

"Mom, I'm not your son, I'm a girl."

She wasn't listening. The barber was talking low to Mom, trying to calm her down. But then he said the one thing she most hated to hear: "There's nothing to be afraid of."

She snapped. "You're choking him!" Mom screamed as loud as she could, like Janet Leigh in *Pyscho.* The barber jumped back and Mom grabbed me, snipping the scissors in the air. "Don't hurt him!" She screamed out. "Get away from him with that thing!" The clippers droned off and Dad ran inside.

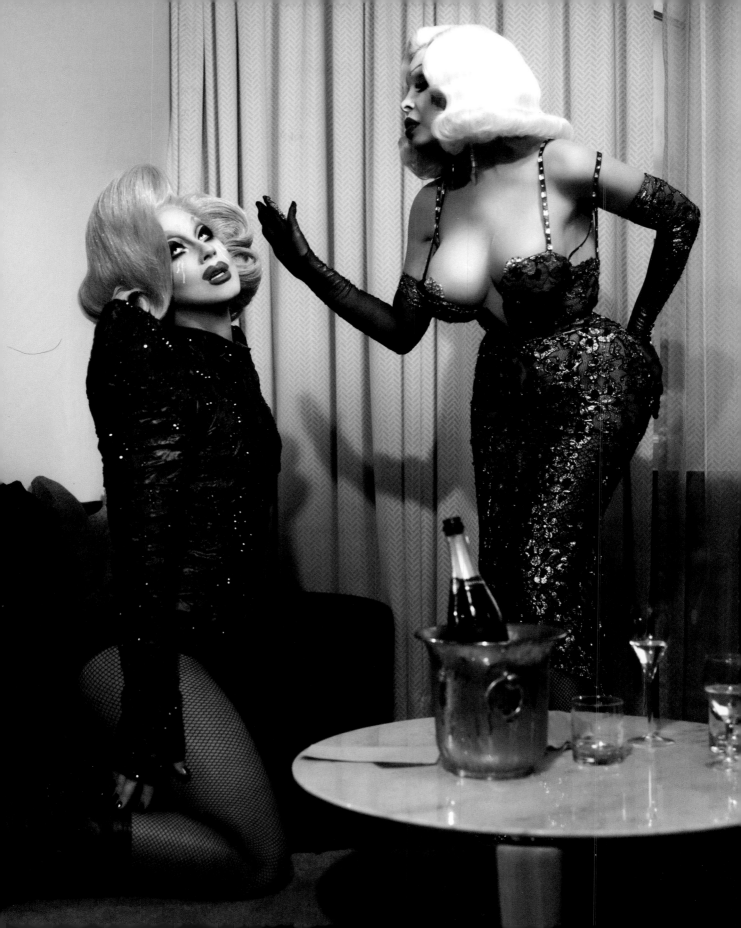

MY HAIR LOOKS FIERCE

My favorite hair product is bleach.

•

A thick conditioner is my second favorite. I take a drop of Aveda Blue Malva conditioner and mix it into a thick white conditioner until it turns lavender. That keeps my hair platinum.

•

All girls should experiment with hairpieces. It's like wearing a chicken cutlet push up bra, but for your hair. I keep my real hair in a one-length long bob, which I roller-set and comb forward, pin curl half my head, and wear a half wig hairpiece for volume and lift.

•

L'Oreal Paris Elnett Satin Hairspray is easy to comb out, so I can restyle for a few days.

•

My pubic hair is shaped into a neat racing stripe and bleached and conditioned regularly. My pussy is pink, platinum and pretty.

Mom kept screaming, the barber was white as the smock I was covered in, and I was all smiles.

Guess I wouldn't be getting my hair cut after all.

The next day my brother Joseph and I came home from school to find Dad in the living room with his ultra-Catholic sister, Aunt Marie.

Neither of them said anything but they looked super-serious. I was sure they had found out Joseph had fingered this girl down the street and maybe he'd even gotten her pregnant. He was talking about it all the time. Dad was bound to find out sooner or later, and having Aunt Marie in tow meant a whole bunch of Hail Marys were coming.

"What's going on?" Joseph asked.

"Yeah, where's Mom?" I added.

Dad stood up. "Let's go to the toy store."

Aunt Marie and I sat in the back of Dad's turquoise blue Cadillac, his most prized possession. She held my hand and looked down at me like I was a puppy she couldn't save from the pound.

"Your mom decided to take a vacation," Aunt Marie said. She was a bad liar. "To Florida. It was so last minute, there was no time to say good-bye. She's probably on the beach as we speak."

"Oh," Joseph said, "that's weird." His shoulders relaxed. This wasn't about him.

Dad said nothing but I saw him staring at me in the rearview mirror. I was sure he had punished Mom for what happened at the barbershop. It was all my fault; she was only trying to protect me. Aunt Marie pulled me into her oversized bosom. She smelled like smoked sausages and garlic.

At the toy store Dad finally spoke. "Pick any toy you want and I'll meet you up front."

Joseph ran over to the Hot Wheels. I made my way to my favorite section: Barbie.

Barbie was my best friend and everything I wanted to be, before I even knew what I wanted. My first was a hand-me-down Malibu Barbie, in a baby blue bathing suit. A neighborhood girl named Katie, who did ballet and had pierced ears, received a second one for her birthday and gave the old doll to me. I was super-jealous of Katie, but was willing to look past that to play with her dolls. Once I had my own Barbie, though, all I wanted to do was sit in my room, brushing Barbie's long blonde hair and pretending it was mine.

Malibu Barbie melted when I tried to give her a suntan on our space heater. The house smelled like burnt plastic for a few hours but my heart-

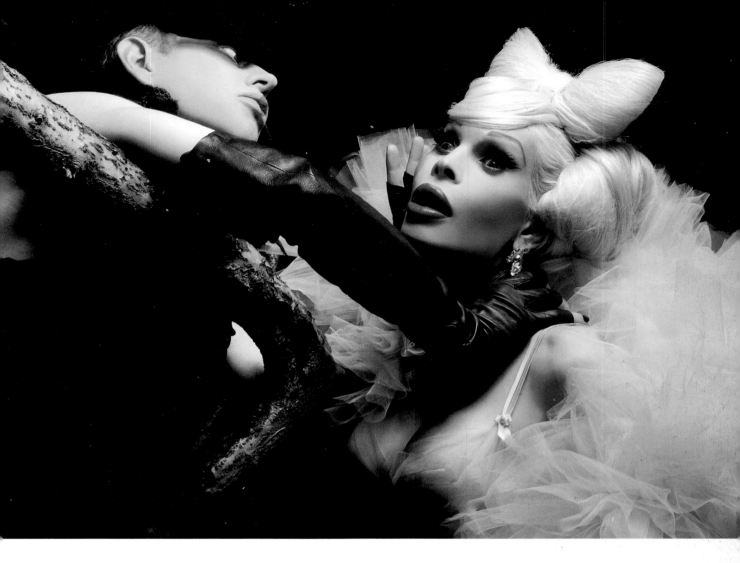

break lasted longer; I'd ruined my favorite toy. Mom told me not to worry and started buying me new Barbie dolls. I built up a respectable collection; my favorite was P.J., with her pouty lips and long lashes. Sears did an exclusive P.J. with a tweed skirt and Mom and I went to breakfast one day, then each got one. We spent the rest of the afternoon playing together; our P.J.s were sisters and best friends.

I dreamily walked toward Dad in that toy store, with a Sweet 16 Barbie pressed to my heart, and a grin pasted across my face.

"That's what you want?" Dad looked disappointed.

"Let him get it," Aunt Marie said. "He's a kid. He'll grow out of it."

"This is getting ridiculous." Dad grabbed the doll out of my hand, paid, and we left.

I kept silent. Dad was upset with me but I had no idea why. Plus I was so excited about Sweet 16 Barbie! I'd just given Quick Curl Skipper an awful bob and I needed a new bratty teen sister to play house with.

On the way home I noticed we passed our street and instinctually knew Dad was driving to the barbershop. I started sobbing and crying for Mom. Aunt Marie tried to settle me down but I was having none of it.

Dad picked me up out of the backseat, placed me in the barber's chair, and stood stoically over me.

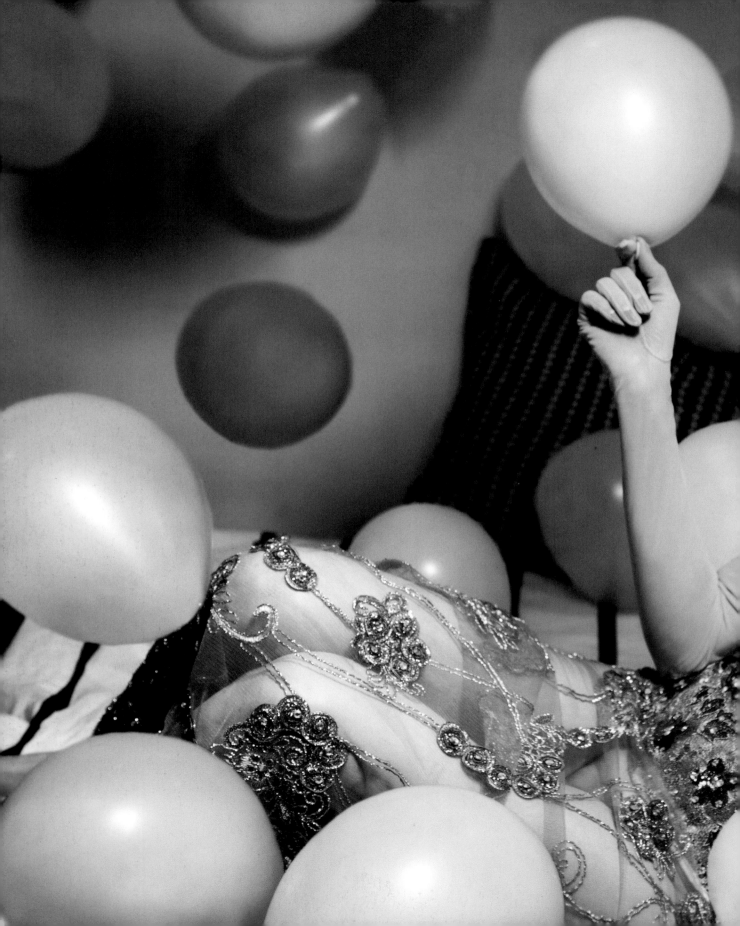

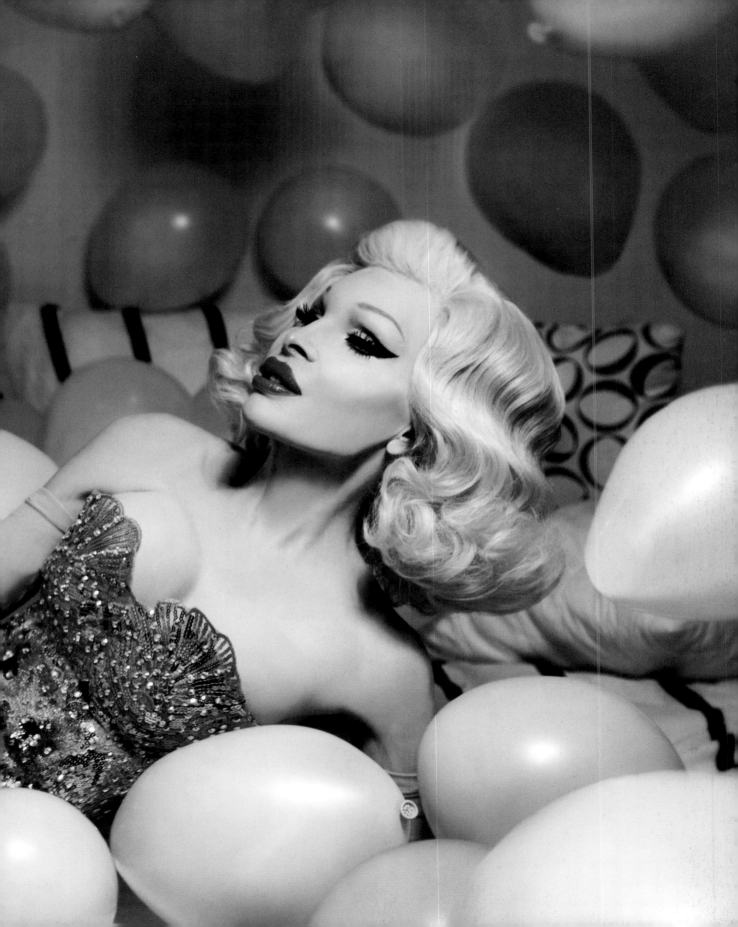

The barber said nothing. Considering last time I was there he was basically attacked with his own scissors, I'm sure he just wanted us gone. As the clippers began buzzing, I closed my eyes and held on to Sweet 16 Barbie, imagining the perfect life she led.

That night I had my worst Rapunzel dream yet. I was stuck in a never-ending ocean of my own hair. I tried to swim through it, but the weight of my hair was pulling me further down.

I woke up grabbing at my head, and cried when I remembered all my hair was cut off. Drowning in a sea of hair would have been way better. I reached

with Dad. Afterward he came up to my room.

"Boys aren't supposed to play with dolls," he said.

I hid my face under my blankets. "I don't care. When does Mom get home?"

"Your dolls are in the trunk of the car . . ." I didn't let him finish. I ran out to the garage and almost unlatched the trunk but remembered it was a bad idea to touch Dad's car without his permission. He followed in right after and I jumped up and down and giggled as he picked up a box filled with my dolls, and brought it up to my room.

Dad tried to make amends: he handed me a perfectly wrapped gift box. In it was a brand-new purple Barbie Corvette. I hugged and thanked him. He patted

"BOYS AREN'T SUPPOSED TO PLAY WITH DOLLS."

out for Sweet 16 Barbie. She wasn't on my bed, where I'd left her, and something was very wrong with my room. For a second I couldn't figure it out. Then I realized; every single doll I owned was gone.

"Dad!" I screamed. "We've been robbed. My dolls are gone."

Dad came in and looked at me like I was a purple duck. "We weren't robbed. Your dolls are gone and you're not getting them back. I don't ever want to talk about this again."

My entire body shook. Dad reached out for me but I ran to the bathroom, feeling vomit rise in my throat.

I was too sick to go to school, so Dad had to stay home with me since Mom was still on "vacation." The next day, he hired a sitter; Nanny Nice I called her.

Nice sat with me and tried to make me eat chicken broth. She knitted while she listened to me cry about my mom, my dolls, and my hair, putting her needles down every few minutes to put her hand to her heart and tell me "There, there" or "Hush, hush."

On the third day of this, Nice had a "private talk"

my head and sat down in his chair to watch the news.

Nanny Nice and I celebrated by going to a fabric store and picking out materials for a pretty green dress with pink stitching for Barbie to wear. It was fun, but I felt guilty, being so happy without Mom.

A couple weeks later Mom came back, seeming much more relaxed but not as tan as I expected after such a long stay in Florida. I cried of course, and told her all about Nanny Nice and my new doll clothes and Sweet 16 Barbie who P.J. thought was a real brat.

Nice tried to convince Mom that she could be a big help around the house but Mom told her to "Fuck off." Mom didn't want a stranger in her house. I watched through the bathroom window as Nice left. She was crying, but she smiled when she saw me and waved good-bye.

I was born the second child to Herman and Francis Lepore in Wayne, New Jersey. If you're unfamiliar with Wayne, picture mostly any other suburban town in

northern New Jersey, place me in it, and you're there.

Armand Lepore was my birth name. Just like my mother, I was a tiny, underweight baby, with a hip dysplasia that kept me in leg braces until I was five.

Dad was also tiny, no more than 5'-5", with a round belly and a waddle to his walk. He was a hard-working, decently paid chemical engineer, and Mom was his trophy wife.

Mom was a stunningly beautiful woman, who resembled Shirley Temple, even as an adult. Face

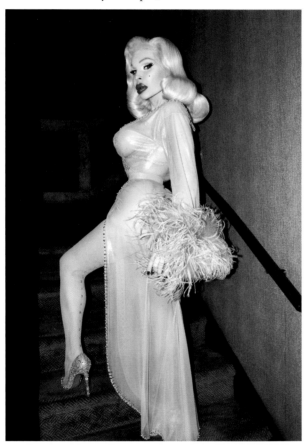

done daily, beauty parlor once a week, roots never showing, and a closet full of elegant hats. Each hat always kept in its hatbox, and the matching shoes kept right underneath. If she could have dyed her eyes to match her hat, she would have.

Because Mom was such a perfectionist, when she

started slipping, it was very noticeable. It was like a different woman stepped into her skin. A homeless woman. Her hair would go unwashed and unset and her teeth would go unbrushed. She never wore much makeup to begin with, but her beautiful ivory-white skin began to look ruddy and greasy. The hatboxes would sit untouched, and pretty, expensive day dresses—a luxury she took such pride in—would be replaced by a nightgown that quickly started to stink.

When this happened, Mom would hide away in her room, saying she was deathly ill. Joseph and I wouldn't see her for days at a time, but at night we would hear her and Dad fighting. She'd go on another "vacation" and be gone for a few weeks, then come back peppy, hatted, and pretty again.

The neighbors were a constant source of agitation for Mom; she always thought they were out to "get" her. On one particular afternoon, they really had her worked up. As I watched television, she ran in and out of the living room, peering out the window, muttering to herself: "That bitch. I can't believe that bitch did this."

Mom was a sophisticated woman. "Bitch" was not in her vocabulary and hearing her say it made me feel like something horrible was about to happen.

I asked her what was wrong but she didn't respond. Instead she unlocked the front door and flew outside, screaming into the bright day, "You bitch! Do you think I'm stupid, you fat, dirty Polack?"

Joseph poked his head out of his bedroom. "Mom's yelling," I said. "Should I call Dad?" He didn't answer. He turned back into his room and shut the door.

I followed Mom outside and saw her across the street, in our neighbor's yard. She had picked up a potted perennial and was screaming, "I know what you did! You think I can't tell?"

"Mom!" I ran over to her. "Mom, what happened? What did she do?"

She looked at me, dirt spilling all over her night-gown, her hair in tangles, the planter held in front of her like a shield. "They stole my planters and switched our lawn furniture with theirs. They just painted it and thought I couldn't tell the difference, but I can tell. You can see the paint chipping away. These are my flowers."

Our poor neighbor was peeping through her blinds. Mom stared at me, waiting for a response. How could I calm her down?

"Oh my God, Mom, you're right!" I said. "I saw her painting out here earlier. And those *are* your flowers! But you know what? She is pretty stupid, because the new furniture is much nicer. It's so expensive! She must be a real idiot!" Our furniture was right where it had always been, but that hardly seemed important at the time.

For a moment Mom looked at me, confused. She stammered over her words, trying to figure out what

IF I'M DRESSED DOWN, I'M SAD. IF I'M REALLY DONE UP, I FEEL HAPPY AND MENTALLY WELL.

to say next. And then I was rewarded with a big smile. "Yeah, you're right," she said. "What a fucking idiot!" She put the plant down and we walked back home.

That night I asked Dad what was wrong with Mom.

He explained to me that she was a paranoid schizophrenic, and sometimes she thought everyone was out to get her.

I made a promise that night always to be there for Mom. If she needed validation, I'd give it to her. If she thought we were being spied on, I'd go along with her and make it a game. Whatever happened, I would be a friend for her.

Even though I know it's not always the case, I associate dressing up with mental stability. If I'm dressed down, I'm sad. If I'm really done up, I feel happy and mentally well.

I don't like to be depressed, so it's a big thing for me always to look my best. I'm not leaving the house unless I'm happy with how I look.

HOMETOWN STORY

At ten years old, I knew what I wanted to be when I grew up. Like many children in the late '70s (okay, 1870s), my future was laid out for me in front of the glow of the family television.

Watching my favorite late-night talk show, I heard a term I never knew existed, and yet it knew me: *Sex change*.

My legs became still. My heart started to beat to a new rhythm. SEX-change-SEX-change-SEX-change. There were three women on stage, all in various states of transitioning. Two were still rather masculine, but the third one was beautiful. She had curly blonde hair and stunning cleavage that jiggled as she talked. The host asked about her breasts and she said they were natural: "I swear," she said, "I took hormones and they grew." I wanted to be that woman.

I ran to my parents' bedroom and swung open the door, waking them both. "Mom! Dad! I know what I want! I know what I want more than anything in the world! Please, oh please, can I have a sex change?"

My parents, still half asleep, turned to look at each other and rolled their eyes. "You're too young," my mother said. "No doctor would give a ten-year-old a sex change."

"Please, Mom, it's all I've ever wanted, I just have to have a sex change!"

They told me it wasn't going to happen and to go to bed.

"Fine," I said. "What's estrogen?"

Proclaiming myself a girl was not new to them.

Mom had come to an understanding about it long ago, and Dad was sure it was just a phase I'd grow out of. But now everything was different to me. A sex change. *Sex change*. Such a thing existed! I had seen it with my own big, brown eyes, right there on the television.

That night I had my Rapunzel dream again, and this time I woke up smiling. I was a young girl in love.

I guess ten years old is pretty young to know what you want from life, but I felt like all my problems, while not yet solved, at least had solutions. I wanted to be a girl. And now I knew that I could be.

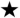

Some of you might be thinking that I displayed feminine behaviors and interpreted this to mean I was a girl. That's not the case. I was a *girl*. It was a *fact*. It wasn't a conscious decision.

Physically, I was basically female, aside from a tiny, underdeveloped penis. Substitute teachers would ask if I was a boy or girl. I had a boy's name and was dressed like a boy, but they'd still be confused.

The kids I went to school with were used to me, but they would sometimes make fun of my feminine mannerisms. They would tell me to walk—"Walk! Walk! Walk for us!"—and I'd walk, and of course I walked like a girl, hands on my hips, swinging from side to side. They were making fun of me but it was easier on me just to play along. I would turn around toward them, put my hands over my chest like I was covering my tits, and press my knees together, sticking

one hip out like I was being modest. "It's like a girl coming out of the shower!" they'd yell. The boys didn't beat me up or anything like that because they didn't think of me as one of them.

My older brother, Joseph, found the whole thing pretty embarrassing. We were exact opposites in every way. His features were very dark, mine were porcelain fair. He was broad and athletic, while I was as thin and waiflike as our mother. The biggest difference between us was his penis; I saw him changing once and knew something was wrong with me, because mine was so much smaller.

I knew early on that I had no business having a penis, and I'd do whatever was necessary to get rid of it.

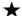

As my teenage years crept up, Mom's "vacation" charade disappeared.

She liked the manic stage of her illness, and would work hard to maintain it. Her medication only slowed her down, so she'd stop taking it and take diet pills instead. She'd also carry around a cup of iced coffee larger than she was, like a baby bottle.

It never lasted. Whenever Mom stopped taking her medication, she was inevitably checked into Greystone Park Psychiatric Hospital, in Morris Plains.

About an hour from our house, Greystone was a massive, beautifully designed brick building on the outside. Inside, it had all the personality of a manila enevelope. A real bait and switch.

The first time I went, Dad drove me and waited in the Cadillac while I was inside. A physically imposing but very friendly nurse showed me to a large sitting room painted dental-rot yellow and filled with sad-looking women, none of whom had their hair done or any makeup on.

"Your mom's in there," the nurse said. "Don't worry, they're all sedated."

Mom was in the middle of the room. When she saw me, she stood up and belted out, "Here she is! Miss America!"

That was a lot of energy from a tranquilized woman. Everyone turned to look at me—Armand Lepore—with my shoulder-length hair, button-down shirt, jeans, and loafers. The nurse shot Mom a surprised glance. The other patients took a quick scan of me, then looked away, unfazed.

I spent the whole day talking to Mom, going through movie magazines and making small talk about the family. We talked about everything except her illness and the hospital. She was in a great mood, and so happy to see me. They had her on all the right medications.

A patient named Amy sat with us for a little while. Her husband was coming to visit and she was very excited. She told me over and over again. I was happy for her. When she walked away, Mom leaned in and said, "Her husband's not coming. He died, and she can't deal with it. That's why she's here."

I looked at Amy skipping around from table to table, telling everyone her good news that would never come true, and I hoped I would never be so lonely.

Leaving was more of a relief than I'd like to admit. The whole place was so depressing, and I had a sinking feeling Dad was leaving me there too. But the big nurse came up and told me it was time to go and I feigned sadness. Mom and I hugged for a minute, then she walked me to the door of the sitting room and watched me walk down the hallway.

When I got to the door, Mom yelled out, "Hey! Miss Hollywood! Pick up the phone, there's a producer on the line!"

Dad was waiting right out front. He didn't ask me about Mom, or what we had talked about. I didn't say anything either; I was trying to wrap my head around what I'd seen. Mom seemed so happy and so normal. Why couldn't she always be like that?

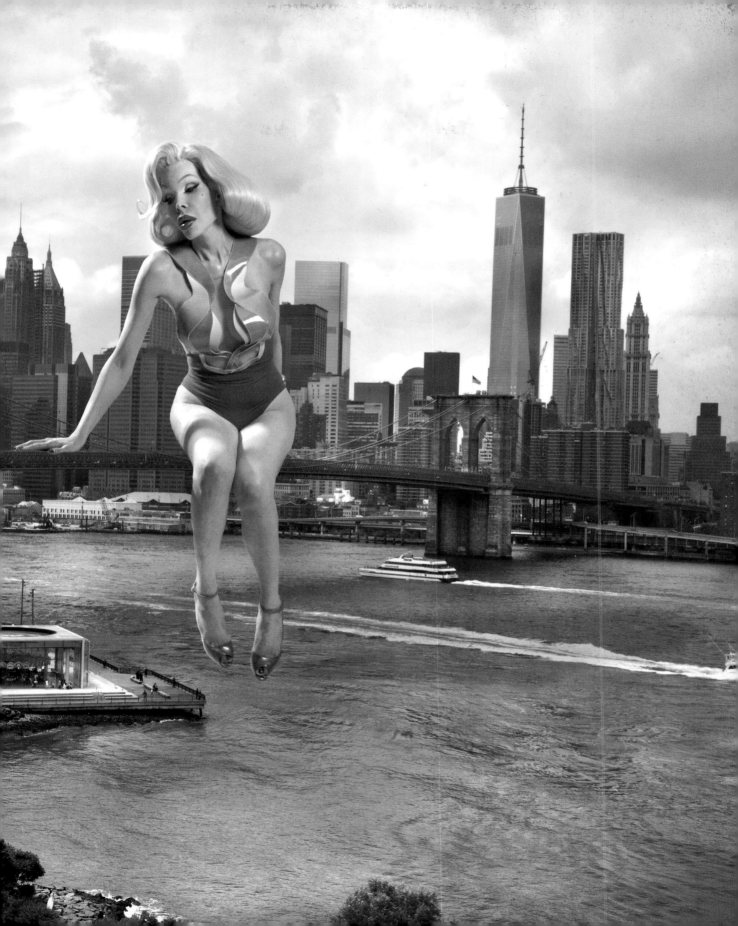

On the way home Dad stopped at the toy store and bought me a Superstar Barbie. It made me feel a little better.

Joseph was totally horny and girl crazy when he was a teenager.

Often he'd bring me with him when he was chasing pussy. Hitchhiking was easier with me because he didn't get picked up by as many "pervert queers," and when he "borrowed" a car to get to a girl, cops took it easier on him when they saw me. The main reason he brought me with him, though, was because girls always liked me, which made them like him.

One of Joseph's girlfriends was a high school senior named Stephanie, who had a twin sister named Sandy.

At the twins' house my gender was never a question. They taught me all the basics of female beauty and thought it was funny that I didn't know any of it yet. I tweezed my own eyebrows and spent hours in front of their mirror with an eyelash curler. "Beautifying is part of being a woman," Louise Sr. used to say. "It has been throughout the ages, from way back to Cleopatra. It's just what women do."

Louise Sr. worshipped Elizabeth Taylor, and all the big-screen beauties. Her biggest gripe with her daughter was that Louise Jr. thought Marilyn Monroe was more beautiful than Liz. The twins were evenly divided between the two greats as well. One night I was asked for my opinion on the matter.

"I've never seen any of their films," I said.

"But surely you know who they are. Come on

"MOM! DAD! I KNOW WHAT I WANT! I KNOW WHAT I WANT MORE THAN ANYTHING IN THE WORLD! PLEASE, OH PLEASE, CAN I HAVE A SEX CHANGE?"

Joseph would go see Stephanie, and they would fuck in the woods behind her house. It was my job to keep Sandy entertained until they were done.

Getting girls was what my brother was best at, but this time his plan backfired. He would end up sitting in their living room watching television while Stephanie, Sandy, and I gossiped and joked around. Eventually Stephanie and Joseph stopped dating, but I kept going to the twins' house after (or instead of) school every day.

The twins lived with their mother and grandmother, who were both named Louise and who both did hair in their finished basement. Both Louises loved to smoke and loved to talk about sex. The first time I met Louise Jr., she showed me how to put a condom on a banana.

now, which do you think is the most beautiful?"

I thought about it. "Which is the blonde one?"

That night Stephanie and Sandy gave me my first makeover. My eyes were lined and multiple layers of mascara were brushed on. They evened out my skin tone very lightly and applied Revlon's Love That Red very heavily (PS: it remains one of my favorite colors of lipstick). When they were done I looked in the mirror, touched my face, and started crying. I looked so beautiful, but I would never be able to show it to anyone outside that room. What a waste.

Louise Sr. walked in, already halfway into a speech about how I had to tighten up my tear ducts. When she saw me she froze and gasped. Her hands went up to her mouth in shock. "Sweet Jesus, Mary, and Joseph!" she said. "You look just like Jean Harlow,

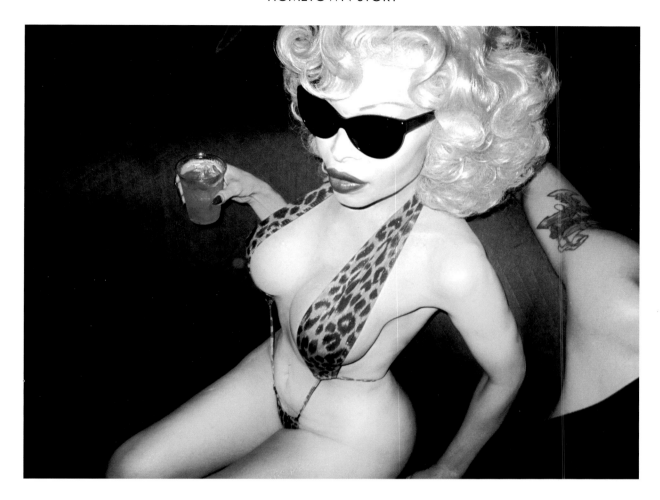

God rest her soul!" She came over and hugged me, and drew a big mole on my chin.

The twins and I listened to Louise Sr. review all the great movies featuring all the great leading ladies. We'd discuss in detail the life and works of Jean, Mamie Van Doren, Ginger Rogers, Grace Kelly, Jayne Mansfield, and, of course, Marilyn Monroe, who, I quickly sided with Louise Jr., was the most beautiful actress of all time.

"Glamour is the best part of being a woman," said Louise Sr. "If you're not going to be glamorous, you might as well be a man."

I agreed completely.

I don't know much about astrology, but I am a Scorpio, which is supposed to be a sexy sign. Publicly I'm a Sagittarius because I always celebrate my birthday on December 5th, but my real birthday is November 21st, which is way too close to Thanksgiving and too hard to celebrate. Scorpios are ruled by their genitals, which seems fitting.

The more sexually aware I became, the more disturbed I was by my penis. It was like a hangnail that needed to be clipped. I tried my best to pretend my penis didn't even exist.

There were a few wet dreams. I would fall asleep with a pillow on top of me, pretending a man was fucking me. When I'd wake up, the pillow would be

a mess. It was so humiliating, like my own body was betraying me. I had to change my pillowcases a lot.

I knew about sex at a pretty young age. Joseph showed me a porno and pointed to the different parts. "If you want to be a girl," he said, "then these are all the things you'll have to do." I thought the men were peeing in the girls' mouths. Gross.

Boys my own age largely ignored me, but Joseph's friends were a few years older and they knew too much about me. It made their feelings toward me a little more complicated.

One of his friends, Johnny, seemed to take extra pleasure in being mean to me. If I saw him around school, he'd call me "fag" or "queer." I wouldn't say anything back, but it was impossible not to internalize all that. Typically if I saw Johnny at school I would bolt toward the exit and run the four blocks back home. There was a creek behind our neighborhood and I'd run along it as fast as I could, through backyards and wooded enclaves, holding my books against my flat chest. I'd ditch school for the rest of the day.

I cut school early one day and was sitting by the creek when Johnny jumped out and wrestled me to the ground. He pinned down my arms and laughed at me when I tried to push him off.

"I don't want to hurt you," he said, "so stop wiggling and don't scream." I stopped moving and looked up at him. He was smiling and seemed to be in a good mood, which made him look a lot cuter than I'd thought before.

He jumped off me and sat on a large rock about five feet away. "Sorry for calling you a fag," he said. "I'm just trying to be funny."

I told him it was fine—whatever I needed to say to keep him from jumping on top of me again. He started talking about all his problems, mostly about girls and how they weren't having sex with him. He stood up and walked around while he was talking. Then he put his leg up on the rock, and I noticed his

cock was hard and sticking straight out. He rubbed on it a little, trying to show it off to see what I would do.

I didn't acknowledge the obvious fact that Johnny wanted me to suck his dick. Instead I prodded him further along in the conversation, to try to fully understand what he wanted and why he wanted it. I thought if I understood, then I'd be able to figure out why he acted so masculine while I was so feminine.

This happened a few more times; sometimes Johnny was by himself and sometimes he had a friend along with him. They were very sweet to me out in the woods, but if I saw them at school I knew to run in the opposite direction.

Johnny started to get impatient. He took his dick out and jerked off while we talked one day, but I pretended I didn't see it and just kept asking him questions. One day he offered Joseph a personal radio player in exchange for a blow job from me. Joseph begged me to do it but I refused and stopped talking to Johnny after that. He started harassing me even more at school, which made other kids jump on the bandwagon and bully me as well. Soon I was spending more time skipping school than in class.

My sexual awakening happened when I was twelve. A man picked me up while I was hitchhiking on my way home from Stephanie and Sandy's. I was dressed as a boy, but I was regularly clocked as female.

This man, let's call him Clint, was very attractive. A businessman. I was young but I could tell his suit was Italian, and his stylish leather briefcase was a thing of beauty. I love a man in a suit; he's always the best accessory.

Clint didn't ask me my name, my age, or why I was hitchhiking. The first thing he said as we drove away was, "You're very pretty."

"Thank you," I replied, and tried to break the tension by focusing on buckling my seat belt. It was the

first time I'd ever been called pretty by a man, and I felt my face redden. Clint apparently knew that speaking to my vanity was the key to my heart (it still is).

We came to a stoplight and he reached down by my legs and picked up the briefcase, putting it on the seat between us. "Let me show you something," he spoke under his breath, like Clint Eastwood or one of those wheezing people in a COPD commercial. In my head I was pretending to be Sondra Locke, before she went nuts.

He opened up the case and it was filled with porno magazines. I'd never been interested when Joseph showed me porn, but this time the pictures fascinated me. "This is called a blow job," he said, pointing to a woman sucking a big dick. "And this is doggy style, when a woman bends over in front of a man, and gets fucked from behind. You can do all these things, you know."

Not all of them, I thought. I picked up one of the magazines and leafed through it. He pointed to a picture of a woman getting nailed spread-eagled. "What do you think of that? Do you want to do that?"

As he was driving he started grabbing my chest. There was nothing to grab but he said, "You're going to develop in a few years; you'll have nice big tits." He started trying to touch me between my legs, saying he wanted to feel if I had hair on my pussy, but I clamped my thighs together to keep him out. "Let's go to a motel," he said. "We can do all these things in the magazine."

Even though I was only twelve, I wanted to give myself to him. But I couldn't. I wanted to do it like the women in his pornos, with their pink pussies and big tits. As much as I wanted to be with this man, I couldn't do it the way I was thinking about. He treated me like a girl and it seemed very natural. But when he started reaching for my nonexistent puss-puss, I got scared. Not about him being angry, but about the embarrassment that would come when he found out I had a dick. *The party's over,* I thought, *I gotta get outta this car, and we're not going to a motel.*

Clint dropped me off at the mall, gave me ten dollars, and told me to buy some sexy underwear.

I don't know what might have happened if I had been born a girl. Maybe Clint and I would have gone to a motel, fallen in love, and moved to one of those states where the age of consent is nine. Then we would've gotten hitched and had tons of kids. I could be fat and miserable right now. I could have my own TV series on TLC. How disturbing. I could have had a horrible life if I wasn't born exactly the way I was.

If it wasn't for the twins, I would have had no friends.

Kids I went to school with weren't sure what to make of me. I was clearly a

MY FAVORITE
MARILYN MOMENTS

7.
Let's Make Love:
She played Amanda, a rising-star nightclub singer. Sound familiar?

6.
The Seven Year Itch white dress: The most expensive dress ever sold at auction.

5.
Chanel No. 5: *Marie Claire* asked what she wore to bed. Marilyn's response: "Chanel No. 5." I love Chanel, but I prefer to sleep in the exclusive Amanda Lepore fragrance; the notes are amber, violet, champagne, and orange blossom.

4.
Entertaining the troops in Korea: Is ever a woman more in her element than when she's front and center, surrounded by throngs of warm-blooded, able-bodied, DTF men?

3.
Cameo appearance in *All About Eve*: "Why do they always look like unhappy rabbits?" Marilyn smiled and all of Hollywood quaked in its heels. The star had already been born, but here, she became a supernova.

2.
Gentlemen Prefer Blondes: Her greatest performance IMNHO. Marilyn as the diamond-studded-tiara-wearing white fox in the henhouse. The dumb-blonde stereotype was to be believed at your—and your marriage's—peril.

1.
"Happy Birthday, Mr. President": She never looked better than in that flesh-colored, rhinestone-covered, barely-there dress, breathlessly singing to President Kennedy. My inspiration.

BEAUTY in VOGUE

girl, but I had to stay with the boys during gym class. Once I started high school and everyone hit puberty, I couldn't hide behind asexuality any longer. Kids started to realize I was different.

I'd show up to school with polish on my nails and my eyebrows tweezed. The twins helped me take in the boy clothes Dad bought me so they were more flattering. I thought I looked good, but kids would give me a hard time.

It didn't help that I always seemed to say the wrong thing. Walking to school one day, a group of girls in my class passed me. "You girls look so nice," I said. "I love your lip color." They looked at me and laughed.

"Get away from us," one of them said, "Armand LEPER LEPORE!"

The name stuck. When I was in the halls, classmates would run away from me, yelling out, "Leper Lepore! Leper Lepore! Don't let him touch you or your nose will fall off!"

Guys didn't mess with me too much, either because they thought of me as a girl, or because they thought their appendages really would fall off if they touched me. Sometimes they'd smack my books out of my hand and kick them away as I tried to pick them up. One time I was drinking from a water fountain and a boy yanked my pants down and laughed loudly, yelling, "Hey everyone, look at Armand's baby penis!" I never used the water fountain again.

"Try to figure out how their minds work," Stephanie told me when I complained about school.

"Yeah," said Sandy. "Think of yourself as a psychologist. Just let them talk so you can figure out what it is they want. That will keep them from worrying about what you're doing."

It didn't work. No one wanted to talk to me.

Freshman year of high school, I signed up for an acting class. I figured the most logical career goal was to become the next Marilyn Monroe. I walked into the theater the first day and the entire class started booing loudly.

The teacher stood up and said, "You can't be in here. You're too distracting, you'll disturb the rest of the class."

"What's distracting about me? Besides, aren't you supposed to want attention when you're an actress?"

"Ac-TOR," she said. "Girls are actresses, boys are ac-tors. Now go to the guidance counselor."

The other students cheered as I walked out.

MY SEXUAL AWAKENING HAPPENED WHEN I WAS TWELVE.

"Miss Lepore," one of them yelled, "can I have your autograph?"

The guidance counselor, Mrs. Penny, was a stout, matronly woman, always in a floral-print dress, a short perm, and wire-rimmed frames that sat on top of her flat chest when they weren't on her face. I walked into her office that day and said, "I was kicked out of acting class."

"Oh dear, what happened?"

I told her the whole story—how I loved the great Hollywood actresses and thought acting would be a perfect career for me. It seemed so sensible and logical, I was sure she'd march me right down and tell that teacher to make a star out of me.

Instead, she assigned me a study hall for that class period. "Acting isn't a real career," she said. "And if

the teacher doesn't want you in there, I can't do anything about it. What else do you want to do with your life?"

This wasn't how I had expected things to go. I was sure she would defend me, not take the teacher's side.

"Come on, Armand, speak up," she said.

"Well, I love to listen to people's problems. Maybe I could be a psychologist?" I could see myself doing that.

"No, you'll never get into college," Mrs. Penny said. "Your teacher is right, you're too distracting. You need to figure out what you want to do. You could become a hairdresser, maybe."

I told her I'd think about it and left her office, hoping I'd never have to go back.

That night I thought about what she'd asked. I loved playing makeup with the twins, so maybe I could do that for a living. And of course there was always the allure of becoming a famous fashion designer. I'd been making clothes for my Barbies ever since Nanny Nice taught me how to sew.

I asked Mom what she thought and she loved the idea of me being a designer. She told me all about Coco Chanel and Karl Lagerfeld, and how lavish their lives were. "It's hard work, though," she said. "You'll have to go to school and really study. You think you can do that?"

I thought about it. I was doubtful I'd be able to get into fashion school after what Mrs. Penny had told me. I settled on the most practical of solutions for a career: marrying into money.

"Mommy? How come you didn't marry someone really rich? Then we could have a big place and if you didn't get along with your husband, you could just go to a separate wing of the house."

"There are women like that," she said with a laugh, gulping down her iced coffee. "Zsa Zsa Gabor had plenty of rich husbands." We went to the bookstore and Mom bought me Zsa Zsa's book, *How to Catch a Man, How to Keep a Man, How to Get Rid of a Man.* I pored over the pages, imagining what it would be like to be as beautiful and elegant as Miss Gabor.

"What do you think?" Mom asked as I was reading. "You think you could be the next Miss Hollywood?"

Yes, I thought. *This I could do.*

School seemed like a real waste of time after that, so I played hooky as much as possible. I was failing most my classes, except for a couple of Cs from teachers who took pity on me. It didn't bother me that much. Nothing I could learn in school was important; all people care about is how you look. Zsa Zsa had taught me an extremely valuable lesson: a beautiful girl can have anything she wants.

Mom and Dad separated when I was fourteen.

Dad explained to me that when they first met, he thought Mom was just funny and silly. He didn't realize then that she was schizophrenic. Once they were married, it was too late, and though he tried to make it work, he was not happy. You could never rationalize with Mom. She was a beautiful woman, though, which I'm sure is why he stuck around for as long as he did.

I told him I understood, and really I did. Besides, what good would it do to call him out for bailing?

Financially, Dad still took care of us. The burden of taking care of Mom's mental health fell to me.

Without Dad there to force her, Mom stopped going to Greystone, and her illness took over. The key to getting along with her was treating her like she was completely sane. I'd just let her talk, let her vent, and agree with her delusions. I was the only one she trusted. I accepted her mental illness, the same as she accepted my femininity.

Joseph made himself scarce, sleeping at Johnny's house most nights. It wasn't a bad thing. If Mom was starting to cycle into paranoia, Joseph would tease her and make it worse. He'd come home and say the

MY FAVORITE
BLONDES

JEAN HARLOW
Such a tragic life. She
married a guy who was
impotent. Or maybe he
was gay. Or just had
a small penis. Favorite
film: *Dinner at Eight.*

MARILYN
Obviously. Favorite film:
Gentlemen Prefer Blondes.

JAYNE MANSFIELD
I visited her pink mansion
and flashed my tits!

DIANNE BRILL
The party girl of the
'80s and '90s. One of the
first of the voluptuous
female models.

ANGELYNE
I thought she was a bitch
when I met her because
she pulled out a fan
and put it in front of her
face. But that's just
what she does.

ANNA NICOLE SMITH
Her Guess ads were
spectacular. Her beauty
was a blessing and a
curse. Much like Marilyn,
she was as dumb as a fox.

GWEN STEFANI
She's been able to combine
alt and glam looks better
than anyone ever has.
"Magic's In the Makeup"
is a beautiful song.

Honorable Mention—
DAPHNE GUINNESS
She does a mixed blonde
and brunette look. Have
you seen the video for
"Evening in Space"? David
LaChapelle directed it.
Fantastic.

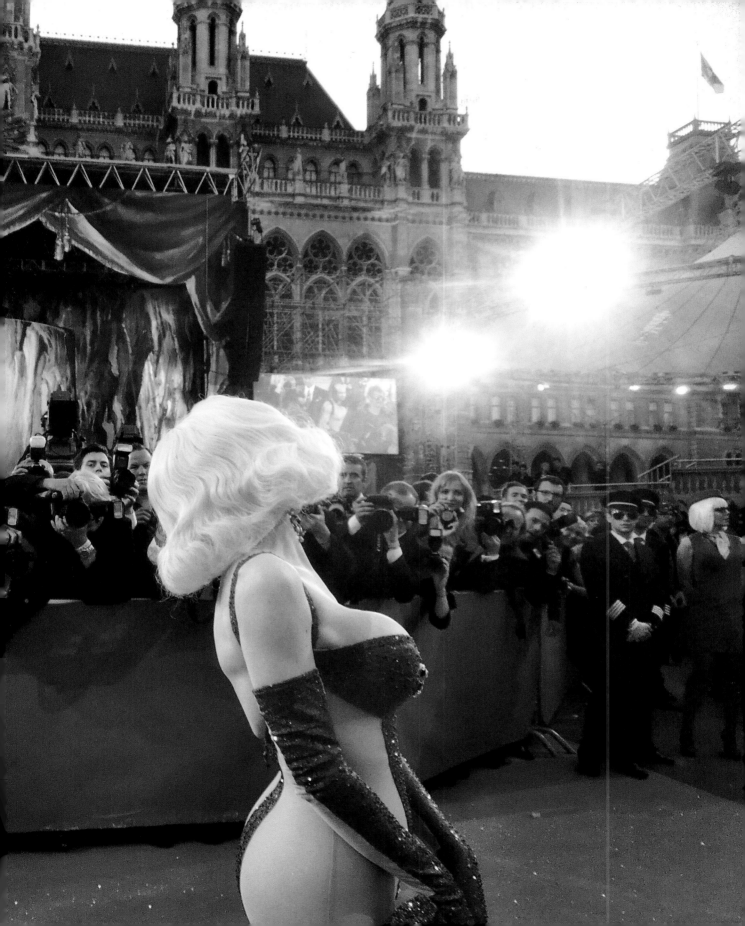

A WOMAN SHOULD NEVER...

RUN.
—Exception: She's on *Baywatch,* and she better nail it in one take.

GET A BOY'S NUMBER.
—Exception: None. She can't make the first call anyway, so why even pretend?

CALL A BOY BACK.
—Exception: Rough trade. He's only allowed the one call.

LEAVE THE HOUSE IF HER FACE IS BREAKING OUT.
—Exception: She's on her way to get a facial. (PS. cum is very good for the skin. It's babies!)

SWEAT OUTSIDE THE GYM.
—Exception: None. There's one kind of fluid that should come out of a woman when a man's around, and it's not sweat.

TAKE OUT THE TRASH.
—Exception: Spinsterhood. A woman can do any other housework, but a man should take out the trash. It could leak on her shoes.

neighbors were outside spying on us, which would set Mom off. Joseph would laugh, get a change of clothes, and leave me to try to calm Mom down.

I kept Mom's situation as under wraps as I could. Stephanie and Sandy only saw Mom when she'd drop me off out front of their house. Having people over made Mom nervous and she was unpredictable. A switch would flip in her head and she'd be out of her mind before anyone knew what was going on. My home life was kept completely separate from everything else.

Sandy started dating a boy who played in a rock-and-roll band, and she invited me to see him play at a bar. I'd never been to a bar before and was excited to see what it was like, but I was only fourteen. How was I going to get in?

"That's easy," Sandy said. She gave me a fake ID that had a picture of Marilyn Monroe on it.

"When a girl shows up looking good, they don't care what your ID looks like," Stephanie told me.

Mom agreed to let me go, on one condition: she had to meet this boy in the band who would be driving us. I accepted her terms begrudgingly. I was terrified the twins would see Mom's true colors and might never want to see me again.

Stephanie and Sandy introduced Mom and me to Steve, a drummer who very obviously played in a hair band. We all sat in the living room, and Mom was a great host—friendly and super charming. She asked Steve to run to the diner down the street and pick her up a piece of cheesecake, so she could have a few minutes of "girl talk." While he was gone she asked the twins a lot of questions about me, trying to embarrass me, the way normal moms do. Then she thanked them for "watching out" for me and treating me so nicely.

"Why don't you girls sleep over here tonight?" Mom asked. "You can have a slumber party." Stephanie and Sandy looked at me. They had only the slightest idea of what went on in our house.

"Sure," I said warily. "That would be nice."

Steve came back with the cheesecake and we took off. I dressed plainly, but on the way there Stephanie told me to get undressed. "If you're going to be a groupie you have to dress the part." In the rearview mirror, Steve was staring at me as I lifted up my shirt and removed my bobos and jeans. Stephanie handed me a brown bag. I looked inside and smiled wide.

When we walked into the bar, every man in the tiny room turned to look at us. The place was dark and smelled like cheap beer and sweat. I held on to Stephanie's arm real tight, trying to hide myself behind her.

"Don't worry," Stephanie said. "You look great."

"I look like a slut." I was wearing an extra-long women's blazer with no

shirt underneath, panties, and high heels. My face was done like Jean Harlow's. I felt really vulnerable.

"That's the point. No guy can resist an underage slut," Stephanie said. Steve nodded in agreement.

"What if I get beat up?"

"Don't worry," she said. "We won't let anything happen to you."

Sandy handed me a drink. "It's a tequila sunrise! Drink it slow. Steve will kill me if you throw up in his car." I didn't like it, but after a sip I felt more relaxed. The anxious feeling slipped away. I felt sexy. The attention I was getting from all the guys felt exciting rather than threatening.

The band wasn't great but they were loud and

spread open the jacket, and revealed that nothing was there.

"I still don't believe it. There's no way you're a boy," he said.

I ended up getting really drunk and making out with Dylan. It was my first kiss. He picked me up like a baby and carried me outside when it was time to go. He tried to get me to go home with him but Stephanie and Sandy weren't having it.

"She's a boy!" Sandy yelled at him.

"I don't care," he said, locking eyes with me. "I want to pork her." We made out some more. "Do you feel this?" He took my hand and put it on his cock. It felt like a traffic cone.

"THERE'S NO WAY YOU'RE A BOY," HE SAID.

cute, and the energy in the bar was visceral. I danced with Stephanie and Sandy and had a couple more drinks. We took a break to the girls' bathroom and Stephanie reapplied my lip gloss. She said, "Every guy in the place is looking at you. No one cares if you're a boy or a girl. Just have fun."

"How can I have fun," I said, "when I'm busy trying to find a husband?"

Flirting with guys was much easier than I ever imagined it would be. No one knew who I was, so there wasn't a preconceived notion of the way I should act. I didn't have to try to fool anyone. Calling myself a girl or a boy didn't matter; guys just assumed I was a girl. Even when I introduced myself as Armand, guys didn't believe me.

The hot bass player in Steve's band—a tall, skinny Italian rocker named Dylan—wasn't buying it for a second. "If you're a boy, then open your coat and let me see your tits."

I laughed and slowly undid the top two buttons,

My eyes widened. "It's so big," I said.

"That's right, because I'm a man, and I'm going to make a woman out of you."

I wanted him and his huge cock right then. The twins had to pry us apart. Sandy promised to give me his number, and Dylan put me in the back of Steve's car.

Everything was spinning. "You better not throw up," Steve said. My ears were still ringing from the loud music. I laid my head on Stephanie's lap and she stroked my hair.

"I wish I looked like you," I told her. She smiled.

Steve pulled up in front of my house, I sat up, dizzy and nauseous, looked at my house and lay right back down. Every single light was on—a foreboding sign. When Mom got super paranoid she needed all the lights on. I sobered up real quick.

Sandy told Steve to wait until we were inside, and the three of us walked up to the door. It was locked and bolted.

I knocked. Nothing happened. I knocked again,

and saw Mom peeking out of the living room window. "Mom, the door is locked. Let us in." The twins said nothing. Vomit started to rise in my throat and I braced myself against the door.

"Maybe she's asleep," Stephanie said.

I waited a few minutes and knocked again. The living room curtains rustled and Mom peeked out. "Mom, I can see you. You have to unlock the door."

She moved away from the window, saying nothing.

"Mom, you said they could stay over!" Still no answer.

I looked to the twins, not sure what to tell them. It was humiliating.

I gave it one last try. I screamed as loud as I could, "MOM!" Now I was definitely going to vomit. I ran to the side of the house and threw up, hard and ugly. Mascara was burning my eyes.

Stephanie and Sandy came over to me. "It's fine," Stephanie said. "You can come stay with us."

"It's no big deal," said Sandy. "Just make sure you throw up everything you can now."

I didn't puke in the car. Steve's eyes bulged the whole time but he was enough of a gentleman to keep his concern to himself.

Louise Jr. met us at the door and took me to the bathroom, cleaned my face, gave me something to settle my stomach, and made up the couch for me, leaving a bucket close by.

The next day Mom let me in and asked how my night was. I told her it was fine but that I was really tired and needed to go to bed.

The twins never said anything to me about what happened, and neither did Louise, but they all made me promise never to get drunk again. I agreed on one condition: I needed Dylan's phone number.

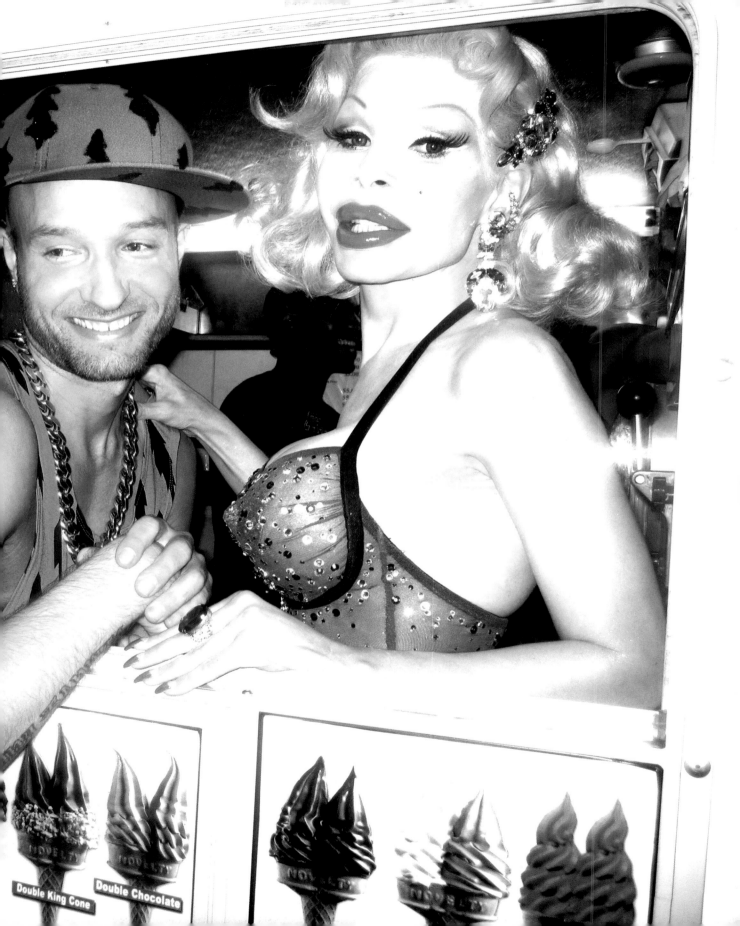

Double King Cone Double Chocolate

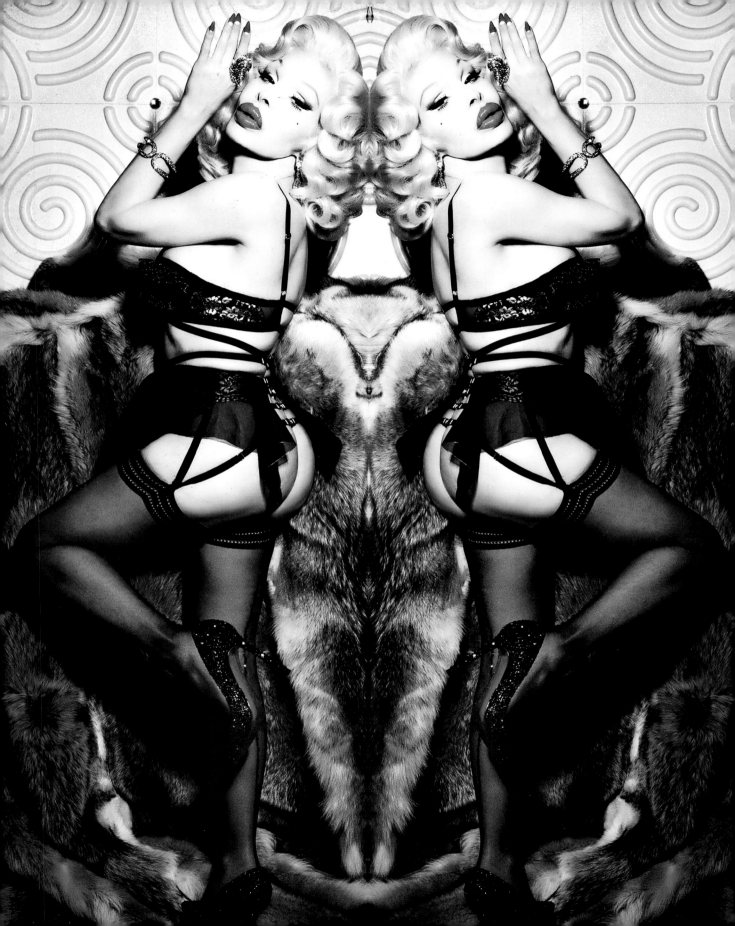

Chapter 3

SOME LIKE IT HOT

Stephanie became a stripper in Newark, which I thought was really neat. She was perfect for it: big tits and even bigger bleached blonde hair. Sandy was a little too conservative to strip, but they had both grown up unashamed of their bodies.

In preparation for her new job, Stephanie used red hair dye to give herself pink highlights. I was so jealous that I literally ached, like the woman in me was trying to claw her way out to the surface. Stephanie would come home after a shift and Sandy and I would help her unwrinkle her stripper cash while she told us about all the horny guys at the bar.

Louise Sr. made Stephanie costumes to strip out of, and I begged her to let me help. She showed me a few simple patterns and I caught on quick, embellishing them with hundreds of cheap jewels and beads. When all you're making are G-strings, bikini tops and pasties, it doesn't take that long to figure out.

My designs were a hit. The other dancers at the strip club really liked what I was making for Stephanie, and she said I should go along with her one night and bring some outfits to sell.

I called up Dylan and asked if he would be my escort to the bar. It seemed like a good setting for a first date. He agreed, and the next night he picked Stephanie and me up in his brother's car and drove us to Newark. I sat up front and we held hands; his boner was so big it was resting on the steering wheel.

"You know she's a virgin, right?" Stephanie said from the backseat. "You'll rip her in half with that thing."

Dylan winked at me. "Don't worry, I know what I'm doing."

The strip club stood singularly in the middle of an empty block. I felt so mature, going to make money with a boyfriend in tow. Stephanie introduced me to the sweaty manager, who gave me a table in the back of the smoky room to set up my wares.

"When the girls are done with their set onstage, they'll come through the audience for lap dances. They'll have cash on them, so you should make out okay." He didn't ask for any split and left me alone the rest of the night. I don't know why he let me in there in the first place, I was a kid.

I sold a few pieces, though it wasn't really about the money. I was mostly just charging for materials. Sparkles aren't cheap, you know. It was more exciting to be there with all the girls, to see the way men looked at them, even the way Dylan looked at them. I wasn't jealous when he was ogling. Who could blame him? These girls were sexual goddesses. How could I be mad at him for wanting to fuck them when I wanted to *be* them?

After a couple of hours, Dylan started getting restless. He told me he had something he really needed to show me, and I assured him I really needed to see it. I sucked his dick in the backseat of his car in the parking lot. It was bigger than my arm, and I'd never done it before, but he was very patient with me. Once I figured out how to open my mouth wide enough I started to really enjoy it. He asked if he could cum in my mouth and I said, "Only if you're my boyfriend."

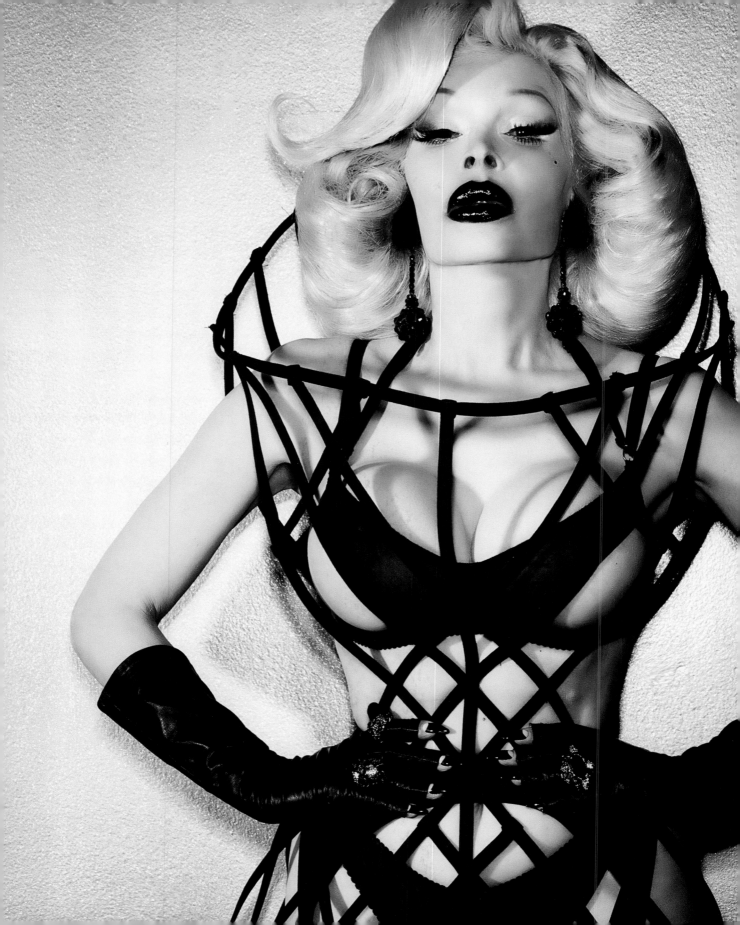

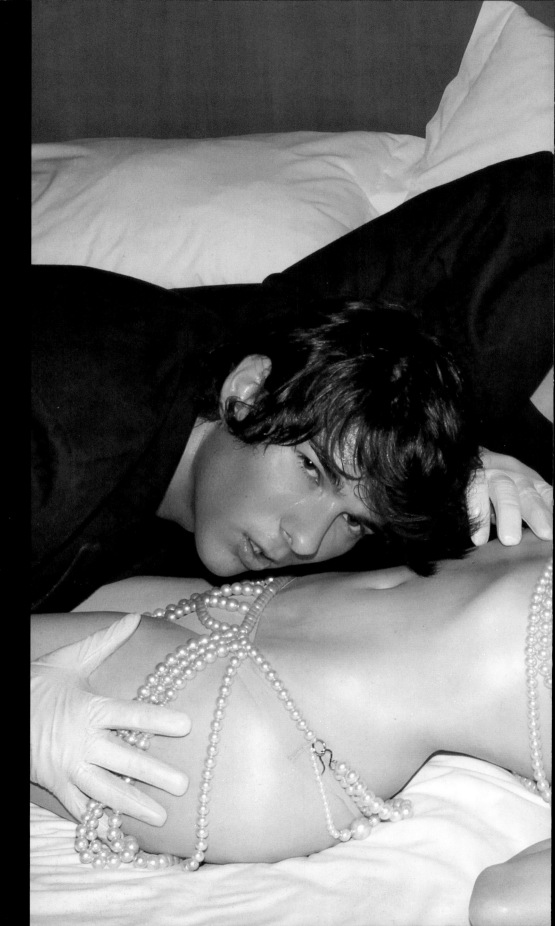

4 NON BLONDES

DOVIMA

Dovima With Elephants, taken by Richard Avedon in 1959, is one of the greatest photographs ever taken. She wore Dior, the elephants wore wrinkles and chains.

GRACE JONES

I did a show with her once; I had to pull off her pantsuit to reveal a dress underneath. The pants got stuck and she yelled at me, "Pull! PULL!" I pulled so fucking hard I thought my tit would pop.

DITA VON TEESE

Inspired me to get into burlesque. Understands body angles better than anyone else alive.

LANA DEL REY

"Will you still love me when I'm no longer young and beautiful?" Honey I'll be beautiful when I'm 100, and so will Lana. Oh, and she has great nails; we have the same nail technician!

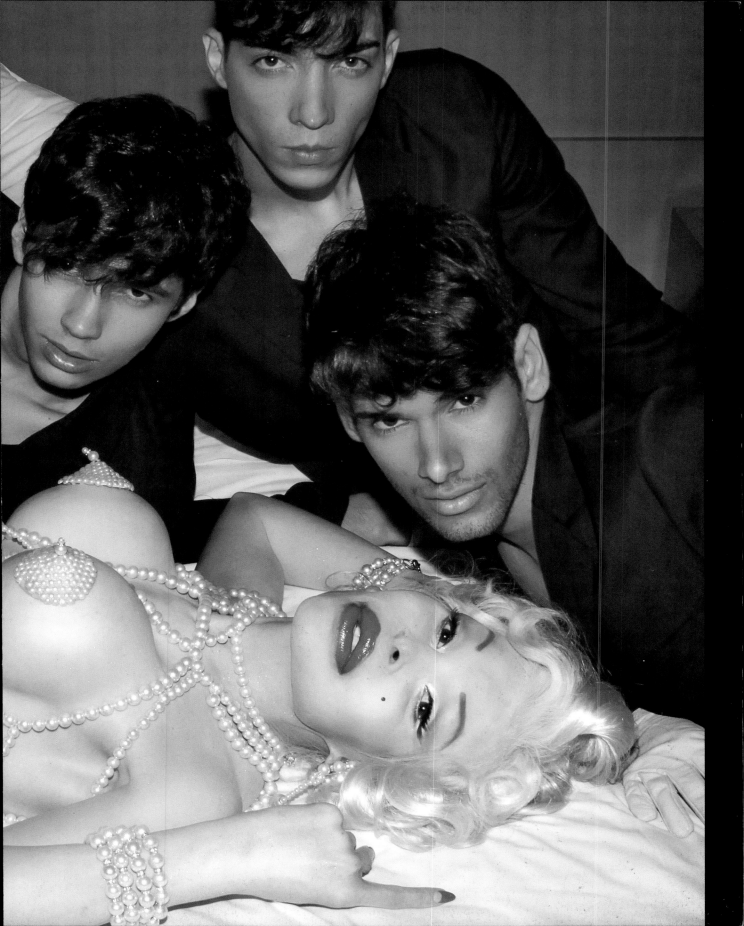

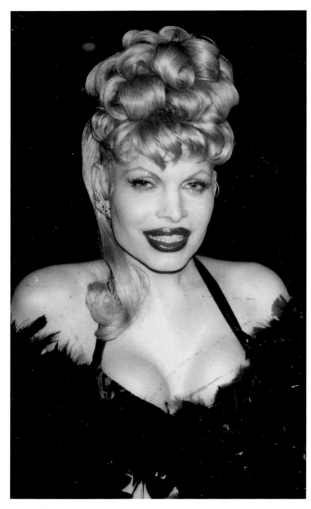

He agreed, and I swallowed.

We waited for Stephanie's shift to end, and Dylan dropped us off at her house. I kissed him good-bye and made plans to see a movie with him that weekend. Stephanie was laughing at me as we walked to her door. "He's the horniest guy I've ever seen," she said.

"You don't know the half of it." I was trying to be coy.

"Wipe the dried cum off your chin before my grandmother sees you." She handed me a napkin and patted me on the shoulder.

As we sat around the kitchen table, each counting our cash from the night, Sandy made us Bloody Marys (mine was virgin) and they plied me for the details of what had happened. "Are you going to let him fuck you?" Stephanie asked.

I'd been thinking the same thing all night. I wanted Dylan to take my virginity; I had thought about it since the night I met him. But not in the body I had. I wanted to have sex the way a woman was supposed to.

I think Stephanie and Sandy always assumed I was homosexual. That night I tried my best to explain to them what was really going on, even though I barely understood it myself.

"I just wish I had titties," I said. "Like a girl is meant to have."

The twins were unfazed. "You can take estrogen hormones; they'll make your tits grow," Sandy said.

"Yeah, but where am I supposed to get hormones from? My parents will never get them for me."

"You know," Stephanie said, "I'm pretty sure this girl Bambi I work with had a sex change. Maybe you should talk to her."

An image popped into my head: me, dressed as my Dolls of the World Japan Barbie, in a red-and-gold kimono, kneeling at the feet of my wise she-sensei as she made tea and told me the meaning of life and the burdens of tying a corset.

"What makes you think she had a sex change?" I asked.

"Her hands and feet are too big. Her toes hang off the ends of her shoes. Guys don't notice those things, but girls do."

I had to meet this dancer.

The next night Dylan dropped Stephanie and me off at the titty bar. Stephanie pointed out Bambi to me, said "Good luck," and went to prep for her set.

Bambi was on the stage, topless. She looked like Raquel Welch, with a large mound of Rita Hayworth red hair. An older man was playing with her large, pink nipples while he tucked cash inside her G-string. Her million-yard stripper stare was down cold.

Set finished, Bambi gathered her clothes and stepped down into the audience. She walked by and I said hello.

"You want a lap dance?" She looked irritated.

"Uh, no," I stammered. "I'm friends with Stephanie. I make G-strings and bikini tops if you're interested?"

Bambi stared at me hard. Then she sighed, shrugged, and started looking through my piles.

"These are nice," she said, "but I like green. It looks good with my hair. Make me a set in green and I'll buy them." She walked away, not giving me the chance to ask her anything else. But something told me Stephanie was right, and I had just met my first transgender woman.

I designed Bambi an extra-special bikini top.

It was emerald green, just like she wanted, and I created a studded necklace with hundreds of tiny green and pink gemstones that would cover her tits but flash a lot of skin when she moved. It was gorgeous, and Stephanie begged me to let her wear it. "This one's for Bambi," I said, "but she's not getting it for free."

I set up shop as I normally did, and waited for Bambi to finish her set. As soon as she got offstage I waved the emerald-colored bikini in the air, the jewels catching flecks of light in the dim bar.

She smiled and hustled toward me. "Stunning," she said. "How much?"

"It's yours, on one condition. You have to tell me: are you a transgender? Because I am."

She set the bikini down and looked at me, really looked at me for the first time. "I know," she said.

We were both silent for a few seconds.

"Are you going to do the whole thing?" she asked.

"Yes, I want to, but I need hormones and I don't know how to get them. Do you think you could trade me hormone pills for costumes?"

Her million-yard stare faded away.

"Okay, I'll do it," she said. "On one condition. Don't tell your mother." Bambi picked up the bikini and walked backstage.

The next night she gave Stephanie a month's worth of pills for me. I took one as soon as they were in my hand, and spent the next hour staring in the mirror. I felt so badass. I was fifteen, taking female hormones on the sneak.

Because I was so young, they started working almost immediately. My skin cleared up and became softer, the hair on my arms became even finer than it already was, and my weight redistributed so my hips got bigger. Most exciting of all was that my chest became really sore, to the point that it was hard to take a shower. I was developing breasts. Not enough to fill a bra, but they were becoming noticeable.

Bambi never became the mentor I wanted her to be, but she did show me how to properly "tuck" my penis, which she used to do while stripping before she had her sex change. She also taught me to wear a large belt around my waist to pin in my stomach and give me a great shape. For the most part, though, I was just another business transaction for her.

When young transsexuals approach me and ask if they should start taking hormones, I always encourage it. If you know that's what you want to do, you should just do it now. As you get older, the male hormones set in and it becomes harder to change. Once you have a man's build, a man's feet and hands, you can't reverse that. If you chemically castrate early, you'll never experience being a man, and you can deal with the surgical aspect when/if you're ready.

Whatever you decide to do, do it legally, with a real doctor. When I was going through it, there were a lot fewer resources for transgender youth. Don't use my risky decisions as your excuse. You never know

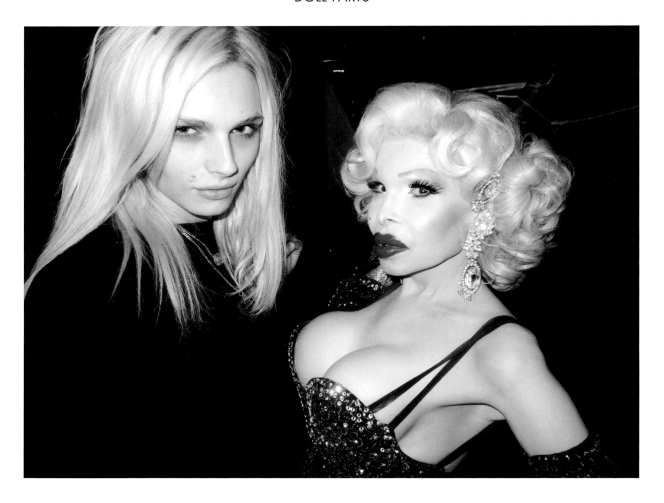

what you could be taking when you buy something off the street.

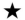

Two months after I started taking the hormones, my mother walked into the bathroom as I was getting out of the shower. Before I had a chance to cover up, she got a good look at me, and dropped her laundry basket.

I wrapped a towel around my body and walked to my bedroom. Mom followed me in, staring at me. "When did you get breasts?" she asked.

I'd developed full A cups by that point; I knew I could only hide them for so long and was prepared with a cover story. "Isn't it great? I asked Jesus to send me boobies, and he did!"

"Oh. That's nice. He gave you really pretty ones." She walked away.

Was it fair to play into her mental illness, and let her believe that Jesus had made me a girl? Or was this one of those little white lies that didn't hurt anyone?

I decided that if Mom was able to believe that Jesus had made me a girl, then I might as well go with it. And since Dad had completely disappeared (besides a weekly check in the mail) and Joseph had a girlfriend he'd basically moved in with, there was no point hiding anymore. When I was home or at the twins' house, I dressed as a girl.

I wore light makeup and Mom told me I looked nice. When she went clothes shopping, she'd buy me girls' clothes. I really loved a black top with ruffles that was super girlie and cute. Mom also bought me a padded bra, which she said would make me look fuller. She really embraced it.

One day she gave me the greatest present I've ever received: my first very own lipstick. It was Revlon's Cherries in the Snow; it was just the perfect shade of red. I wore it every day.

She did start to get on me about wearing too much makeup. "You look like one of those girls on the corner, swinging their pocketbook," she would say. "If you use your lipstick every day you won't have any left for special occasions." The thought of running out terrified me. I went and bought three more.

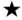

I still hadn't decided on a name. My mom told me she would've named me Kristen or Stephanie if I was born a girl, but I already knew a Stephanie, and Kristen didn't feel right. I considered a stripper name, something like Corvette, but I wanted a real girl's name, not a character.

Louise Sr. came up with Amanda, which is Armand if you drop the "r" and add an "a." "This isn't a science fiction project," she said. "You're not becoming someone new."

I loved it. She was right, I was always Amanda, even when I went by a different name.

Now that my outside was more matched up with my insides, I felt it was time to go all the way with Dylan.

We'd been dating somewhat steadily but it wasn't too serious. He'd take me out every Friday night—to the movies or to see *Rocky Horror Picture Show* play at an old run-down theater in central Jersey, or to see his friend's cover band. His own band wasn't that great, so they didn't play very often.

Mom liked Dylan and thought he was cute, but I tried not to let her see him. He'd drop me off and we'd make out on my front porch but he hardly ever came inside. One time he did, and we made out in my room. Mom saw us and screamed at the top of her lungs until he ran out the front door. I never brought him over again.

Dylan was probably fucking other girls on the side but I didn't care that much. He was just too horny to wait for me to be ready, so how could I blame him? I'd give him blow jobs every time I saw him, but he was a man and he needed more.

One Friday night, I called and told Dylan I was ready to go all the way. He picked me up and we went to the house of a friend, whose parents were hippies. They were laid-back, and Dylan said they'd definitely let us have sex in their bedroom.

I didn't know what to expect. Dylan gave me a Quaalude to help me relax. It worked. He took off all my clothes and laid me down on the bed. My tits were still very sore, so he kissed them a little but didn't touch them too much. He climbed on top of me, between my legs, and slowly put his entire huge dick in my ass and kissed me. It was painful, but I really loved the feeling of him being on top of me. It reminded me of when I was a kid, with the pillow and the wet dreams. This was exactly how I imagined sex would be.

After that, Dylan and I started spending a lot of time together. We'd hang out and fuck at the hippie house a few times a week. He had me completely dickmatized; I'd do whatever he wanted once he came at me with that huge dick.

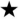

Stephanie and Sandy both moved to Chicago for college right before my junior year of high school.

I missed their friendship and advice, and I really missed going out to bars with them and flirting with boys. My breasts were a B cup by then, and I loved showing them off.

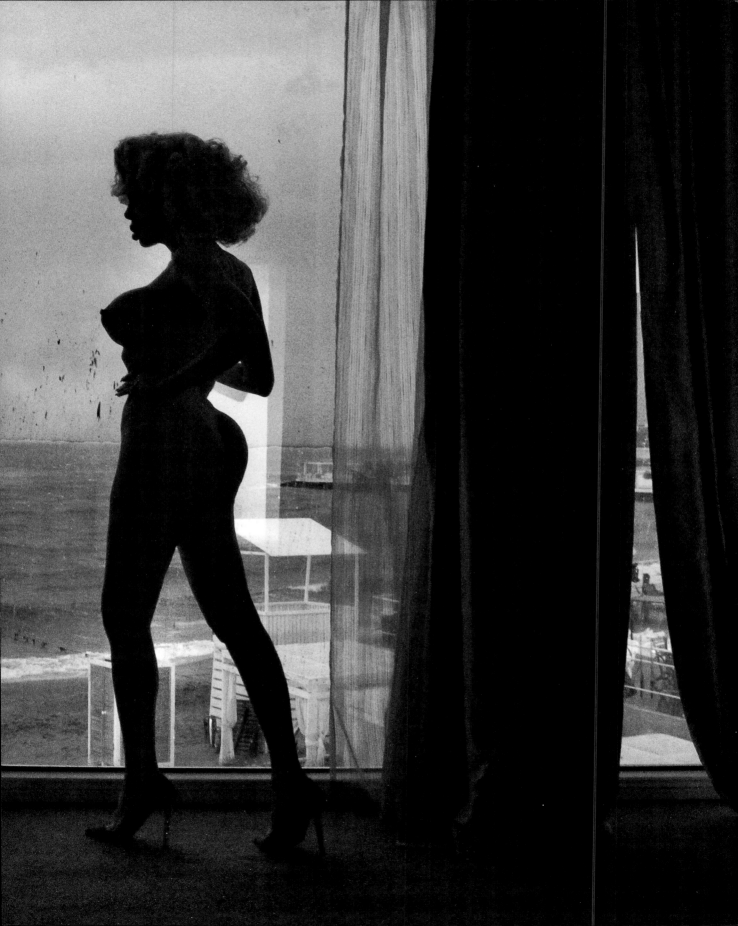

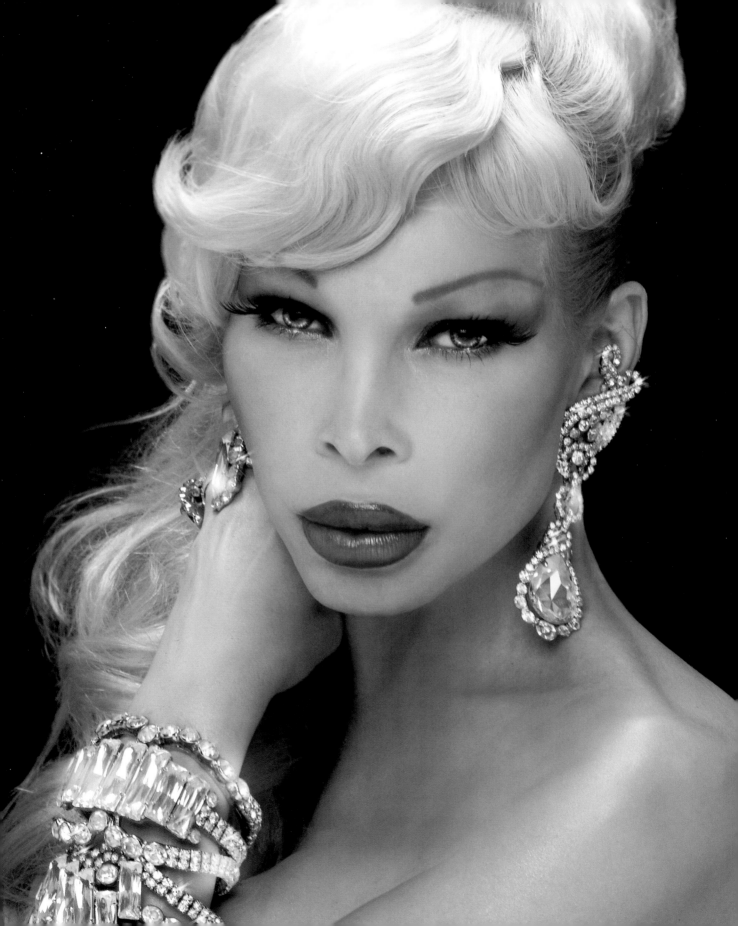

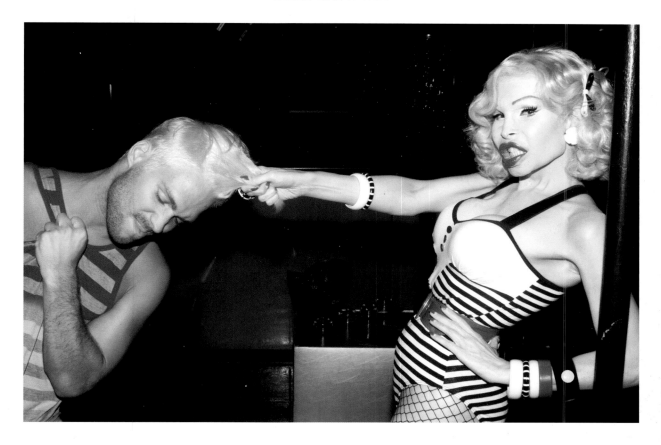

The only times I would dress as a boy were the few days a week I showed up to school. Mom would take me clothes shopping and I'd look through the girls' sections for things that were unisex enough to keep me happy and not draw attention from my peers. One time a girl in my class was wearing the same shirt as me and everyone laughed and laughed. It wasn't even a girlie shirt, so I didn't see what the big deal was. The next day I stole a pentagram patch from Joseph's room and sewed it to my T-shirt. Kids left me alone that day. For a few weeks I sewed it to whatever shirt I was wearing if I went to school.

I had to wear baggy shirts to hide my breasts, and I'd wear sneaky makeup—a little cover-up and liner that I'd borrow from Mom. We had the same coloring. My hair was long and I'd wear it parted in the middle, but a lot of guys were wearing long hair, so that didn't matter so much.

The hardest thing to deal with was gym class, so I stopped attending it altogether. Most of my school days were spent hiding in the library so no one would notice how my body was changing, or sitting in Mrs. Penny's office, trying not to gag on her rose musk perfume.

I was really getting sick of having to hide. It was so stupid that I was getting made fun of for the way I dressed, when I wasn't dressing the way I wanted to anyway. If I was going to be mocked, I might as well like the way I looked.

"Fuck them," Dylan said. "Why should you change the way you are for anyone?"

Yeah, fuck it, I thought, and decided to go to school dressed as a girl.

Louise Jr. offered to bleach my hair for the occasion. It was a little more painful than I expected, but Louise promised, "The pain passes, but beauty remains." It came out incredibly. I really did look like Jean Harlow.

Louise also helped me pick out a sensible outfit: a cinched top with a push-up bra, a stonewashed jean skirt, and slingback sandals with three-inch heels. I plucked out what remained of my eyebrows and drew them on, and wore my Cherries in the Snow lipstick with a matching nail polish.

Before I walked out the door for school that day, I asked Mom how I looked. "Stunning," she said. "But take off some of that lipstick, unless you're hanging out on the corner."

I walked to school as usual, and passed all the same neighbors I always did, but that day they all smiled politely and said hello instead of ignoring me. The same group of girls walked by me that I saw every day, but they didn't call me Leper Lepore. One of them told me I looked pretty, which I was grateful to hear. I didn't know why everyone was being so nice to me. Maybe seeing me as a girl was something they could finally wrap their heads around.

Shortly after I got to school, I was sent to Mrs. Penny.

There was another girl waiting as well. I'd never talked to her before but the rumor was that she was a lesbian. She was wearing gym shorts and a tank top, and had obviously been crying.

"What happened?" I asked.

She told me the girls in her gym class were making fun of her because she didn't shave her legs or armpits and she had smacked one of them.

"Why don't you shave them? You'd look so much better."

I thought she was going to hit me too. "I don't want to shave them. I'm proud of my hair. Mind your own business," she said. I felt bad. I didn't mean to judge her. I didn't get it.

Mrs. Penny called me in and I stood up. "I'm sorry," I said to the girl. "I think you look nice." She didn't say anything.

I sat down at Mrs. Penny's desk, nervously clutching my handbag. "Armand," Mrs. Penny said, "you can't wear makeup to school."

"All right. I'll take it off."

"And you can't have bleached hair either. You have to dye it back."

"Why in the world would I do that? I'll ruin it. I'll never get the color right, and besides, everyone already saw me, so what difference does it make now?" My voice was trembling as I spoke. I'd never stood up for myself before.

"Do you want to quit school?" she asked.

"No, I want to graduate! I want to have an education."

That's when Mrs. Penny looked down and noticed I had breasts. The top I was wearing was cut low enough that you could really see them.

"How in the world did that happen?" She turned as red as my lipstick and jumped out of her chair.

"Well, I prayed to Jesus to send me breasts, and he answered my prayers."

Her eyes bulged. "How did this happen, Armand?" She was yelling now. My mind could only focus on how happy that hairy lesbian probably was to hear me getting chewed out.

"I've been taking hormones," I told her. It wasn't any of her business but I just wanted this to be over. "I bought them. On the street."

"I can't allow you to stay in school in your condition. If you'd like a diploma, you'll need to go into a private tutor program."

I was sick of talking about it. No one else had an issue with what I was doing, what gave Mrs. Penny the right to give me such a hard time?

"If I get a tutor," I said, "will I ever have to come to your office again?"

That was my last day of high school.

Now that everyone knew my big secret, I was assigned a psychiatrist—an older gentleman named Dr. Robertson.

He had never worked with a transgender patient before, but he did his best to remain open-minded. I told him I would not stop taking my hormones, which he seemed okay with, but he said he would rather I got prescriptions from him. That sounded much better than going to Newark once a month and dealing with Bambi's shitty attitude, so I acquiesced.

There was one catch: I needed written permission from both my parents.

"Hello . . ."

"Amanda. My name's Amanda."

He stopped laughing.

"You're beautiful," he said, which made me smile, and I thanked him. "You have . . . breasts."

I filled him in on the whole story—Bambi, the hormones, Mrs. Penny, the private tutor, and Dr. Robertson.

"You're seeing a psychiatrist? Are you schizophrenic too?"

"No, I'm not like Mom," I told him. "I have what they call gender dysphoria."

Dad said he wasn't surprised completely, but he always thought I'd become a homosexual hairdresser, and maybe dress as a woman on the weekends.

HE OFFERED ME A DEAL: HE WOULD GIVE HIS CONSENT FOR THE HORMONES IF I STARTED ATTENDING BEAUTY SCHOOL.

Mom was easy. I told her Jesus said I needed the hormones, and she signed.

Dad would need a little more finessing. I asked him to meet me at the diner by my house.

When I got there, I saw his Cadillac parked out front and my heart beat a little faster. This would be the first time Dad saw me dressed as a girl. I walked in, past the spinning display of cakes and pies, and stood in front of Dad, who was sipping his coffee. He looked confused for a second when he noticed me. Then he started laughing. Was he laughing with me, or at me? I wasn't sure, but it could have been worse, I guess.

"Hi, Daddy," I said, and sat down.

"Maybe I will, Dad, but I don't think so."

"What does Mom say?"

"She's fine with it."

He offered me a deal: he would give his consent for the hormones if I started attending beauty school.

"You've got a deal," I said, and shook his hand.

He laughed. "You shake like a girl."

Dr. Robertson gave me my prescription and I continued to see him once a week. We talked about the first surgeries in Sweden and Germany, and places where I could have the operation done. Christine Jorgensen was the most famous case and we talked about her a lot, though I didn't relate to her so much. She wasn't that pretty.

DOLL PARTS

My school tutor, Jill, had a much clearer sense of transsexualism than Dr. Robertson or my parents. When we met, she asked me my name and whether I identified as male or female. Very strange start, I thought, especially since she was suspiciously tall, with what looked like an obvious wig.

Jill set up her books in my dining room, while Mom spied on her from behind the refrigerator. Women never came to our house. Maybe five total that I can think of, if the twins count as two. This was a big deal.

Things went smoothly until Jill asked me for a glass of water. Mom yelled out "No!" from her hiding place. Jill jumped up, but I laughed and tried to make a joke out of it. Getting upset would only make it worse.

I went for the water and pulled Mom into the bathroom. "Mom," I said, "I promise you I will not let that woman steal anything from us. But if she sees you watching, she'll know we're on to her!"

She kissed me on the forehead and went to her bedroom. Usually she would end up lurking around while I studied with Jill, but Mom never interrupted us again, and Jill never said anything about it during the whole two years she tutored me. Without the distractions at school, I earned all As. Jill was a real saint. Not a tranny, though. I asked.

"As an icon, Amanda is one of a kind because of her unique and singular look in the art of fashion. She has established herself as the most original and glamorous image in the world of transgender."

—PATRICIA FIELD

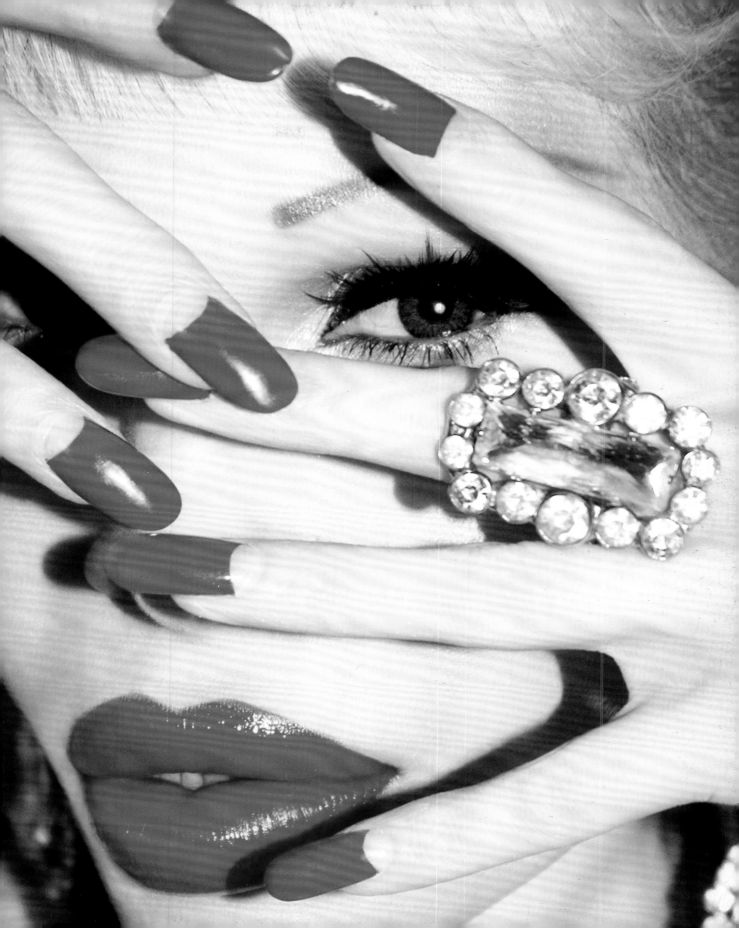

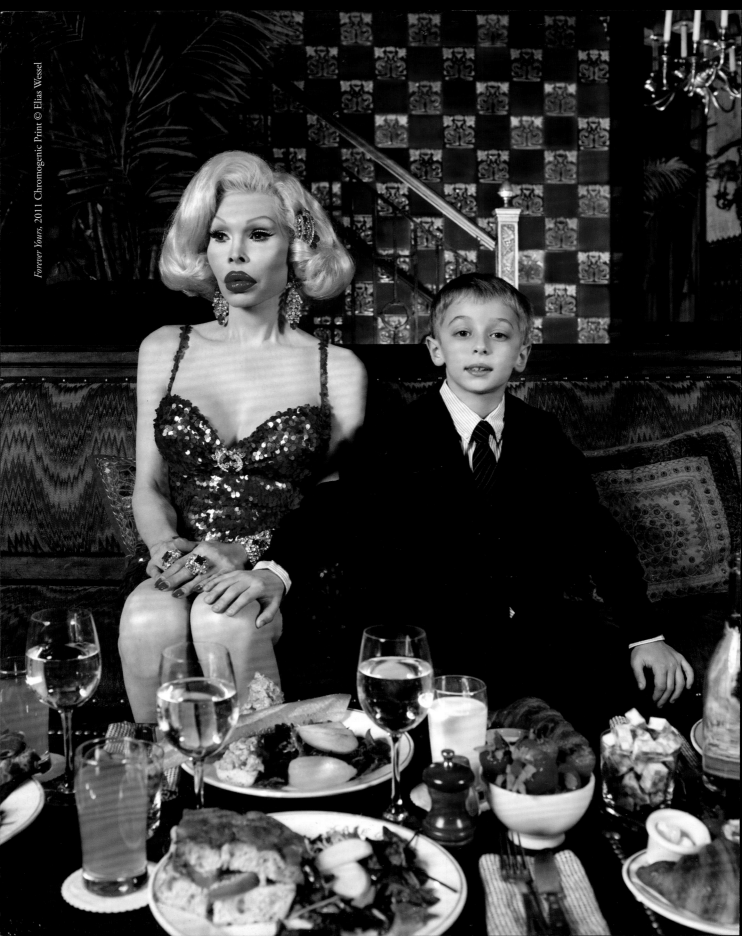

Forever Yours, 2011 Chromogenic Print © Elias Wessel

HOW TO MARRY A MILLIONAIRE

Dad wanted to "spend more time" with me, so he offered to drive me to beauty school every night. I learned some interesting things about Dad on those car rides. Here are my three favorites:

1. He was remarried, to a Southern Baptist woman who had three kids that called him "Daddy."

2. His former roommate, whom we all called German Chris, was gay. So he "understood what I was going through."

And my personal favorite . . .

3. I hadn't gone through puberty yet, and when I did, I'd "grow out of this dressing-like-a-girl phase."

Dad was born on April Fool's Day. Maybe that explains it. I mean, Mom was no picnic but at least she didn't start a new family without telling anyone. Eventually I just started getting rides from girls in my class. It was easier that way, and Dad seemed relieved.

Beauty school was a real bore. The main problem was that I had no desire to do other people's hair. I don't know if that makes me a narcissist, or if it's simply proof of my vanity. Even from a young age I was very vain about the way I looked.

My hair was growing out nicely, and my main goal for going to school was to learn how to properly care for it. I learned how to color and roller-set my hair, and give a basic manicure, but I'd already learned a lot of those things from the Louises, so I never paid much attention in class.

The upside to beauty school was that I made some new friends who loved to go out and have a good time. One of the girls in my class had fucked Dylan before, and when she found out I was dating him she just loved it. "Dylan's an asshole. He's controlled by his dick. It's so big there's no blood left for his brain to function," she said.

Sex with Dylan was wonderful, but she was right. I knew he was fucking around, and even though we had fun, I really wanted to get into something more serious. I didn't want to work in a beauty salon. I wanted what Zsa Zsa Gabor had.

The girls decided to help me find a real sugar daddy of a boyfriend, so they took me out dancing one night . . . to a gay bar. They thought they were doing me a favor. I did dance most of the night with this cute guy named Keni Valenti, who had worked with Betsey Johnson and just opened a boutique in the East Village. I told him I loved to sew and he gave me his number and said he was always looking for help. It was a fun night, but how was I going to meet a boyfriend in a gay bar?

"I'm not gay," I told my classmates at the diner afterward. "I'm a girl. Gay guys aren't going to be interested in me. I need to meet straight guys." Enlightenment came over them.

None of the girls treated me any differently because I was transgender, except for one: Tina. The whole thing fascinated her. She loved that I was trans and wanted to know everything about it.

Like Olivia Newton-John at the end of *Grease,* Tina was a good girl by day with a wild side that came out at night. Her hair was almost as big as she

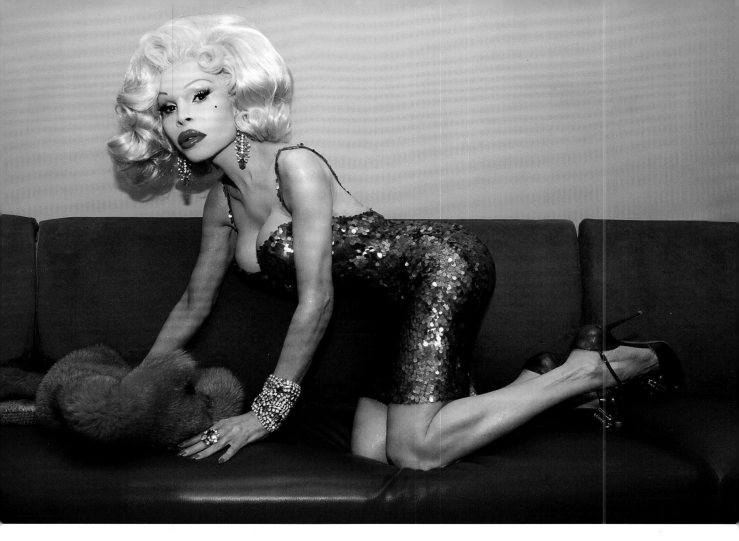

was; that girl kept Aqua Net in business. Sometimes her questions about my sex organs were a bit much, especially when she was smacking her gum in my face as she asked them, but I couldn't hate her for being inquisitive, even if she was insensitive.

Tina was a world-class tease. Her favorite thing to do was to lead guys on and then give them the boot. "Men are so gullible, they'll believe anything you tell them. They believe you when you tell them you're a girl, right?"

"I am a girl."

"You know what I mean," she said.

Tina had a great idea: we'd go out, find the most straitlaced guy in the bar, and trick him into thinking I was a regular girl. It was a new way for Tina to tease men. I willingly played along, since the prize for the game was a hot guy for me to make out with. When things started to get a little too hot and heavy, I'd tell my date I had my period to throw him off.

Stephanie came back from college for a couple of weeks and I was so excited to tell her about how easily I'd transitioned into living as a woman. "Can you believe it?" I said. "You wouldn't believe the hot guys I'm meeting." I felt like I had something to prove—that I was just as much of a woman, and just as desirable, as she was.

Stephanie wasn't impressed. "So you're lying to men now about your gender?" she asked.

"Not lying, just keeping secrets."

"You didn't have to trick men to be with you before. You're enough, Amanda. I thought you knew that."

I was furious but did my best to conceal it. Who

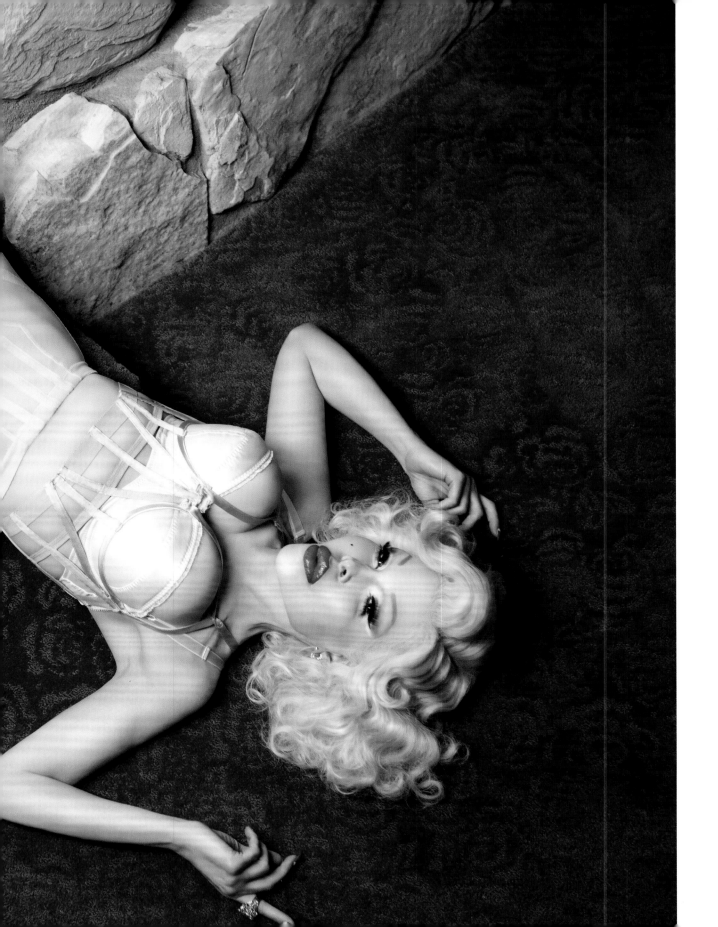

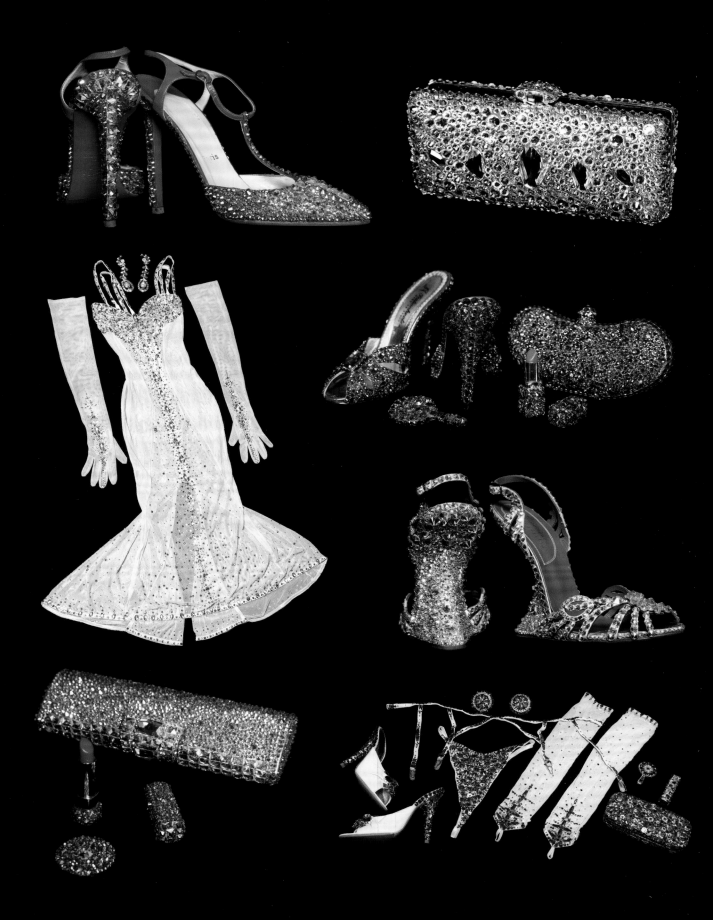

was Stephanie to judge me? She had no idea what it was like not to be born the correct gender. She had everything: she was perfect and beautiful and she had a pussy of her own. What did she know about what I went through? And who the fuck cared about these guys? Tricking them was like paying back all the people who had made fun of me for being so feminine.

All kinds of women were on display. Some looked like grown men who had simply put on a cheap wig and a pair of heels and called it a day. Others were stunningly gorgeous, completely and perfectly done. I was overwhelmed; I felt like a little girl going through her big sister's closet.

The most beautiful woman in the room was a tall,

"MEETING THAT DOCTOR MADE ME REALLY THINK ABOUT HOW MUCH I WANT A PUSSY."

Stephanie dropped me off at home and said she was going to be busy the rest of the week and probably wouldn't be able to see me again. I told her that was fine by me.

I couldn't sleep that night. Stephanie calling me out like that had made me realize I was angrier about my situation than I knew.

The next day I saw Tina and told her I needed to make a change. I couldn't live a lie anymore. She said she understood and had just the solution: there was a tranny bar in Manhattan she'd heard about. We could maybe meet some other girls, and meet the men who wanted to fuck them.

We entered the tranny bar through vinyl curtains, like in a butcher shop. Behind them was an enormous coat check with a bored-looking blond boy.

"You're new?" the kid asked. I nodded. "I'll keep your coats close. Pretty girls like you will get a date real quick."

There were about thirty girls in the bar and roughly the same number of men. Disco music was beating in my eardrums, but no one was dancing. We walked to the bar and ordered sodas, avoiding eye contact with the girls who were staring daggers in our direction.

busty Puerto Rican with perfect facial features and long, silky black hair. Her dress was short and cut extremely low, revealing perfect tits that needed no bra. A short, heavyset man was talking her up and she seemed to be enjoying his company. He escorted her to coat check and paid for both their coats, and they left together.

A middle-aged guy in glasses approached and offered to buy me a drink. He introduced himself as "Dr. Steve," which sounded kind of silly.

"What kind of doctor uses their first name?" I asked.

"I'm a plastic surgeon." My ears perked up. Now, this was interesting. I put my flirting skills to use, and he turned out to be a nice guy and was definitely into me. I asked him about his practice, and he said he worked on a lot of transsexuals, performing feminization procedures.

"Like boob jobs?" I asked.

"Sure," he said, laughing, "and some other things."

I looked up and saw the Puerto Rican beauty enter the bar again, alone, and drop her coat off.

"That's weird," I said. "That girl left here with a guy like fifteen minutes ago. Why is she back so soon?"

Dr. Steve filled me in on what was going on. A good 99 percent of the girls in the room were prostitutes. They turned tricks in order to pay for their procedures.

"A girl like her," he said, "could turn four or five tricks a night at this place." As he said it, another man walked

up to the girl, and within five minutes of checking her coat, she had it back again and was out the door.

"You're lucky," Dr. Steve said to me. "You don't need to do anything to your face. Just trim your nose a little, and you'll be perfect." I'd never thought about my nose like that before.

"What about breasts?" I asked. "My hormones got me a B cup, but I want to go bigger, like Jayne Mansfield."

"That's for big mamas. Just take your hormones, get the sex change when you can, and let me fix your nose."

Tina tapped me on the shoulder; she was ready to leave. I gave Dr. Steve my number and promised to let him take me to dinner. On the way out, Miss Puerto Rico was heading back in. She smiled as we walked by and I smiled back. She seemed happy enough.

We went back to Tina's house and I called Dylan to pick me up. I told him all about the tranny hooker bar and the doctor and the poor coat check boy who was checking the same coats over and over again.

"Where exactly is this place?" he asked, and laughed, but I knew he wasn't kidding. We fucked for like an hour, but my heart wasn't in it. He stopped pounding into me and lay down, playing with my hair and looking at me.

"Meeting that doctor made me really think about how much I want a pussy," I said. "Having sex is fun and all, but I wish I could give myself to you the way a girl is supposed to."

"What kind of pussy do you want?" he asked.

"The pink kind?" I didn't know there was any other brand of pussy besides pink.

Dylan reached under his bed and pulled out a stack of *Hustler* magazines.

"Oh my God, you really are the horniest guy in the world," I said.

"Just look," he said, and started flipping through one of them. "See, there's different types of pussies. At first they all look the same, but when you open them up, they're all different."

That's the nice thing about *Hustler:* those girls open wide so you can really see what's going on. It was a real life lesson. I jerked Dylan off while we looked through the magazines and picked out our favorite pussies.

A week or so later I saw Dr. Steve for dinner and asked if he would do my sex change. He said he couldn't, he didn't do that kind of surgery, but he'd happily fix my nose for me. I figured it was a good start.

I went to his office really early in the morning, before any other patients arrived. He did my nose job for free (nothing is free). It made a huge difference. There was nothing wrong with it really, but he made it a little narrower. For about a week my face was swollen and I had black eyes. I pretended I had the flu and locked myself in my room until it calmed down. When I reintroduced myself to the world, my eyes and lips stood out more. I was so happy with the whole thing. It made me look a little like Gidget, and I started wearing a ponytail with little bangs, just to go along with that look.

It was my first plastic surgery and it was a resounding success.

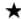

Tina was dating this really dorky preppy guy, and she promised him she'd find a friend to go on a double date with.

"He's got money," she told me. "He has his own car and everything."

I agreed to go, on one condition: she had to tell my date about my situation beforehand. She promised she would.

In preparation, I wanted to bleach my hair. It was starting to get really long, past my shoulders for the first time in my life, and I wanted to make sure it was perfect. I'd been taking care of it myself—I'd learned a few tricks in school and had been putting highlights in and fixing my roots—but it was time for a major overhaul.

The color I wanted to get to was basically a white blonde, so I figured I'd leave the bleach on a little

AMANDA'S BEAUTY TIPS

Think of the sun as Kryptonite. Bring a camisole with you everywhere you go. And wear SPF every day, no matter how little you'll be outside.

•

Exfoliate. I repeat: exfoliate. Whether you use retinol, glycolic acid, manual exfoliation, or all of the above (like me).

•

If you're having sex, wear just lip liner and a Kat Von D lip stain, then blot. It looks great and doesn't make a mess.

•

More skin, more makeup, more powder, more perfume.

•

When in doubt, keep blending.

•

Suzanne Somers once told me, "Work with what you got." Good advice, I think.

•

Your skin needs a rest from makeup. Don't wear it all the time, like when you do yoga.

•

If you're not constantly touching up your makeup, then you're not looking your best.

•

At my funeral, someone had better touch up my lips and foundation before they close the casket. (That's not a tip. It's a formal request.)

longer than I usually would. It burned pretty bad, but I was used to it, and I thought about what Louise Sr. would have told me, about the price of beauty.

Unfortunately, Louise had never told me what happens when you leave bleach on your head for two hours. All my hair broke off. I was devastated. Mom was the only one I'd let see me, but she couldn't handle my crying; she started freaking out, asking who had hit me, or if someone had tried to touch my private parts. It was worse than all that. I had ruined my own hair.

I went to see Louise Jr., and she fixed it the best she could. She trimmed it down and layered it a bit, but my hair was short . . . boyish short.

"It's not boyish short," Louise said. "It's Twiggy short. Just tell everyone you're going mod!"

There was nothing I could do about it, the damage was done, so I did my best to move on from my pain and accept my hair for what it was. I still looked cute, and Louise did style it very well.

I tried to get out of my double date with Tina, but she insisted I go.

"He's a bit of a dork anyway, so who cares what you look like?" she said.

I did. I cared. I always care. But I gave in, and we showed up together for our date.

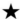

"I like your hair. You look like Mia Farrow in *Rosemary's Baby*. That's my favorite movie."

That's the first thing my date said to me. His name was Michael. He was the complete opposite of Dylan in every single way.

Michael was ten years older than me, and dressed all in black with white socks. His skin was blotchy and red, his nose bulbous and riddled with rosacea. He sat hunched over and took a while to stand up, the result of a car accident he'd had as a teenager. He owned a bookstore that his grandmother had left him when she died, and he talked about books most the night. Basically, he was a total nerd.

I wasn't physically attracted to him, but there was something different about Michael that made me want to get to know him. He seemed sad and vulnerable, and I was used to hanging out with loud, aggressive men. Total lost-puppy syndrome.

There was an undeniable chemistry between us. We held hands for most of the night; his were clammy and sweaty, like he was nervous about something. It was endearing. We made plans to go on a second date that weekend.

I broke things off with Dylan that night. He seemed sad but wasn't too upset. There was probably some girl sucking him off while I was on the phone with him anyway.

Mom overheard the breakup and asked if I was okay. "He was such a good-looking guy," she said. "Why on earth would you break up with him?"

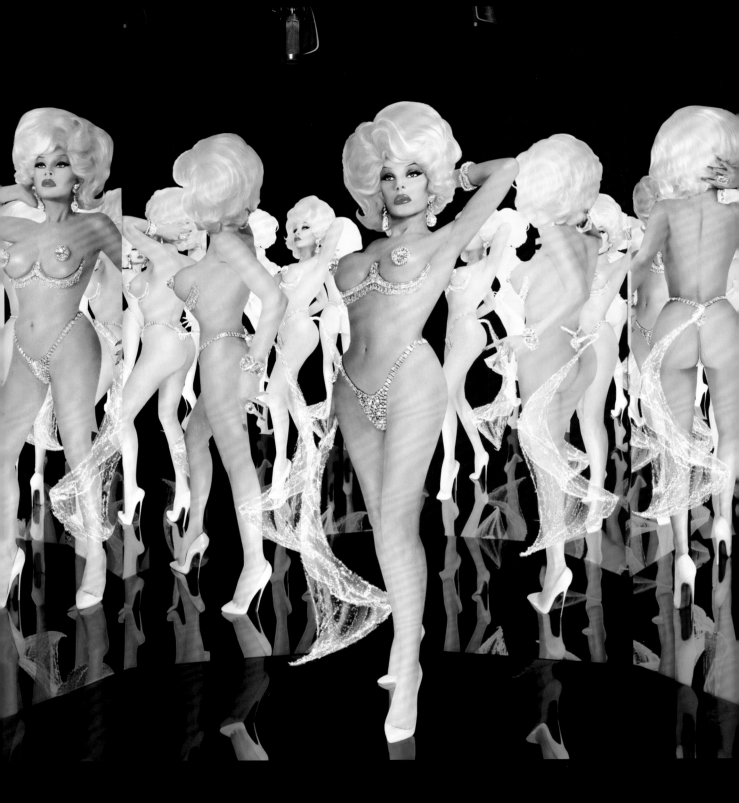

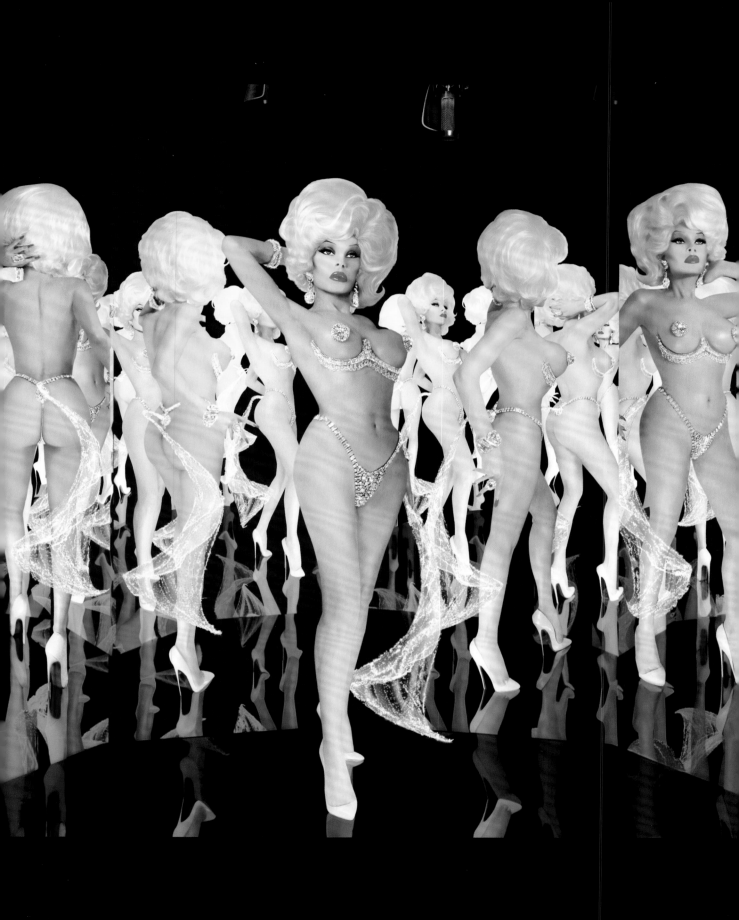

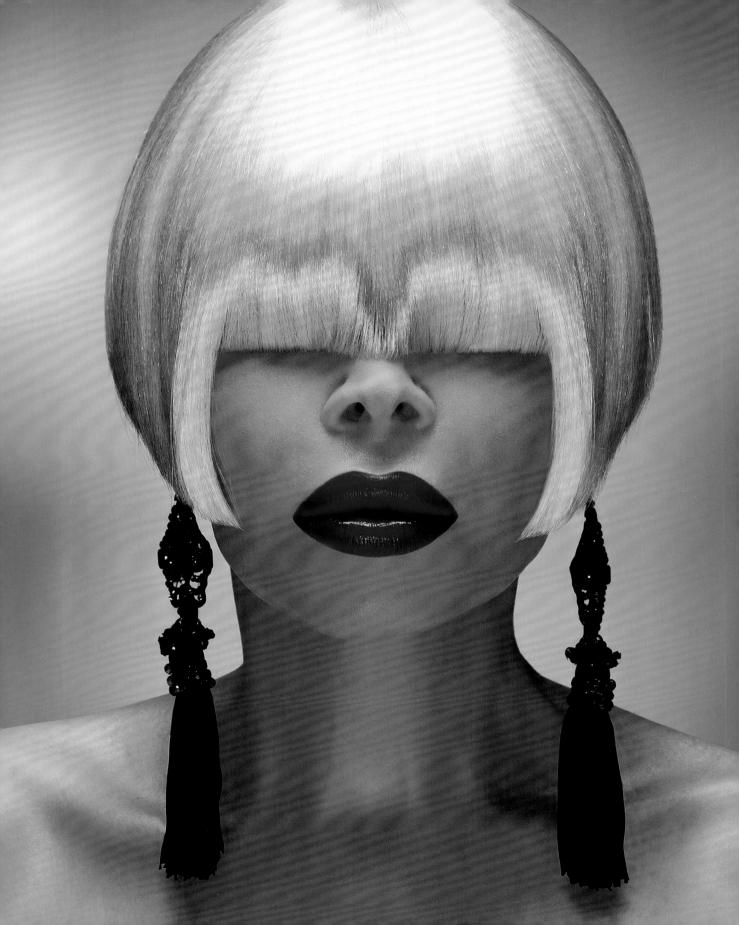

I told her about Michael, who I thought was a much more serious prospect for a boyfriend. He'd paid for dinner for all of us, and dropped me off in a very nice car. Dylan was a boy, but Michael seemed like a man.

The phone rang; it was Tina. "So what did you think?" she asked.

"I think he seemed very nice."

"Listen, Amanda, I know I said I'd tell him about your situation, but I didn't think you'd like him anyway, so I didn't say anything. He doesn't know about you."

"Oh. Okay." I was pissed but I've never been very good at expressing that. I hung up and continued to talk about my date with Mom as if nothing was wrong.

I'd have to tell Michael the whole story and hope he was understanding.

Our second date came and went without me telling him anything. It just never seemed like a good time to bring it up.

On our third date, Michael introduced me to his parents, whom he lived with. His father, Thomas, was an accountant, and his mother, Audrey, a housewife. They were much older; they had Michael in their late thirties. I was wearing shorts and when I went to the bathroom Michael's father told him I had really nice legs. Michael told me this later and I thought it was pretty funny that such an old man could think like that. Even still, Thomas and Audrey were normal, nice people who welcomed me into their home warmly. They loved Michael and seemed to be a very close, nurturing family. I felt awful keeping my big secret from them when they were being so nice to me.

We continued to date for several months—movies, dinner, making out in his car or in his bedroom. His parents let him do whatever he wanted.

My secret never came up. I stopped talking to Tina completely; I was so angry that she had put me in this position, even though I knew I was just as much to blame. I could have just told him on our second date and dealt with the consequences, either way. But now, so much time had gone by. What a mess.

For a long time Michael didn't put pressure on me to have sex. He loved blow jobs, and I happily blew him at least three times a day, which kept him happy. His dick was only a little bigger than average but still, my jaw hurts thinking about it. I told him I was a virgin to keep him from bothering me for anything else, and I'd wear really tight jeans and tuck my penis the way Bambi had taught me.

Fooling around started becoming more and more difficult, though, figuring out ways to keep my panties on. Michael wanted to see me completely naked and couldn't understand why I wouldn't let him.

My heart started beating out of control whenever we were alone. My entire body would shake with nerves, like a bass machine was pumping under my skin all the time. I'd lie and tell him I was quivering with excitement because I liked him so much. The good girl excuse could last only for so long.

We were alone in his house one night, making out, and Michael started pressuring me pretty hard to see me naked. It was odd that I'd blow him so much but refused to undress. "You'll still be a virgin. I won't even touch it, I just want to see it," he said.

The time had come. I couldn't keep lying. I got off the bed and put my shirt back on, crying and shaking. I can't imagine what he was thinking.

"I have to tell you something," I said.

"Okay. You can tell me anything."

"I have a problem," I told him. "I was born a boy. I don't like being a boy and I'm taking hormones and want to have a sex change, but right now I have a penis."

At first Michael didn't say anything. Part of me thought that maybe he had always known, that I had only confirmed his suspicions. Maybe this wasn't that big a deal. Then he exploded. He picked up his

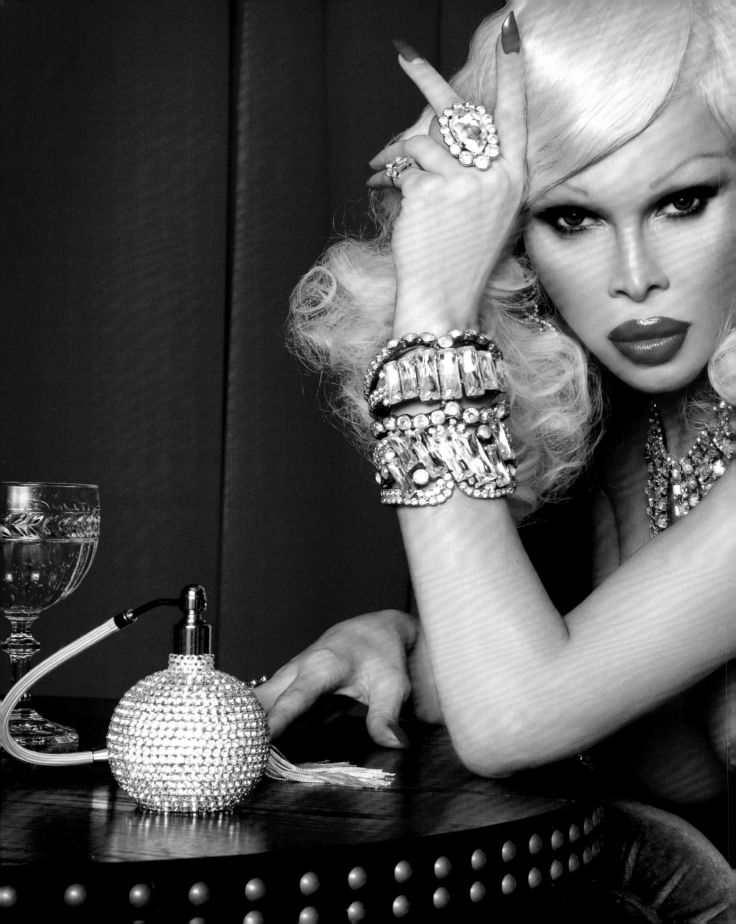

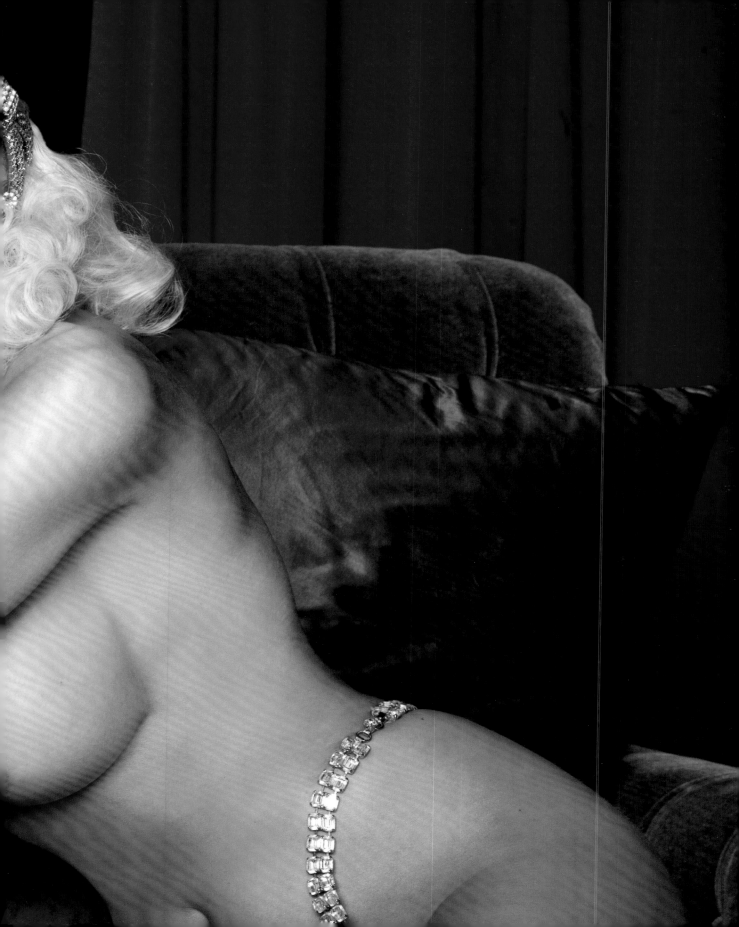

nightstand and threw it against the wall, sending books and prescription bottles flying through the air. He came toward me, thrusting his finger in my face, accusing me of deceiving him, of being a liar. I tried to explain myself, but I was so upset I could barely put words together, and besides, I knew I was wrong. I told him I was afraid he wouldn't understand.

That didn't make him any less angry. He punched a hole in the wall right next to my head, cutting open his knuckles. I braced myself. *This is it,* I thought. *He's going to kill me.* He could do whatever he wanted with me, and in the morning when they found my beaten body, everyone would agree it was my own fault.

Michael grabbed me by my hair, dragged me to the front door of his house, and threw me out. He said, "If I ever see your faggot ass again, I'll kill you."

I hitched a ride home from an old man who was listening to an AM radio preacher going on about the actions we take and the consequences they lead to. I could barely see I was crying so hard, so he turned it up louder. A fucking radio was calling me out on my shit, as if I didn't feel bad enough already. When he dropped me off, he said, "Whatever has you so upset, remember you can always turn to God."

Mom was asleep. I went into her bathroom, picked up the first bottle of pills I saw, and swallowed them all. Then I sat in the kitchen and waited to die. I remember thinking about the movie *Imitation of Life,* and that poor black girl who had been passing as white. Things didn't end so well for her. *This isn't a new story,* I thought. *You're just another girl with a secret.*

My ears started ringing horribly. I felt like a siren had gone off right next to my head. Mom heard me crying and ran down the stairs. She rushed me to the hospital, where they pumped my stomach.

They kept me in the hospital for a couple of days after my "suicide attempt."

The pills I'd taken were aspirin. I thought they were Mom's antipsychotics, or maybe sleeping pills.

My psychiatrist came to see me. "Being self-destructive and suicidal are symptoms of your unhappiness with your body," he said. "This is further proof that you need to have gender reassignment surgery."

I had been taking hormones for a little more than a year, and I knew I needed the sex change operation if I was going to have any chance at a normal life.

There were two things standing in my way: I needed money for the surgery and I needed my parents' consent, since I was only sixteen. Mom sat with me in the hospital and I begged her to give permission, but she refused. "Wait until you're twenty-one," she said. "What if you regret it? You'll never be able to go back. It will be permanent."

I was so angry with her, I yelled and screamed until she left the room. Why would she deny me the one thing in the world I needed? There wasn't a question in my mind that this was the right thing to do. How could she not see that?

My situation felt hopeless, and now I didn't even have Michael, whom I had genuinely come to love. I lay in the hospital bed, feeling empty and lost. It was hopeless.

Then, Michael's father walked in the door.

Michael had told Thomas everything.

Instead of freaking out, Thomas was sympathetic. "I can't imagine what you must be going through," he said, "but I promise to do whatever I can to help." With my permission, he talked to my psychiatrist in order to better understand what was involved.

After I was released from the hospital, Thomas sat Michael and me down together.

Michael wouldn't look at me. His face was even redder than usual, and his eyes were puffy, as though he hadn't slept.

"I know things are a mess right now," Thomas

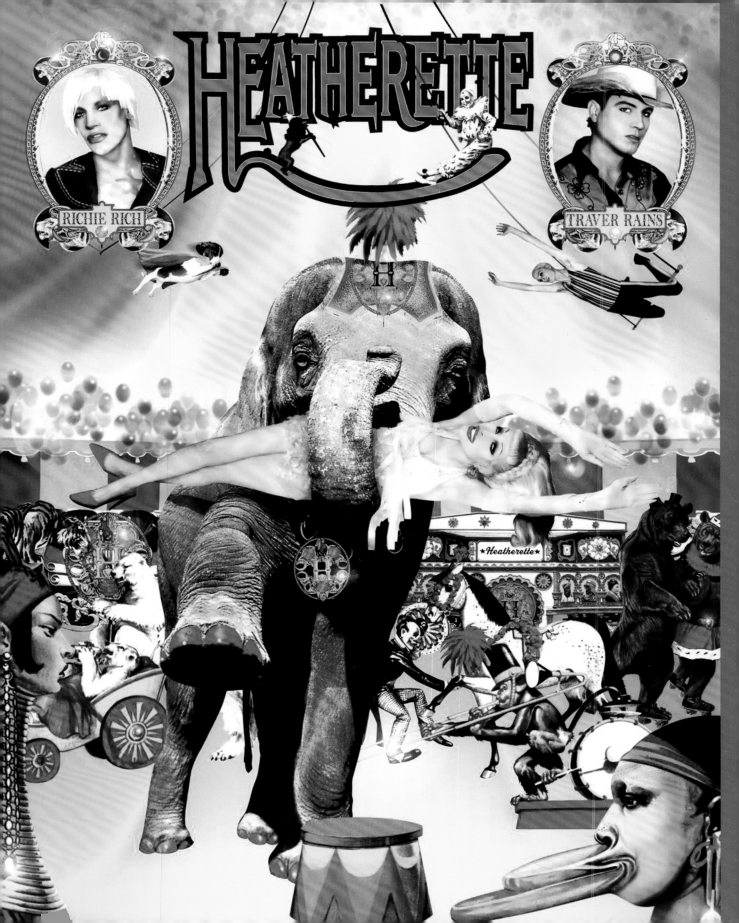

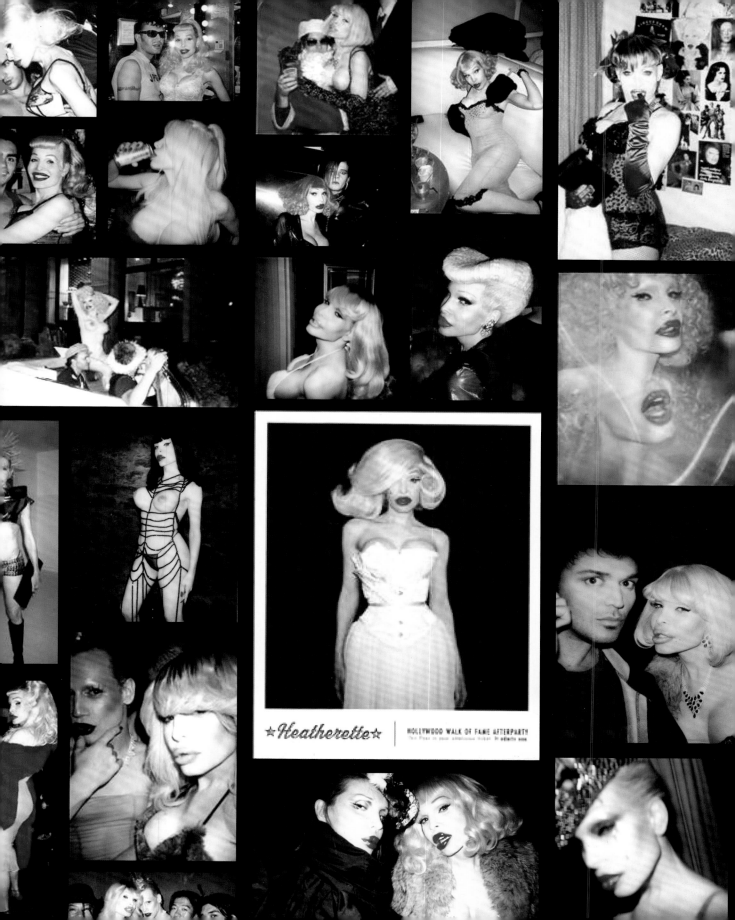

★Heatherette★ | HOLLYWOOD WALK OF FAME AFTERPARTY

said. "But as far as I can tell, there's only one thing standing in the way of you two being happy."

"Yeah, she's a man," Michael said.

"No, she's not," his father told him. "She has a problem that can be corrected surgically. You can't turn your back on people you love. Amanda needs our help."

I didn't say anything.

"Michael," Thomas said, "I've been putting money aside for some time now to buy you a new car for your birthday. If you prefer, we can use that money to pay for Amanda's sex change operation."

I couldn't have heard correctly. There was no way.

"It's up to Michael. Decide what you want to do," Thomas said.

Michael looked at me, finally. I looked him in the eye and started to cry.

"Fine," he said. "Let's do it." I screamed with excitement. It was almost too much to process. I jumped up and hugged Thomas, thanking him repeatedly. Michael stood up and I walked over to him. He hugged me too, and we kissed.

"This is the happiest day of my life," I said. "I'm sure that new car smell doesn't hold a candle to a new vagina smell." They both laughed.

"We're family," Thomas said. "Family sticks together, no matter what."

Money was only half the problem. I'd still need to convince Mom to give her permission.

Thomas wanted to talk to her face to face. "Any reasonable person can understand," he said. Mom didn't want to unlatch the front door for him, but I convinced her to let him inside so we could really talk.

She was wearing her bathrobe and furiously cleaning an already clean pan while Thomas tried to explain what was going on. Every time Thomas asked her a question, Mom banged the pan against the countertop as hard as she could, then tried to change the subject.

Thomas told her he thought I should have the surgery and that he would pay for it. All Mom had to do was sign the papers giving her permission.

She wasn't having any of it. She accused Thomas of kidnapping me, brainwashing me, and trying to kill her.

"Mom, you haven't been taking your medicine, have you?" I asked. She didn't respond. She told Thomas to leave or she'd call the cops, and locked herself in her bedroom.

"Is she always like this?" Thomas asked.

"Only when she doesn't take her pills."

Thomas left. I was furious. After all the times I'd stood up for Mom, she couldn't be there for me when I needed her most?

I didn't see Thomas or Michael for a couple of days. The next time I did, Thomas had come up with an idea to get around Mom: he would legally adopt me, so he could give the permission himself.

At first I wasn't sure. Mom's mental health obviously made her a less than ideal caretaker, but was this too extreme?

I called Dad. He hadn't been around in some time, but I didn't think it would be hard to get his permission. A woman answered his phone. "Who is this?" she asked.

"Amanda. I'm calling for my Dad, Herman."

Dad picked up. "You can't call my house anymore," he said. "I have a new family. If you need to talk, I'll give you my work number."

"Don't bother," I said. "If you're embarrassed by me, then I don't need you in my life."

I hung up the phone. Guess he wouldn't care if another man wanted to be my father legally. With everything else going on I tried not to think about it too much, but when I went to bed that night I stayed up thinking about how my own father couldn't support me.

Because of Mom's mental situation, the adoption process was surprisingly easy. All I had to do was sign a paper and my legal guardianship was handed over to Thomas and Audrey. Mom wasn't too upset about

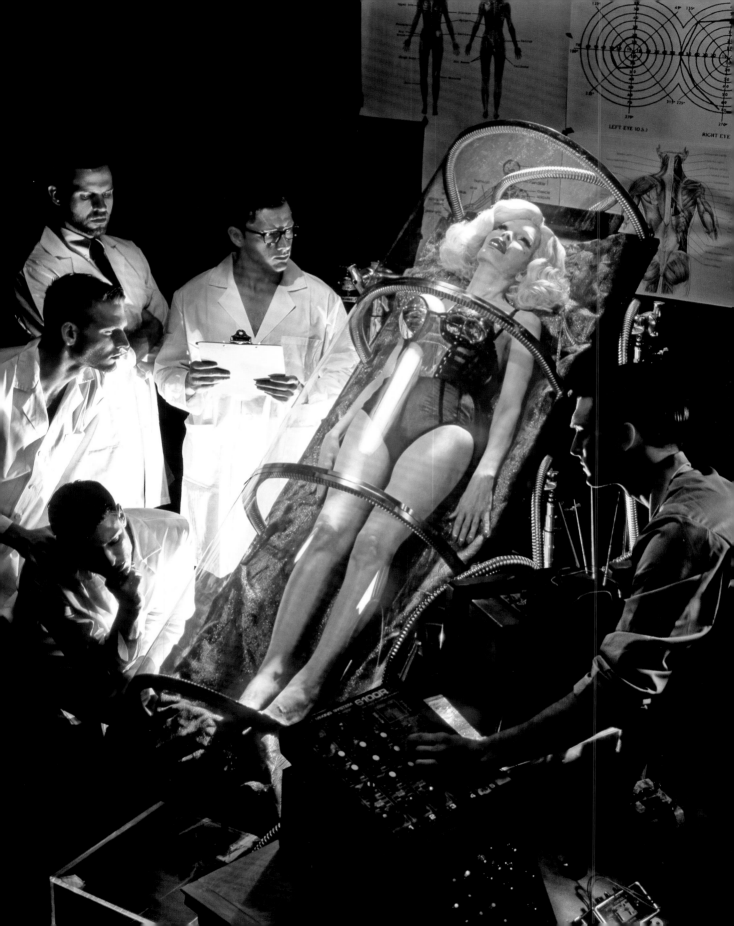

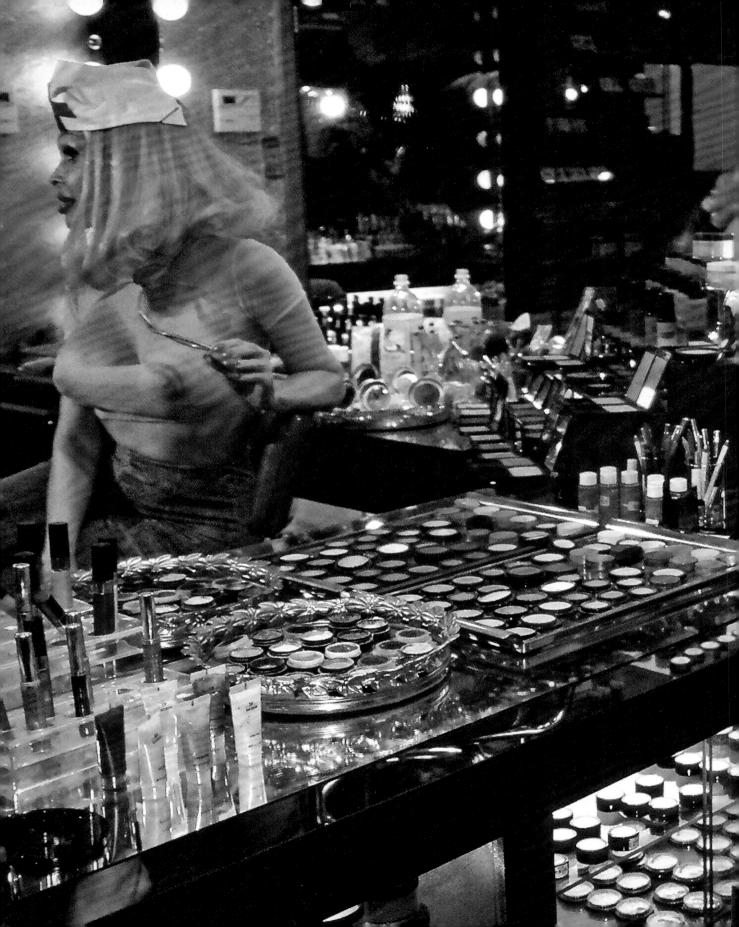

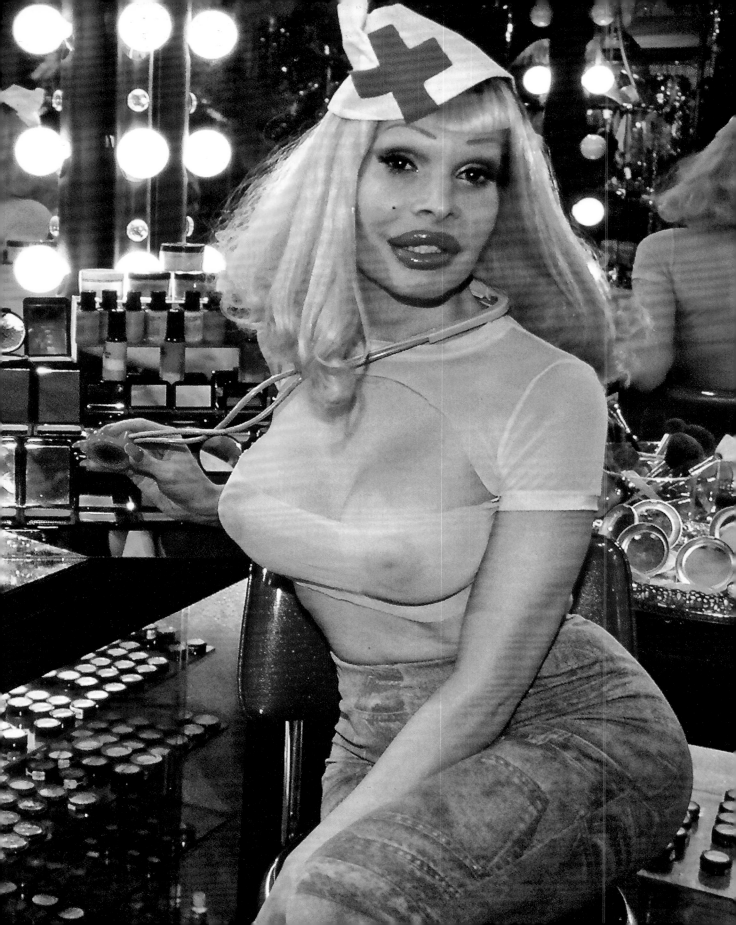

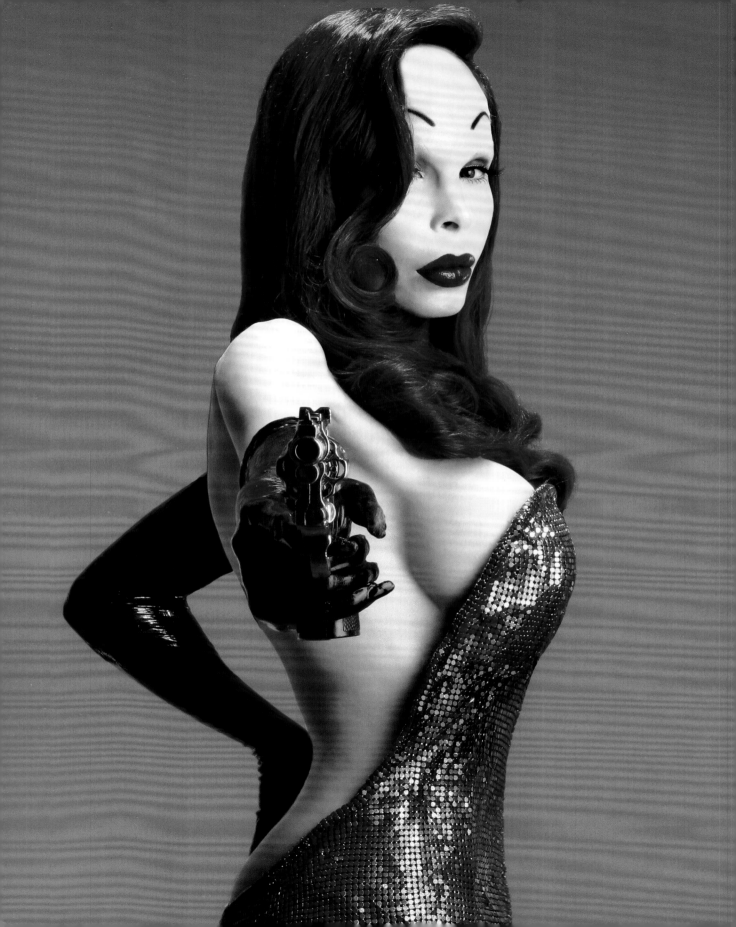

it; I don't think she understood what had happened. Her mind was hopelessly focused elsewhere.

After that was taken care of, things moved quickly. Thomas took me to see a well-known doctor on Park Avenue in Manhattan who performed sex changes. This wasn't some backroom operation; this was the real deal. The waiting room was ultra-luxurious, and completely packed. At the reception desk was a hulking black man; he looked and acted like a bouncer. I gave him my name and Thomas and I found two seats together.

The reception office was sort of like the high-end version of what I'd seen at the tranny bar. Some of the girls were by themselves and some were there with an older man, like me. All of them had already been done, and they looked flawless and larger-than-

her back to a very clean exam room. Dr. Reinhorn came in and introduced himself; he reminded me of Gregory Peck in *To Kill a Mockingbird:* fatherly, in a warm and loving sort of way. Much more personable than I'd expected from a doctor.

He told me there were three things I needed in order to have the surgery: a clinical diagnosis of gender dysphoria, two years of hormone treatments, and his determination that my life would be better if I had the surgery. The first two were already covered, and by the time I left, I had the third one down as well. He told me I'd be a beautiful woman and he'd be happy to perform my surgery. I did need a diagnosis from his recommended psychiatrist, though, just to cover his ass because I was so young.

"YOU CAN'T CALL MY HOUSE ANYMORE," HE SAID. "I HAVE A NEW FAMILY. IF YOU NEED TO TALK, I'LL GIVE YOU MY WORK NUMBER."

life . . . Thomas was 5'9" and was one of the shortest in the room, besides me.

"Look at all these girls," I said to Thomas.

"I'm looking," he said. "I can't look away." Every time one of the girls got up his head would tilt a little. Thomas was an ass man, apparently.

The Puerto Rican beauty from the tranny bar walked in the door. I was so shocked I jumped up and said hi to her before I realized she didn't know me. She was very sweet, and could tell I was nervous. "Don't worry," she said, "Dr. Reinhorn is the best." I sighed with relief. If he was good enough for one of the most beautiful women I'd ever seen in my life, he was good enough for me.

A nurse called my name, and Thomas and I followed

I had no problem with that. I knew no psychiatrist worth his salt would talk to me for five minutes and not recommend a pussy, stat. Everything went as planned with the new psychiatrist. I liked the way he described me in his report; he said I was very attractive with feminine features and that I'd make a pretty girl. That was the doctor's opinion. It meant so much to me. He recommended that I have the procedure right away.

When we made my surgery appointment, I felt very grown up and confident. I was finally going to be a complete person. I wasn't nervous at all. All my dreams were finally coming true.

I didn't tell Mom what was happening; she was living in the thick of her mental illness. Too much was going on in my life to deal with her. For all

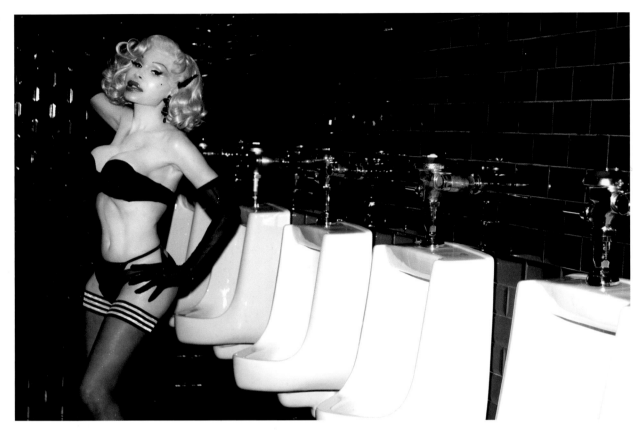

intents and purposes, I moved into Michael's house, with my new family.

The night before the surgery, I lay in bed with Michael and he proposed to me.

I said yes. Of course I would. All I ever wanted out of life, he was about to give me. I felt like the luckiest girl in the world.

Early the next morning, Thomas drove me to a hospital in Yonkers, where Dr. Reinhorn would be performing the procedure. Michael was too scared to go, but that was okay. I'd become close with Thomas through all this and it seemed right that he'd see it through to the end.

As I lay on the operating table, ready to go under, I could hear the nurses talking about me.

"This one's really beautiful."

"Her skin's like peaches and cream."

"This might be the prettiest girl we've ever had."

I was told to close my eyes and count down from ten. I closed them and prayed: *Please let me have a* Playboy *pussy, please let me have a* Playboy *pussy, please let me have a* Playboy *pussy.*

They were feeling my tits as I passed out.

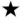

I woke up with an intense pain between my legs, but it was completely overshadowed by an all-consuming euphoria I still feel to this day. I never once doubted my decision; I knew this was right for me.

At first Michael was too scared to come see me in the hospital, but once the catheter was out he was there every day. Thomas came every day too. Audrey had no idea what was going on. She had always

thought I was a woman and nobody ever told her otherwise. As far as she knew I was having cervical problems (she wasn't especially bright).

After the swelling went down a bit, Dr. Reinhorn's big-titted nurse Kimmy removed all the gauze and showed me how to properly dilate. A hard, white rubber dildo had to be inserted for a long time every day. It felt like a knife when she first did it.

which I usually never do, and he gave me a Quaalude.

We got home, lay down on the bed, and started kissing. I was nervous but excited; this was the culmination of all my hopes and desires. I had always wanted to give myself to a man but never had the body to do so. Now here I was, with a man on top of me who loved me and was ready to make a woman out of me.

Michael fucked me gently. It hurt at first but it was

I LOOKED LIKE I BELONGED IN *PLAYBOY*. MY PUSSY WAS PERFECT.

"This one's like a tunnel," Nurse Kimmy said. I thanked her for the compliment and tried to pretend my pussy wasn't in excruciating pain. It got easier. And I had good painkillers.

I was in the hospital for two weeks, and afterward I moved right back into Michael's room. Because of the pain, we waited much longer than we had to before having sex. He would play with it and kiss it, but I wouldn't let him in; I was too afraid.

We were both mesmerized. I stole my Mom's mirrored perfume tray so I could kneel over it to stare at my pussy for hours. Once the swelling went away I looked like I belonged in *Playboy*. My pussy was perfect. Thank you, Dr. Reinhorn!

Having sex for the first time scared the hell out of me. You're supposed to be able to fuck after about three months, but I waited much longer than that. Michael and I talked about it almost every day, but he was scared too. He didn't want to hurt me. One night we went out to dinner and I decided we just had to do it and get the first time over with. I had a few drinks,

bearable. At the time it didn't seem like that big a deal, but looking back, it was a defining moment in my life.

After that first time we started doing it and doing it and it started to feel good. Since we had so much sex I didn't need to dilate as often, which was a relief. Certain positions hurt, and I'd get rubbed raw if we fucked more than once a day. Nurse Kimmy said to use a heavy lube to help it along. I wasn't orgasmic yet, but I was a woman, and that's all that mattered.

A year after the sex change Michael and I were legally married by a justice of the peace.

I wore a white lace dress and carried a small bouquet of white carnations and roses. My hair was still short but had grown to a respectable Twiggy length. Michael's parents were our witnesses. My mother checked herself into Greystone the day before the wedding, so she didn't go. My father and brother were not invited.

I was eighteen years old and I had everything I ever wanted: I was married, I had a loving family, and I had a pussy. My life was perfect. But perfection is all about perspective, and my perspective on life was still developing faster than my hormone-grown titties.

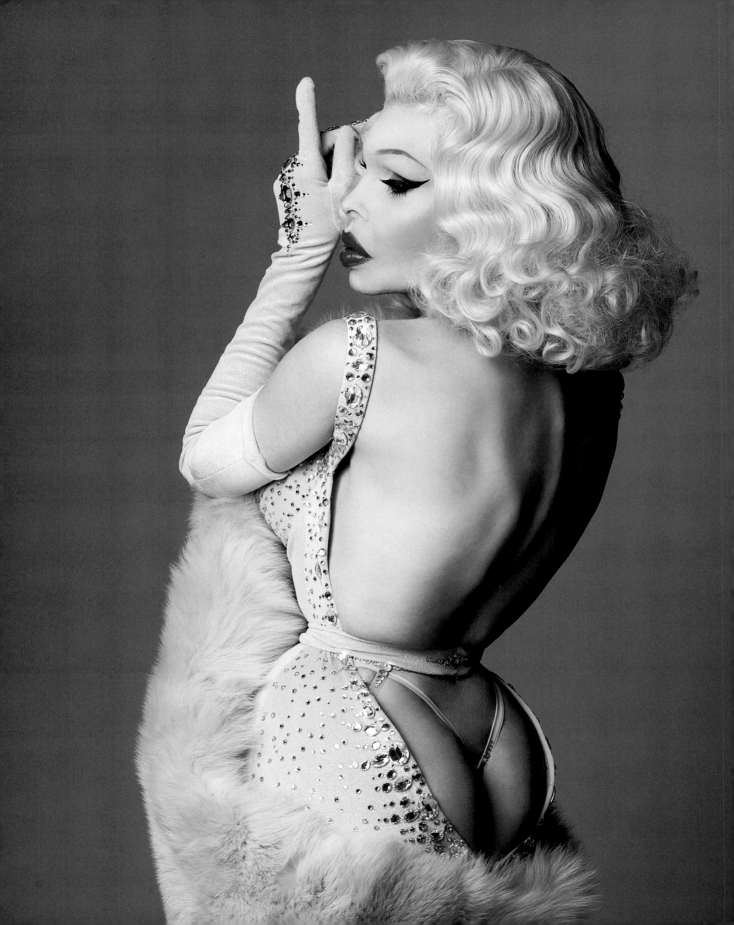

Chapter 5

RIVER OF NO RETURN

Living with Michael and my in-laws, I caught happy. My look was really coming together. My hair was almost down to my shoulders again, and I figured out how I liked my makeup the best: thick eyeliner, lashes heaped with mascara, peach blush, and a cherry red lip. I'll never get sick of a red lip.

I was also totally anorexic. I guess that's bad, but I looked great.

Beauty school was over but I never took my final exams. Michael preferred it that way; he wanted me to be a housewife, which was fine by me. I primped and preened, cooked and cleaned, kept in shape with aerobics tapes . . . everything a housewife was supposed to do.

We lived pretty close to my mother, but I was completely wrapped up in my new family and barely ever saw her. I'd check in with her once a week or so, but Michael didn't really like that either. "She's loony tunes; you don't need that in your life," he'd say. Every time he called Mom loony tunes, I imagined an anvil falling on his head. But I must admit it was a relief not to have to take care of her.

Michael spent his days at the little bookstore he owned in Belleville. I went a couple of times but tried to avoid it. Most of the store was devoted to occult books. He was obsessed with Aleister Crowley, necromancy, and other devil sorts of things. There were some pretty drawings of evil fantasy women on the walls, but that was the only thing in the store I didn't mind looking at.

Once a week I would bring him a bag lunch in exchange for a romance novel, or sometimes he'd find me a book about transsexuals, like Christine Jorgensen's or Tula's autobiographies. When Michael gave me a tranny book, he'd hide it in a paper bag and hand it to me under a sweater, like it was a drug deal. My favorite book was called *The Transsexual Phenomenon,* by Dr. Harry Benjamin; he was a pioneer in trans surgery. It was a bit dated, but it was interesting to read about transgender history.

Thomas was pushing seventy but still working nine to five as an accountant. That left me home for most the day with Audrey. She was a sweet old woman, with a pinch of verbal hysteria. Even when she slept she'd talk. We didn't have much in common except she liked gabbing and I never minded listening.

Once a month Audrey and I would visit the dentist. Audrey would fake a bad toothache in one room, while I would cross my legs and tell the dentist I was depressed. We'd both leave with prescriptions for Demerol, which we'd hand off to Michael, who needed them for back pain. His own doctor didn't give him enough, so he needed us to help him.

I liked getting the prescriptions for Michael. It made me feel like we were supporting each other, since I needed him to pay for my hormone treatments and vaginal checkups. I was in my surgeon's office once a week and it wasn't cheap. If I was running low on my hormones I'd become agitated, just like Michael would when his pain pills were running low. We had something in common: we were both medically maintained.

The first crack in our happy family started to show

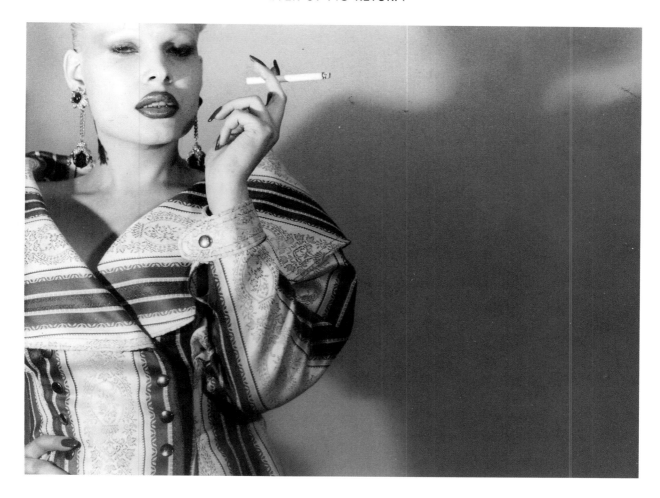

one night when we were all out at a pizza restaurant. As has often been the case in my life, it was my looks that started the trouble. Two white trash loudmouths started catcalling me from the booth across from us.

"Hey, blondie," they called, and, "Sweetheart, come sit with us." They were obviously drunk.

My husband didn't know what to do. Sweat beaded on his forehead. I'd seen him get mad at me, I'd seen him punch a hole in a wall, but in this situation, I didn't know what would happen.

Thomas and Audrey were pretending none of this was going on, just like I was. They kept chowing down pizza while I pushed a salad around my plate and Michael emptied another beer bottle. The waitress brought us our check and we left, Thomas driving us home while Michael and I sat silently in the back. I could tell my husband was not angry with the dim-witted Neanderthals who had somehow escaped extinction. He was angry with me for looking the way I did.

When we got home Michael took a couple of pills and locked himself in our bedroom. I sat at the wooden kitchen table, trying to figure out what I had done wrong. Thomas came up behind me and started rubbing my shoulders.

"You okay?" he asked.

"Yeah. I just feel bad. I hate when he's unhappy."

Thomas sat next to me and took my chin in his

hand. "You can't make everyone happy. All you can do is what's best for you."

Then he kissed me. On the lips.

He pulled away and looked me dead in the face. I smiled nervously. "I better go check on Michael," I said, and got up.

That night I did not sleep at all. I looked over at Michael, asleep with a grimace on his face, and wondered, for the first time, if I had made a huge mistake.

At the time I thought I was in love with Michael, but looking back on it now, it could have been Freddy Krueger offering me a pussy and I would have taken it. Actually, Freddy Krueger is a good comparison because Michael had early-onset rosacea and his skin was red and blotchy all the time (wear sunscreen, kids). I thought he was the perfect husband, and it was my goal to be the perfect housewife.

Michael didn't want me leaving the house for any reason. I tried to go back to beauty school to finish my tests but he faked an illness and I missed them. He didn't even fake it well, but I couldn't call him a liar; he was my husband.

So I got a job as a shampoo girl at a local beauty salon, and they really liked me there. But every day I came home to find Michael waiting for me on the front porch, and he'd ask how many men's heads I'd shampooed. It wasn't worth it to fight; it was easier to just let him have his way. I quit after a week. Michael would go to work in the morning and I'd be stuck at home with his mother.

Mom called to give me a message she'd received from Keni Valenti, the fashion designer I'd met the night Tina took me to a gay bar. He needed help with his fashion line. I begged Michael to let me do it and he agreed, as long as I would never be alone with Keni. "He's gay," I said. "I don't think you have to worry about him."

That was the winning argument, and the next day Michael drove me into the city to pick up a box of materials from Keni's Tribeca apartment. Michael stood in the doorway while Keni showed me what I needed to do. It was mostly hand sewing and embellishments, the same kinds of things I did for the stripper outfits, only this time there was more fabric to deal with. I thanked Keni for giving me the chance to do the work, packed everything into a box, and Michael and I were on our way.

We walked through the gay West Village together, hand in hand, and had a pleasant day. Gay boys hollered to me as we walked by, yelling out, "Yes, mama!" and "That's right, Miss Thing!" The attention was nice. Michael wasn't amused. His back was starting to bother him and he needed to get home to take his pills.

I don't know when I started to realize Michael was addicted to painkillers, but I'm sure it was around the same time I realized his mood swings were out of control.

Keni wanted to take some pictures of me wearing his designs and Michael accused him of "trying to make a sideshow out of my wife." He was somehow sure everyone would know I was transsexual if they saw me. I didn't think so, but he refused to let me see Keni ever again.

I was so confused about how to feel. I looked great, I had the body I always wanted, and nothing else ever mattered to me. But shit was falling apart.

As Michael got more and more into his pills, we would fight more often, and Thomas and I would end up alone in the kitchen, talking every night. He tried to kiss me a few more times but I'd always stop him. Other times he'd just want to hold my hand, and that didn't seem so bad, so I'd let him.

One night, Thomas was holding my hand and I was feeling especially blue and vulnerable.

"Would you pay for my breast implants?" I asked him.

"Of course," he said. "I'd be happy too." He opened his arms to hug me, and when I obliged he held me close and kissed my neck.

I knew what I was doing. I was sexually manipulating my father-in-law in order to get what I wanted, but I thought it was innocent enough as long as I

the results were fantastic. I loved my new titties. The whole family did.

Everything I thought I was getting with my new family (except my pussy) was a lie.

Michael stopped going to work because of his "chronic pain," which meant he was at home with

I KNEW IF I GOT CAUGHT MICHAEL WOULD BE FURIOUS, AND MIGHT EVEN KILL ME, BUT I COULDN'T HELP IT.

kept everything under control and never let him actually fuck me.

"I'll pay you back you know, but I just think it'd look so great if my tits were bigger. What do you think?"

"Well, let me see them so I can judge better," he said.

I lifted up my shirt and asked him to help me take off my bra. I stood before him, topless, while my husband slept upstairs. He grabbed one in each hand, and lightly squeezed.

"I guess you could go bigger. But you don't have to pay me back. I want to get them for you."

He held on a few more minutes while I inspected the ceiling. Even though I knew it was wrong, I didn't feel that bad. Michael was being such a jerk, and he barely ever said anything nice to me anymore. We hadn't fucked in months, and I was starting to go boy crazy.

Thomas and I went to Dr. Reinhorn's office the following week and made an appointment for my breast enlargement. I went from a B cup to a C. The recovery time kept me in bed for a week or so, but

me all the time. When I had to run errands for the house, he would insist on going with me. I blamed his behavior on myself. Maybe if I was just a girl with no problems, he wouldn't have been that way. He was so scared of people finding out I was a tranny.

One time we were at the supermarket and a couple of guys working there started flirting with me. I flirted back, innocently. It felt good; I was flattered. I wasn't trying to sleep with them. Michael smashed a ketchup bottle on the floor "by accident."

That night we had a huge fight and afterward I couldn't deal with Thomas, so I ran out of the house, just to clear my head, not heading anywhere in particular. A construction truck pulled up next to me and the really hot guy driving it asked if I needed a ride. He looked like James Gandolfini.

He said, "I'll take you anywhere you want to go."

I don't know why I got into that truck. Part of me was curious to see if he'd be able to tell my secret. Part of me just didn't know what else to do. He told me his name was Chuck and that I was the most

beautiful woman he'd ever seen. He asked if I'd like to kiss him and I said yes.

He drove to a secluded wooded area and parked the truck. I was wearing a little floral sundress, which he reached under to grab hold of my panties and slide them off. He smelled like a man who worked hard all day; it got me really horny.

I was scared; this was the first man besides my husband to see me naked since the surgery. What if he could tell something was different? What if he became angry? We were in the woods, in the middle of nowhere, parked next to a pond. He could kill me and nobody would care. I'd just be another dead tranny.

He started fingering me and I got less scared. "Your pussy feels perfect," he said. I figured that was a good sign. We got out of the car and this big, beefy, blue-collar Italian man picked me up and carried me down toward the pond. He laid me down on the grass and started licking my pussy and playing with my clit. All seemed good. I felt like a total slut and I loved it.

"You're a bad girl," he said. He spit on his dick and penetrated me. "Fuck, you're tight. What are you, a virgin?" He spit some more.

"No," I said, "I'm married." That seemed to turn him on. He asked me all about my husband while he was fucking me.

"Do I have a bigger dick than your husband?" he asked.

"Yeah," I said. "Way bigger. His dick is tiny; he's not a real man like you."

"I'm gonna cum," he said. "Where do you want it?"

"Cum inside me, cum in my pussy."

"You sure? On the pill?" *Yes.*

He came in me, helped me back up, and brushed the grass and leaves off my dress.

After that, every time I could get out of the house for more than an hour, I'd call Chuck. He would pick me up down the block and take me to a motel.

I knew if I got caught Michael would be furious,

and might even kill me, but I couldn't help it. Chuck was a nice guy. We would sit in his truck and he'd listen to me complain about how unhappy I was and how stuck I felt. He told me I should just leave and get my own place, that I could do makeup in the mall and support myself.

I started to feel guilty about cheating. And that's not my way of saying the sex with Chuck got bad. I could've fucked Chuck every night. But I really started to feel guilty. About all of it. Michael's family had done so much for me. I felt like I was cheating on all of them.

So I met Chuck one last time and told him it was over, that I had to be faithful to my husband. We had breakup sex, and he dropped me off down the block from my house.

When I walked in the door, Michael was sitting in the living room. He gave me a funny look but didn't say anything. I went to the bathroom, turned on the light, and saw in the mirror that I had a hickey on my neck. I had a split second to think *Oh shit* before Michael was standing behind me.

He smacked me in the side of my face. Hard. It didn't even hurt at first, I was in so much shock that it had even happened. But then he grabbed me by the neck, threw me on our bed, choked me, and smacked me a few more times. I told him everything—about Chuck, the sex, how it had gotten out of hand, and that I'd ended it. He got up and left the house. I didn't move until I heard his car door slam and his tires screech against the pavement.

I went to the bathroom to look at the damage. My eye was swollen almost completely shut. There were finger marks and cuts from his nails on my neck. That bothered me more than anything. I could handle the psychology of being hit, but now I had scratches, bruises, and broken blood vessels around my eyes. I didn't want anyone to ever see me looking like that.

When Michael came back, I promised I'd never see Chuck again, and it seemed like we could move

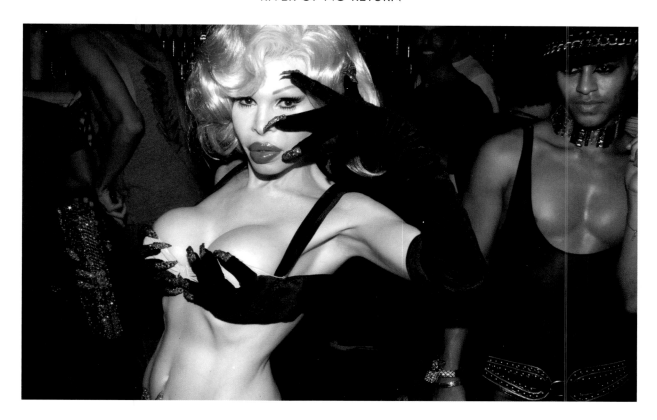

on. Unfortunately, Chuck had gotten addicted to my pussy. He started calling the house and hanging up if anyone but me answered. He'd drive by, real slow, to see if I'd come out. One day he even knocked on the door. I walked into the kitchen and saw him drinking coffee with Audrey. He introduced himself to me as though we had never met, and winked super obviously. What a creep. He gave Audrey his number and said to call him if we needed plowing. Snow plowing. My pussy had gotten me into a real mess.

After that first time, Michael started beating me every time we had an argument. Thomas and Audrey knew what was going on, but they'd never stopped Michael from doing anything in his entire life, and they weren't about to start now.

Chuck stopped coming around, which was good, but now I had no one outside my house. I was stuck. I was Rapunzel in that fucking tower. All I had was my hair, which refused to grow as fast as I wished it would.

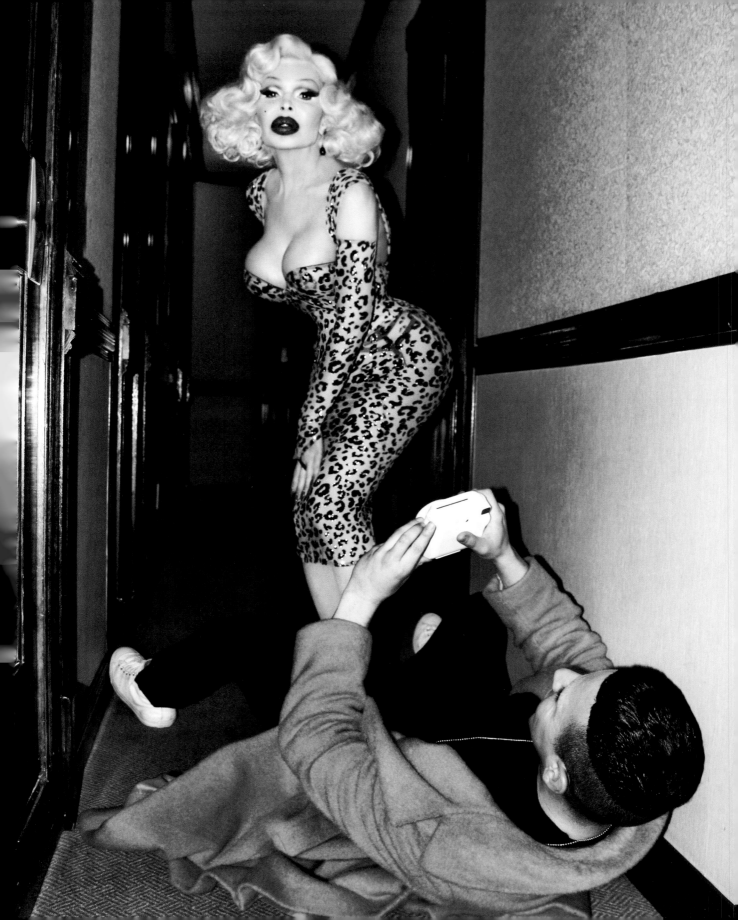

SOMETHING'S GOT TO GIVE

Every Friday I was allowed to take the bus, on my own, to Dr. Reinhorn's Park Avenue office. Girls would come and go all day long. Most just came for hormone shots. Nurse Kimmy would take them behind a curtain on the side of reception, stick them and they'd be on their way. Other girls were coming in to meet with Dr. Reinhorn, to schedule feminizing surgical procedures.

I was too scared to talk to these women. But I took mental notes on what they were getting done, so I could figure out what I needed to have done myself.

I did make friends with this guy Alex, who was a gay hustler/drag queen. He had a beautiful face but a thug-boy attitude that let him easily slip between a machismo uber-male and ultra-female persona. That kept him flush with clients, and with cash.

We'd gossip about the girls that came in, talk about fashion, and he'd tell me about the insanity of New York nightlife. He'd grown up in Studio 54 and was "good friends" with the legendary Dianne Brill—whom I hadn't heard of before but she sounded dreamy—and he said I reminded him of her.

Michael would never let me go to a bar, gay or straight, but I would tell Alex I'd be there, just to make him happy. The next week I'd see him again and have to come up with an excuse for not showing up: my hormones made me sick, my husband had the runs, that sort of thing. "Well, come tonight," Alex would say. "Dianne will be there, and you got to meet her. She'll go fuckin' wild for you." It sounded so glamorous. Of course I wanted to go, and told him I'd definitely be

there. But instead I was stuck at home with the in-laws.

It started to piss Alex off that I kept flaking on him. I apologized but he didn't want to hear it. Then one day Michael showed up unannounced to pick me up. He barged in the reception door, as though he was expecting to find me on my back surrounded by cocks. Alex didn't say anything but I knew he was suspicious.

A few weeks later I came in with a bruise on the side of my chin. "You've got a secret," Alex said.

"I haven't had a secret since the day I got my pussy." (*Shock and distract.*)

"Bullshit. Tell me what's going on."

I told him the truth—that my husband wouldn't let me out of the house. That I'd asked Michael if I could go to a bar one night and was smacked in the face for it.

"That's horrible," Alex said.

"Yes, I guess it is, but what can you do?" That's how karma works: you can't get everything you've ever wanted without paying a price.

"If you ever need a place you can stay with me. If you want to leave your husband you can definitely get jobs in New York and you'll do really well."

I was grateful, but there was no point in worrying about things I could never change.

Mom called one day, out of the blue. We hadn't talked in a couple of months. She wanted to give me her new address.

"You moved?"

"Just write down the address," she said. "It's a hospital. The cancer is pretty bad, and I'm going to die soon."

There was that paranoia. Some things never changed. It was snowing out, so I told her I'd come by and see her the next day, after the roads were cleared.

Michael drove me to the address and it was, indeed, a hospital. I started to get scared. Really scared. I asked Michael to wait outside while I went in. She was sleeping and looked peaceful, but her skin was a dull gray, and she was thinner than I'd ever seen

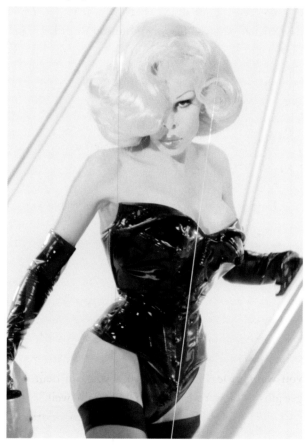

her. It was very obvious she didn't have long to live.

It hadn't been *that* long since I'd seen her. Had it? How had this happened so quickly?

I found her doctor. It turned out Mom had a lump the size of an egg on her breast. She'd had it for a long time but didn't want to have a mastectomy,

so she had never told anyone about it. By the time a doctor noticed, there was nothing that could be done. The cancer had spread throughout most of her body and brain.

There was just no way; this didn't make sense. I mean, I'd seen Mom at Thanksgiving and she'd seemed fine.

I started crying, which woke Mom up, and she started crying too. We hugged and cried as the doctor edged out of the room.

"This is all my fault," I told her. "I was supposed to be looking out for you."

"Don't be ridiculous," she said, and wiped tears from my face. "I'm your mother. It was my duty to look out for you."

That night Michael was sweet and supportive for the first time since before we had married. My in-laws cried with me. All I could do was cry.

Over the next few months, I sat by Mom's bedside every day. Sometimes she was really with it and happy to see me. We'd talk about the past and read fashion magazines, just like everything was normal.

Other times, she'd have no idea who I was. When she was like that I wouldn't stay. It was too hard to take. It eventually got to the point where she didn't recognize me more often than she did.

One bitterly cold February night, Mom woke up, looked at me, wrinkled her nose, and said, "Who are you?"

"I'm your daughter, Mom. Amanda."

She squinted and twisted her face. "I don't have a daughter. Who are you?"

I tried to remind her; I told her about the Sears P.J. dolls, about the barber, about Joseph and Dad and the makeup. All the makeup.

She had no idea what I was talking about and started looking around desperately.

"I don't have a daughter," she said again. "Why are you in my room?"

NAILS DONE

Nails are the one beauty routine that you do for yourself, not for anyone else. You can see them whether there is a mirror around or not, unlike your face, hair, or ass.

A woman's manicure can tell you a lot about her, if you pay attention. They come in a few basic types and shapes.

NO MANICURE
This girl will try to come off as low maintenance, but in reality she is just too busy with her career and family to take care of herself. She needs to schedule some time on the calendar to remember she is a woman. Not to be confused with the girl who has an old manicure that is chipped and rotting away; that is the worst kind of laziness. Either repair the nail or remove the polish.

SQUARE MANICURE
The most common type and shape. Preppy. They do not hinder a girl from performing even the most mundane tasks. She can wear an "accent" nail if she's feeling daring. You can see these nails congregating en masse at your local Starbucks, gripping on to mocha frappé lattes.

"It's Armand, Mom. Your son."

She tilted her head, confused. "Armand?" She fell back asleep.

I sat beside her and cried.

Later that night, Mom woke up, as with it as she ever was. She looked at me and said, "Don't cry, Amanda. Everything's going to be all right." Then she went back to sleep and never woke up again. She died the next afternoon.

Thomas handled all the arrangements. There was no funeral; I couldn't handle one. Mom was cremated and buried in Paramus.

I tried to forgive myself for not having noticed she was sick before it was too late. Nobody else blamed me, but nobody else knew what Mom and I had been through together. At least she was finally at peace, I thought, and tried to focus on that.

Dad came by soon after and met my new family. It was awkward, having him and Thomas in the same room. I could tell Dad felt bad that these people had taken me in when he wanted nothing to do with me. I didn't care; I was too angry with him. It was the last time we ever saw each other.

Joseph showed up too, with a white trash date/whore, asking about any inheritance. It was the first time he had seen me since I transitioned. "Getting married was stupid," he told me. "You should get divorced. Move to New York and become a hooker. The way you look, you'd make a ton of money." That was the last time I ever saw my brother.

After Mom died, instead of feeling despair, I felt a burst of strength. Mom had spent her life trapped inside her own mind. I refused to let that happen to me. For the first time I realized I had sold myself short with my marriage.

I knew I had to run away from my husband.

Over the next year, I scrimped together as much money as I could, and hid it away in the one hatbox of Mom's I had held on to. When Michael gave me cash for clothes or food, I would pinch the pennies and hide the rest. I sold all the jewelry I owned. I did nails for parties, I sold G-strings to the girls I'd see at my plastic surgeon's office. I called Keni Valenti and begged him to sneak me work while I was at Dr. Reinhorn's office. Hustler Alex would sit and sew with me as quickly as we could before I had to catch my bus. The receptionist/bouncer would shake his head at us. "You're crazy, girl," he'd say. He liked me. The whole staff did. I was like the office pet.

Alex's offer was still good: I could sleep on his couch when I ran away.

A year to the day after my mother's death, there was a light snow, but I was ready to go. I packed up all the belongings I could fit into my suitcase and hid it behind a bush outside my house.

SOMETHING'S GOT TO GIVE

"I'm going out for Chinese," I told Michael.

"No, I don't want Chinese," he said. "Just make me a sandwich."

"Oh. Well, I'm going to take a bath." I locked myself in my washroom, turned on the water, and looked at my reflection in the mirror. I thought of what I'd be giving up—the hormones, injections, touch-ups . . . keeping up the beauty routine I had started was expensive, and my father-in-law had been footing the bill. If I left, it would be my responsibility. Was it worth it to give all that up?

I opened the bathroom window. Cold air struck me in the face, but the snow had stopped. Out the first-story window I went, and rolled down the snow that had piled against the house all winter.

My suitcase in hand, I walked to the bus stop, where three cabdrivers were huddled together smoking cigarettes, waiting for fares. The sky was clear and what was supposed to be a nasty storm had turned into a quiet, whitewashed night. They saw me walking toward them, tears in my eyes, wearing black-heeled boots, two coats, and a dark red pillbox hat with black veil that had belonged to my mother.

"Are you okay?" one of them asked. "Have you been hurt?"

"I'm running away from my husband. He hit me and I have to get to New York."

The men each flicked away their cigarettes and came to help the damsel in distress. They told me how stupid a man must be to hit a woman as beautiful as I was. They asked if I'd like them to go beat up the lousy asshole. I said no, I just wanted a ride.

My driver placed my luggage in the trunk and turned his heat all the way up. As we drove off, I sat back and watched New Jersey slowly pass by. The strip malls, the cemeteries, the turnpike. Hardly anyone was on the road because of the snow. As we crossed the George Washington Bridge, I put down my window and let the freezing-cold air numb my face. I was alone in the world, but I was not scared. I knew Mom was looking out for me and that everything would work out.

"Miss Hollywood," Mom used to call me. Miss Hollywood I would become.

OVAL MANICURE
Timeless, classic, and goes with everything. Best in pinks, nudes, and reds. An oval girl sometimes plays with other shapes, usually always with a French manicure. I won't bother to say anything about the "squoval" trend except that those who wear these nails can't seem to make up their mind.

ALMOND MANICURE
Sleek and sexy. Not for the faint of heart. Tapered to a rounded point, long but short enough for everyday wear, with a little practice. She can still type with these nails, but it is doubtful she works as a secretary. She is likely a woman who is in charge of something in her career. She is not afraid of challenges and wears bold colors like red or black on her nails. No-nonsense.

STILETTO MANICURE
My personal favorite. Leaves an impression on everyone they come across. Longer than the traditional manicure, they are filed more severely and meet their end in a fine point, like tiny teeth or claws. Pin-up painter Alberto Vargas made them famous in the 1940s. They are the quintessential nails of the lady who does not lift a finger to do anything. She can't! You better save for LASIK, because you can forget about putting contacts in with them. Men have to open doors for you. They are best for a dignified, refined lady who is made to be admired. I keep mine in red.

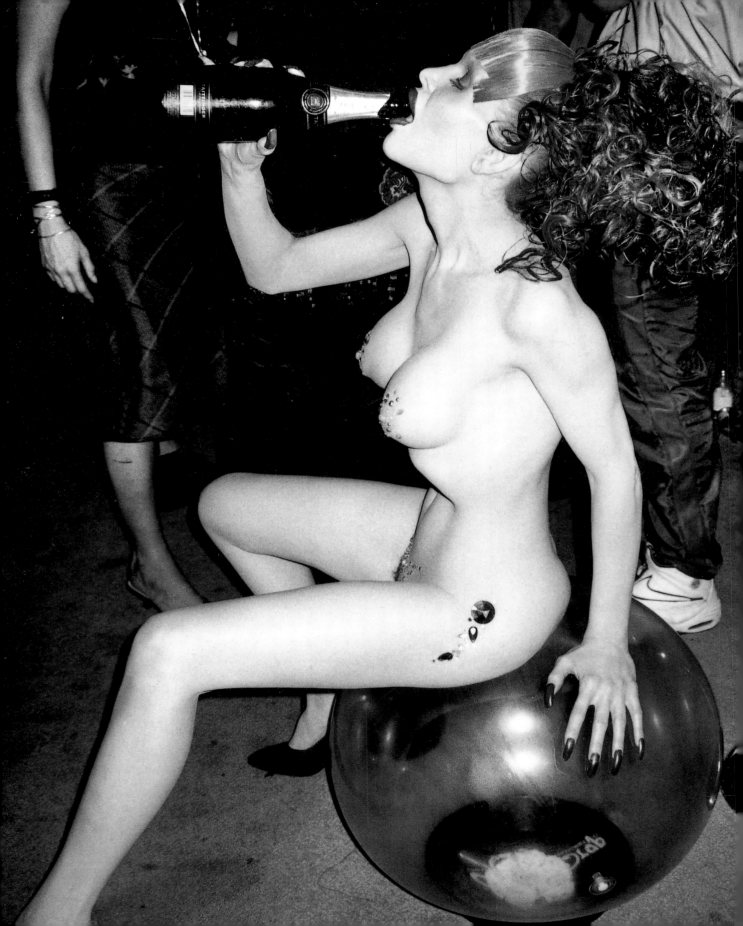

Chapter 7

MONKEY BUSINESS

A couple of weeks living in New York and I was gagging about money. I had saved about $3,000 before running away, which seemed like more than enough, but I quickly realized I needed a job and my own room. Sleeping on Alex's couch was okay for the short term, but every time he had a john over I had to find somewhere else to be. It was hard to get more than a couple hours sleep at a time.

I started doing nails, which was fun and I was good at it, but I was only making around sixty dollars a day, nowhere near enough to get my own place and pay for my beauty routine.

Feeling desperate, I asked Alex what hustling was like. I really hated the thought of doing it. I thought I could handle all the sex, but it bummed me out thinking about how I'd be playing right into the stereotype of a tranny hooker.

"You don't have to be a hooker, though," Alex said. "You could work at a dominatrix dungeon. There's no sex, just role-play. But you do have to be able to deal with crazy people and weird fetishes."

"I've dealt with crazy people my whole life. I think I'll be okay."

"You ever been tied up?" I hadn't. "Try it first. If you don't mind it, I'll introduce you to this bull dyke that runs a dungeon called the Key."

"I don't know anyone who would tie me up."

"I'm sure I can find you someone."

The next day Alex introduced me to this gorgeous black guy named Mitch, a former marine who lived across the street from us. Mitch showed me the ropes and pounded me out. I wasn't such a fan of being tied down, but it wasn't that bad. I could handle it.

I was ready to see this dungeon. As we walked over, Alex told me Mitch had sucked his dick in exchange for setting up my trial run.

"He's gay? He didn't seem gay."

"It doesn't matter," Alex said. "Sexuality isn't all black-and-white. You of all people should know that."

"Now that you mention it," I said, "he did really love fucking me in the ass."

Alex rang the bell for a staircase situated above a Third Avenue Japanese restaurant. "You ready?"

"Fuck yeah." I was a single girl in New York City.

In my head I was picturing the ritzy Playboy Club. That wasn't quite right. The Key looked like any basic massage parlor: a small front desk in front of a hallway that led to several small rooms. These rooms were themed, depending on what the customer wanted. The whole place smelled like cheap rubber and antiseptic. At least the lighting was dim.

The manager's name was Rose; she was a monstrous, man-hating, badass dagger bitch. Rose was the most popular dominatrix in the dungeon because for her it wasn't an act. She was a bull dyke who truly despised men and enjoyed beating the shit out of them. (Before you get out your pitchforks, please note that these were all terms of high esteem at the dungeon, and Rose would not have me refer to her in any other way.)

"Pretty girl like you," she said that first night, "you could make a fucking mint in a place like this. Just keep your nose clean, if you know what I mean. Treat it like a business and it'll pay you like one."

"What did she mean, keep my nose clean?" I asked Alex.

"She means don't snort cocaine."

That wasn't going to be an issue. My nose was *perfect*. Why on earth would I mess it up?

Under Rose's tutelage, I became a popular dominatrix. I moved into her spare bedroom a block away, and I'd go in to work with her every day.

Being a dominatrix was like an acting job, only with a lot more kicking guys in the balls. Rose helped me make up a backstory: I was going to college, my husband just left my daughter and me, and I had to pay for a babysitter.

All us girls would wait behind a curtain in back of the reception desk, doing our nails and reading fashion magazines. A john would walk in and tell Rose what he was into and she'd send him into the appropriate room. If he was into being beaten, he'd go to the wheel room. If it was more intimate, he'd go to the bedroom. If he wanted a girl to submit to him, he'd go into the cage room. If he was into something messier, there was a plastic-covered room for that.

Rose would come back and tell us what the fantasy was, and ask who wanted to take the client. I was highly motivated to take as many clients as I could, no matter what they wanted to do; I was there to make money. If it was something I didn't like, I could just put it out of my mind and think about the money.

Most clients had a specific script they'd want you to follow. A lot of guys wanted to be humiliated for having a small dick. I'd get a magnifying glass and bring them in front of the other girls and say, "Can't see it, can't find it." The girls would laugh and the guy would get off on it.

Some of them were into heavy pain—cigarette burns on their tongues, stepping on their balls in high heels, yelling and degrading them while wearing a police or Nazi uniform. Sex wasn't important to them. They'd cum without even touching themselves.

I really liked having clients who were into cross-dressing, which was common. We had a whole tranny room that was just a big closet of outfits guys could try on. I'd help them dress up and they'd be hard the whole time. That's not the same thing as being transgender, FTR, or even gay for that matter. They just got off on the feel of the lingerie.

There was one guy who got off on the time. I'd wear my day clothes and talk about the time the whole hour. I'd say things like, "Oh, do you have the time? I've been waiting for this bus and it's really late." He'd wear a trench coat and discreetly masturbate.

One time, this girl Mary Ellen and I read from the Bible to some guy while he jerked off. We made faces at each other and tried to make the other one crack up while we were reading. It was so bizarre, making a joke out of it seemed the only way to react. After that guy left, Mary Ellen and I sat in the lobby cracking up. We heard the door open and in walked Mary Ellen's junkie bull dyke girlfriend.

"What the fuck's so funny?" she barked. Mary Ellen stopped laughing. "You're not here to have a good time, bitch, you're here to make some fuckin' money!" the girlfriend yelled, pointing her finger in Mary Ellen's face.

Rose stepped out into the lobby. "Is there a problem out here?" she asked, crossing her arms. The girlfriend put her arm around Mary Ellen and they walked out. Even among bull dykes, Rose was the HBIC.

Being a dominatrix was a great career for me: it was easy work and the money was fantastic. I was able to pay for everything I needed. Most of the girls were spending their easy money on drugs but I was buying shoes and dresses and upkeep. As far as I was concerned, my look was my real estate, and any money I put into it was a good investment.

We had a lot of security at the Key, and I never had a problem with clients. The walls were paper-thin; you could hear everything that went on. Plus I'd usually work the same times as Rose, and nobody would fuck with her.

No girls were ever hurt inside the dungeon, at least while I was there. It was when the guys would want to meet you elsewhere that things would happen. They'd offer you more money, and for a lot of the girls that was hard to turn down. Rose used to say all the time: "If a client wants to see you somewhere privately, it means they want to kill you."

I had one client want to see me outside the club. It was a guy I'd seen a few times before; he was into tying me up in elaborate knots, but that was it. He'd tie me up so I couldn't move a single part of my body, jerk off, untie me, and pay handsomely.

He wanted me to come to his house because he had a bolt in his ceiling he wanted to suspend me from. It sounded like a bad idea, but he offered five times what he paid at the Key. I asked Rose and she thought that for the money he was offering, I should do it. "He's a regular here," she said, "so I wouldn't be too worried. But I'll drive you and wait outside, just in case."

The client's name was Joel, and he was a big guy, good-looking and polite. I walked into his Long Island house and he asked if I'd had a hard time finding the place.

"No," I said. "My boss Rose drove me and she's waiting outside."

"Rose has a good sense of direction?" he asked.

"Yeah. Should I take off my dress?"

Joel tied me up same as he always did, then hooked the rope onto his ceiling and suspended me there. It was a strange sensation—flying free and being caged tight at the same time.

There was nothing out of the ordinary that day.

He did ask me if I would blow him while I was tied up. I said no and he jerked off and untied me.

I saw him a few more times at the club but never went to his house again.

It was typical for girls to disappear from the Key. It was only a step removed from prostitution, and most of these girls were only working to pay for their and their boyfriend's drug habits. A girl came to make money and get out.

Still, when Mary Ellen disappeared, Rose was sure something horrible had happened. Mary Ellen was a pretty and petite Latina lesbian with an overly friendly disposition. She was the first junkie I'd ever met, but even I knew she smiled more than heroin addicts were supposed to. Rose was sure that if Mary Ellen had taken off she would have said something first.

"Maybe she got clean," I told Rose. "This could be a good thing."

"No," Rose said, "I bet it's that bitch of a girlfriend."

A week after Mary Ellen stopped showing up for work, the girlfriend came by looking for her, and that's when Rose really started freaking out. "The girl's heart was always too pure," Rose said. "I shouldn't have let her work. I should've known she'd do something stupid."

I still wasn't convinced of foul play. Rose told me, "You don't know how the world works yet, Amanda. Men do bad things to women all the time."

She was right, of course. I woke up one morning to Rose throwing a newspaper on my bed. There was a picture of Joel on the cover. He'd been pulled over for having a taillight out and the cops found the decomposing body of a woman in his car. They suspected he had murdered several prostitutes.

"Do you think he killed Mary Ellen?" I asked. Rose was sure of it.

At the Key there were two cops waiting for us

outside. They showed their badges and Rose fainted into my arms, taking us both to the ground.

The cops helped me get Rose inside. When she recovered, they confirmed that Mary Ellen was dead. Her body had been found some time before but wasn't identified until Joel admitted to killing her. Rose was furious. She punched the wall and cracked open her knuckles. The cops asked us all if we knew anything about Joel, but none of the girls said anything. They didn't want to talk to the cops. I raised my hand. "I've been to his house," I said.

We went into the fake bedroom and I told the

"What a horrible way to live," I told her, and started crying. She rolled her eyes and left me alone.

Mary Ellen's ex-girlfriend came into the locker room, but she didn't notice me; she was catatonic. I don't know if it was the heroin or the shock of what we'd all just found out. She opened Mary Ellen's locker, which Rose had refused to let anyone touch, and started emptying the contents into a trash bag: a large black dildo, rubber gloves, a blindfold, and a leather whip. That was my tipping point. I started sobbing uncontrollably. The girlfriend didn't even notice, but Rose came back in, hugged me tight, and

"DO YOU THINK HE KILLED MARY ELLEN?" I ASKED. ROSE WAS SURE OF IT.

cops everything I knew about Joel. Rose was right. I really did have no idea how the world worked. If she hadn't escorted me to his house that night, I very likely would have been murdered.

After the cops left I went to our locker room to gather myself. I'd been tightly gripping a tube of lipstick in my hand during my entire statement. By the time I let go, the lid had come undone and my palm was dyed red. It was Cherries in the Snow, the first color Mom had ever given me.

"I would give anything to have that man in here one more time," Rose said. "They would never find that body, trust me on that one."

One of the other girls, who looked like Ann-Margret after twenty years of smoking crack, came in to see what I had told the cops. "Did you rat us all out?" she asked. Drug paranoia. How tacky.

"I told them about Mary Ellen. It's horrible what that poor girl must have gone through."

"Life goes on," cracked Ann said. "You gotta make your dollar."

walked me home. We hibernated for the next month, eating our emotions rather than dealing with them.

Joel was accused and convicted of murdering nine women, including Mary Ellen DeLuca, though it was believed he had many more victims. He told police he picked Mary Ellen up off the street and drove her around to score crack. She complained about how unhappy she was being a junkie, and he asked her if she wanted to die. She said yes. As he strangled the life out of her, she didn't struggle at all.

It was impossible to be at the Key anymore and not think about what had happened. Whenever I wasn't at work, I'd take a sleeping pill and try to zone out.

My designer friend Keni Valenti took me to a flea market one day to look for fabrics, and a policeman started hitting on me, laying it on thick, telling me he wanted to take me on a date. He was gorgeous, had to be 6'4", blue eyes, big arms, everything. I told him I was a lesbian to get rid of him.

"Are you crazy?" Keni asked. "You turned down Adonis himself."

BLONDES
HAVE MORE FUN

MAMIE VAN DOREN
I met her at a Tom Ford party. She had to be eighty, with perfect skin, and she showed up in a sports car with a hot young man. She looked so great, it made me not worry so much about getting old.

PAM ANDERSON
Tommy Lee wanted to see my pussy at a party. We went to the bathroom, I sat on the sink, and he got a good look. Pam was pissed. Super jealous. He loved it.

COURTNEY LOVE
We were doing a photo shoot, and she said to me, "Force me to take these pills"—a big handful of them. "Don't worry, I'm not going to swallow." I put them in her mouth and she swallowed all of them. It was crazy.

PARIS HILTON
I brought this hot college boy to a party and Paris came up to me and said, "Hi, horny." She wanted to have sex with me but I won't do the lesbian thing.

LADY GAGA
She's monstrously talented. Very Club Kid-inspired. Dressing up was a dying art form until Gaga came along.

I just wasn't feeling it. I went home and took another sleeping pill. But as I tried to fall asleep, I thought about the Adonis. It wasn't like me not even to flirt with a guy like that. It occurred to me that since we found out about Mary Ellen, I hadn't had sex with anyone.

Something had to change.

I took a three-step approach to getting my life back on track:

1. Bulimia.
2. Sex at least three times a week, (I even called my old beau Construction Chuck to pound me out. A girl needs a good backup dick.)
3. A new living situation. (I feared Rose's man-hating was starting to rub off on me.)

I moved into Keni Valenti's Tribeca apartment, to help him cover his bills. He had been having a tough time: he'd sold his fashion line to a Japanese company and moved to Japan to launch a bunch of stores there. It turned out he had unknowingly sold to some not-so-great people. He came back to New York mentally and professionally in shambles, and with a huge financial payoff that he blew through real quick. He needed help.

I slept in his sewing room. During the day I'd work on his designs and at night he would escort me to and from the Key. Sometimes I'd have him come to work with me and my submissive clients would suck his dick. Keni thought it was hot, the guy got off on doing whatever I said, and I got to sit back and work on my nails. It was a win for everyone.

When we weren't working, Keni and I bonded over our love for classic Hollywood glamour and the great actresses. Keni had a real talent for understanding the history of fashion. Our favorite was Jayne Mansfield, the cartoon version of Marilyn Monroe. Jayne was a fun, flirty, buxom blonde with the best breasts in all of Hollywood.

One afternoon we were watching *The Girl Can't Help It,* my favorite Jayne Mansfield film, and Keni said, "You know, you would get a lot more attention if you tried for that look."

Well, duh, I thought, but I said, "Yeah, I'd love that, but I wouldn't know how." My main goal for my look was real housewife realness circa 1989: lots of silk blouses and belts, very French-inspired. I dreamed I could be as glamorous as someone like Jayne Mansfield, but I had no idea how to go about doing that without looking like a drag queen.

Sixty minutes later, Keni had made me a tube dress out of black stretch

Lycra, with a padded bra built into it. The dress was cut short and flounced on the bottom; it was simple but elegant. I spent the next three weeks bejeweling that dress to make it resemble what Jayne or Marilyn would have worn.

I taped three pictures on our (empty) refrigerator: Jayne Mansfield, an old pinup drawing of a Vargas girl, and Jessica Rabbit. These were my inspirations. Jayne had the glamour, the Vargas girl had the style and makeup, and Jessica Rabbit had the proportions.

There was no going back: Amanda the housewife was dead. Amanda the sex goddess had been born.

Keni treated me like a Barbie doll, which I loved. We went to fabric stores on Second Avenue in the East Village and picked out satin and cotton Lycra spandex in shiny pinks, matte reds, and virginal whites. Keni would turn these into simple little wiggle dresses and tiny jackets that I'd spend hours embellishing with beading and sequins while watching the classic Hollywood films that inspired me. We'd go to Bergdorf Goodman and check out what Yves Saint Laurent was doing, then we'd go to the Garment District and buy the materials to make those same looks.

"You're not a housewife anymore, so stop dressing like it," Keni once told me.

"Well, I can't dress like a dominatrix, can I?"

"Why not?"

I threw away every flat shoe I owned and started a collection of high heels from discount shoe stores. Louboutins were not an option back then but I became a shoe whore.

Bulimia was sort of outdated, and sometimes throwing up would break blood vessels around my eyes, so I switched back to anorexia. We would not keep any food in the apartment and would order out one meal a day. I'd allow myself to eat half of what I ordered and then douse the rest with dish detergent, to make sure I wouldn't pull it out of the trash and try to eat it later. My proportions were right where I wanted them: 34 C bust, 24 waist, 34 hips.

To complete my Hollywood glam look, I knew I needed some physical enhancements.

Keni took me to a hairstylist who showed me how to wear extensions and hairpieces in a way that I could still show my real hair in the front, to make it look more natural. It's so important to intertwine natural and enhanced looks, instead of going all one way or the other. The added volume was a confidence boost that I never expected; ever since then I never go out with only my real hair. Never. There's always something in it, or I'll cover it with a kerchief. I won't go for coffee without a hairpiece. I only take it off when I take a shower or sleep. I don't feel right if I can't snatch my hair.

The other thing I wanted to enhance was my lips. There was nothing wrong with them, but larger lips are a sign of youth and I thought they'd look good on me. I asked Dr. Reinhorn about silicone injections I'd read about in *Vogue*. Models were calling silicone the fountain of youth, though it was controversial. Dr. Reinhorn tried to talk me out of it, but I had my mind made up: my lips needed to be bigger, and I didn't want to deal with something I'd have to fix every six months. Silicone was permanent. Dr. Reinhorn relented, and gave me microdots of silicone so he could control how much he used. He also put a little silicone in my cheeks while he was at it. It was very minimal but made a huge difference.

Most of my time was spent beautifying in some way. I'd spend hours doing my nails (I've lost several friends who were sick of waiting for me to finish my nails), or plucking hairs, bleaching my pussy hair, or bejeweling a dress. That's all I wanted to do. It still is.

I remember looking in the mirror while trying on one of my new dresses, with my full hair and fuller lips, and thinking about the Rapunzel dream I used to have. Locked away from the world, unable to enjoy everything that life had to offer a gorgeous girl with great hair.

I'd never let that happen to me again.

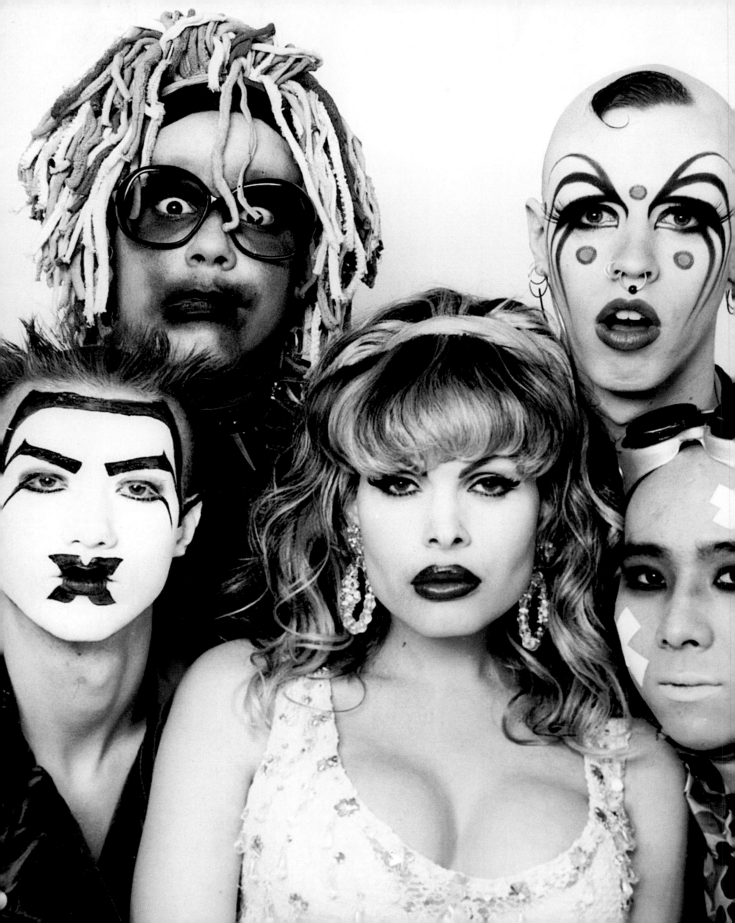

THE MISFITS

t was 1990, and Keni wanted to take me out for a sort of New York society introduction. We went to an anniversary party for *Details* magazine, being thrown at Cave Canem, a trendy restaurant in the East Village that was formerly a gay bathhouse.

My dress was a strapless ivory satin fishtail gown and I wore my favorite waterfall earrings, but my best accessory was Keni: he looked gorgeous in a white suit. We're the same height, so we photograph together well. When we walked through the front door, we bumped right into Christian Slater, who gasped when he saw us.

Canem was like one of those old-fashioned supper clubs you used to see in films from the 1940s. The tables were large and round, and everyone took the time to introduce themselves to the new girl on Keni Valenti's arm. Annie Flanders, Stephen Sprouse, Debbie Harry, and Chi Chi Valenti all came up to say hello. They thought Keni and I were husband and wife and everyone was just dying for us. Christian Slater invited us to the premiere of his new film, *Pump Up the Volume*. I was super shy back then and didn't know what to say to anyone, but when we got home I hugged Keni and thanked him for bringing me. I was so grateful to be out on the scene. It felt like I had found a home.

Details published a picture of me at the party and called me "The Girl of the Minute." I had a permanent smile glued on my face for at least a week after.

"You've met the New York establishment, all the people that have been on top for the past decade," Keni told me. "Now you need to meet the kids who will be running things for the next decade. It's so important to stay on top of trends."

For the location of my anti-society inauguration, Keni chose Disco 2000, a new Wednesday-night party at Limelight, Peter Gatien's Gothic church turned nightclub. Peter was well-known in New York as the king of nightlife, and Disco 2000 was his protégé Michael Alig's homage to the freaks and outcasts of the world. Anyone who was in the least bit interesting was meant to be in attendance.

In keeping with the theme, Keni designed me a pure white spandex evening gown and white velvet gloves. He again wore a matching white suit.

"There are three ways to get into the club," he said. "You have to know somebody, you have to have a look, or you have to be a drug dealer. Dealers get carte blanche."

"I'll just focus on my look," I said. "I can't deal drugs in an evening dress, where will I keep them?"

At midnight on the dot, I opened up our living room window, leaned outside, and waved a scarf, trying to get the attention of a passing cab. I didn't want to be stuck looking for a cab on the street in my dress. I wasn't having any luck. It was a bitterly cold night, and cabs were scarce.

"What do we do?" I asked Keni.

"Just stick your tits out the window until a car stops. That dress looks best with hard nipples anyway." Keni always had a plan.

I pulled my dress down, went back to the window,

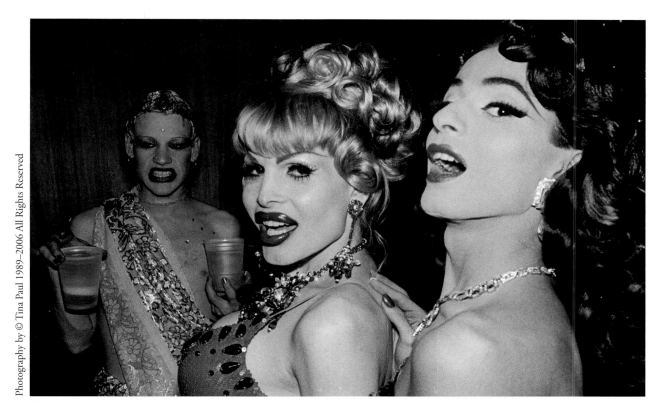

Photography by © Tina Paul 1989–2006 All Rights Reserved

and waved my scarf so my breasts jiggled. A Jeep full of college boys screeched to a stop almost right away.

"Me and my friend need a ride to a party!" I called out.

"Tell them we can get them in the club for free," Keni whispered.

"You can all get in with us, for free! I'm just desperate to get to the club!"

I felt like a movie star.

The boys yelled for us to come down. They were a rowdy bunch of drunk frat brothers, out looking for some trouble. I sat on the lap of the one I thought was cutest, while Keni squeezed in the side. Neither of us wore coats. First impressions are more important than frostbite.

"You smell so good," my cute boy said. "What's that scent?"

"It's my pussy," I whispered in his ear. "It tastes even better." I felt his dick get hard and it was a monster. My sixth sense/dick sense always steers me right. The radio blasted Prince's "Let's Go Crazy" as I talked like a whore in my boy's ear and we made our way to Disco 2000.

There was a long line out front of Limelight, but Keni promised that wasn't going to be an issue.

"Rule number one of going out: the door person is God and must be treated as such. They decide who pays and who doesn't. And they have all the free drink tickets." He walked right up to the doorman and air-kissed him, then peeled me off my date and offered me up for presentation.

"Kenny Kenny, this is Amanda Lepore," Keni said. "Amanda Lepore, this is Kenny Kenny, the most important doorman in New York City."

"Hi, Kenny Kenny, you look great," I said. If

someone takes the time to look good it is your duty as a human being to acknowledge their hard work, even if hypothermia is setting in. He resembled a femmed-up, less androgynous Joel Grey in *Cabaret* —hair slicked back, face washed out with a strong smoky eye, a man's shirt and tie paired with a pencil skirt and patent leather heels.

Kenny double kissed me and unclipped the black velvet rope. "Let this be a lesson to all of you," he yelled to the crowd, and took my hand to spin me around. "That's how you put together a look!"

I walked in, all smiles, with Keni on one arm and my boy candy on the other. I felt like Grace Kelly. The rest of the college boys followed behind us like a gaggle of wide-eyed baby geese, following their mama into incoming traffic.

Inside, Disco 2000 was a crowded, dark, cavernous maze.

The music was like a hummingbird's heartbeat playing loud enough to make my other senses stop working. Spotlights zigzagged around, and the stained glass windows of the church reflected brightly, but otherwise I couldn't see a thing.

We lost the boys almost immediately, though I held on to my cute one for dear life. I mean, that dick was like a billy club, no way in hell was I going to let him go until he beat me with it. It's a shame I don't remember his name. Maybe it *was* Billy.

Keni wound us through the throngs of sweaty dancers, heading toward a back room that was closed off by another rope. "THIS IS WHERE MICHAEL ALIG HAS HIS PARTY," Keni screamed into my ear. "YOU HAVE TO MEET HIM. HE'S GOING TO LOVE YOU."

I'D HEARD A LITTLE ABOUT, oh, sorry, here we go. I'd heard a little about Michael Alig before. He was the high priest of New York's Club Kids, and this back room, called the Chapel, was where he held court.

The Chapel was situated around a circular bar in the middle of the room. The music was more fun than the main dance floor, sort of retro eighties camp, like Devo, Madness, and obligatory Madonna. Nightclubs always tend to recycle music from the decade before.

I met so many people in the Chapel, kissed so many cheeks, and turned down so many hits of ecstasy, that it all became a blur. But here are the people I do remember:

JAMES ST JAMES: Keni introduced us and James said hi (it was more like, "Oh, hiiiiiiieeeeee") and then he searched through his lunch box purse, yelling about something he'd lost and slurring his words so badly I thought he was doing a Nico impression.

MICHAEL MUSTO: The famous *Village Voice* writer. His countenance was quite possibly the inspiration for the scowling emoji. He said I looked like Cleo the Goldfish from *Pinocchio*. I'm not sure if that was a read or not but I took it as a compliment.

CLARA THE CHICKEN: A man dressed in a large yellow chicken costume, doing the chicken dance as though he were on crack (he was). Dadaism. Surreal. Television monitors splashed pictures of Clara all over the place.

PETER GATIEN: Lingering in the shadows, with an eye patch over one eye. A couple of times I saw him staring at me and held on to my college boy extra tight.

ARMEN RA: Dressed almost identically to me, but all in black. Black velvet dress and gloves with a black mink, a black flip wig, and a large diamond ring. We looked great together. Yin and yang. I adored her immediately.

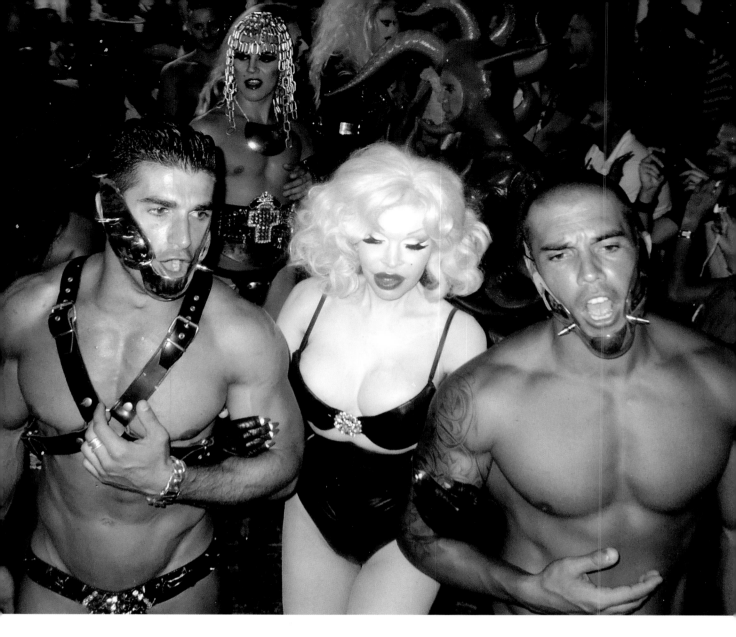

And then came Michael Alig himself. I knew who he was as soon as I saw him, since I had helped Keni design the outfit he was wearing. It was made of red fishnet, and we had woven multicolored rubber tubing into the netting as fringe. His face was femme and his boy shorts had the ass cut out.

Michael walked up to me and the first thing he said was, "You look fabulous. Would you like a job?" His arms jerked and twisted around his face as he spoke, as though he were uncontrollably voguing.

A woman he was with yelled out, "You can't just pay everyone to come to your party, it sets a bad precedent!"

"I have to hire her," he said. "She's exactly the type of person I want coming here."

I looked to Keni, who shrugged noncommittally.

I thought about it. Did I really want to invite this level of insanity into my life?

"Sure."

The first job Michael Alig gave me was working the front door of Limelight, alongside Kenny Kenny.

Michael wanted to show me off to passersby on the street; he thought it would bring people in. It was only a few days before Christmas, and freezing cold outside. I showed up to the front door wearing a little red 1920s-inspired dress, which I had personally hemmed so that my pussy was just barely covered.

"You're going to freeze your ass off," was Kenny Kenny's hello. He was in a military suit with his pants tucked into his boots.

"But I have a fur coat," I told him. It wasn't a coat, it was a stole, and it barely covered my tits. I wasn't wearing stockings either, and I had six-inch heels on. "If they wanted to hire an Eskimo, I'm sure they would have." I winked and he laughed.

Kenny gave me a quick rundown of how the job worked. It wasn't rocket science. People who were part of the scene, who dressed up and added to the atmosphere, got in for free. The "normal" people had to pay because that was how the club made money. You had to have a nice balance of the people who made the party fun and the spectators who kept the lights on.

It was harder than I thought it would be. I felt bad asking for money. Kenny would turn people away, and they'd come up to me and I'd just open the rope. The entire line moved over to my side of the door, completely bypassing Kenny.

On top of this, every fifteen minutes I would have to be escorted down the stairs and inside so I could warm up.

"I think we're in a John Waters movie and haven't figured it out," Kenny Kenny said. "There's no good reason for you to be out here."

He was right. I lasted two nights before Michael moved me inside and made me a go-go dancer and his new best friend.

Michael Alig could have been the next Andy Warhol. He was bright, creative, and he had something

to prove. If only he hadn't become a drug addict and murdered and dismembered someone . . .

A week after I started at Disco 2000, I was invited to join my coworkers on Joan Rivers's new talk show.

Keni and I worked for hours trying to figure out what to wear, which kept me from thinking about how nervous I was. We settled on a gold bikini top and bottom and a white mink coat that a client from the Key graciously, benevolently, willfully, legally bought for me.

When I arrived at the greenroom with my extra-long Madonna ponytail, I hadn't even thought about what to say and I was completely flushed, which made me more nervous, which made me more flushed.

"Just relax," Michael said. "You look amazing; you're every man's fantasy of the ideal woman."

Another of the new Club Kids was there, an androgynous glammed-up Blueberry Shortcake rainbow sparkle named Richie Rich. "Honey," he said, "you're going to steal the show with that body. All of America is going to freak out when they see you."

Michael said, "Tell her you don't even get paid. You just love to party and parties love having you because you look so good." That sounded good. Michael knew what he was doing.

Joan wanted nothing to do with us until the cameras were on, then her whole attitude changed, like a pinball machine turning on. On camera I told Joan I didn't have time to work because I was too busy getting ready to go out all the time. She asked me if I was a hooker, which I thought was rude but not completely out of line, I guess.

Working in nightclubs was my job, and to me, being professional is so important.

My job was to dance for fifteen minutes, three

times a night, in a cage above the dance floor. They'd lower the cage to the ground, a security guard would help me into it, and then they'd yank me up. I'd wear a bikini or lingerie, the same stuff I was wearing at the Key. Between my sets I would hang out with Armen and Richie Rich (who were both way too cool to dance in a cage, which Michael hated), mingle, and look as perfect as I could. After my last shift in the cage, I went home for the night (usually not alone) while the party continued to rage on. By that point everyone was drunk or high anyway and I could slip out unnoticed. I'd make seventy-five dollars for the night, so I still had to work at the dungeon a few times a week to support myself, but I was having a good time and meeting a lot of sexy men.

No one in the clubs knew I was transsexual at first. There were whispers, I'm sure. Transsexuals weren't super common back then, so it wouldn't occur to people right away. It's not like trannies were on *Donahue* at that point. People just assumed I was the new hyper-feminine female on the scene, following in the footsteps of Dianne Brill or Julie Jewels.

Michael knew I had a pussy—everyone knew that, because I wasn't shy about showing it off—but sometimes he'd say things like, "I wonder what you'd look like if you were a boy," to try and gauge my reaction. I was hanging out with him one time in the bathroom at Disco 2000 and he asked if he could watch me pee.

Maybe he thought trannies had to use a straw to go to the bathroom or something, I don't know, but he was so inquisitive about it that I knew he was thinking something he wasn't saying. So I did what I always do when I want to change the subject: I started talking about how pretty my pussy is. "I just love my pussy. It's really perfect, don't you think?"

"Yes, Amanda, of course it is. Why wouldn't it be?"

"I mean, my surgeon really made it beautiful, don't you think?"

He agreed, and gave me a big hug while I peed.

Once I confirmed for him that I was a tranny, he made me his new "It Girl" and started hiring me for every party he'd throw. People told me It Girls only lasted until the next blonde beauty showed up. I didn't care so much. I just wanted to have a good time. There's no point worrying about things you can't control.

Michael had the energy of a ten-year-old and the personality to match. He loved to play tricks on people, tripping them on the dance floor, or pissing in a cup and dumping it out a window that overlooked the line of people waiting to get into his party. Other people would yell at him or call him an asshole. I'd just say, "Oh, Michael, you're too much," and leave it at that. It wasn't my place

THE AMANDA LEPORE COSMETIC ESSENTIALS

Makeup is completely personal. What works for me might not be right for you. But these are all the cosmetic products I most adore!

Chanel No. 5 Foaming Bubble Bath and Body Powder (on all this skin, honey)

Giorgio Armani Luminous Skin Foundation

Chanel Natural Finish Loose Powder

Lips:
I wear red lipstick or no lipstick. MAC Prep + Prime, Kat Von D Santa Sangre Lip Stain, MAC Matte Cherry Lip Liner, Kevyn Aucoin Persistence Lip Stick and Dior Addict #856 Lip Gloss

Cheeks:
MAC Pro Longwear Blush (any pale pink or peach colors)

Highlighter:
MAC Silver Dusk Powder and Fix Plus spray, to keep me porcelain and dewy

Eyes:
MAC Black Liquid Eyeliner, Chanel Eye Shadow quads in any color, Makiash Mascara

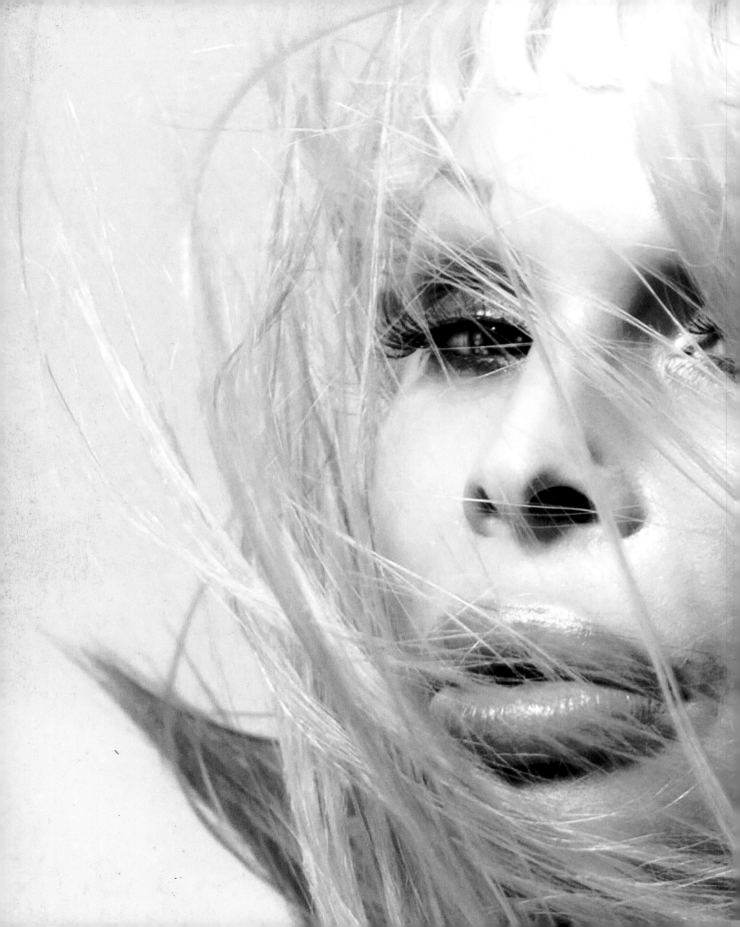

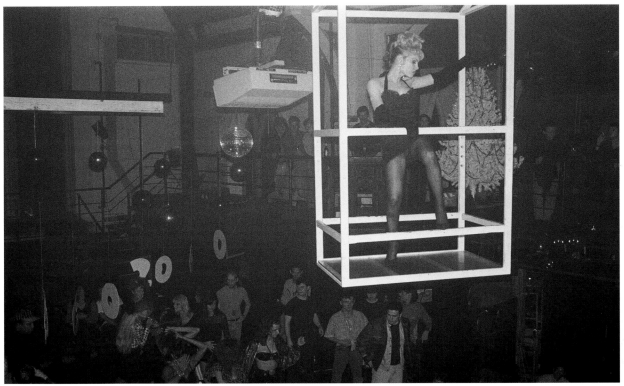

Photography by © Tina Paul 1989–2006 All Rights Reserved

to judge him. I think that's what he liked about me.

Every party Michael threw had a theme, but I didn't usually follow form. I had my look down, I wasn't trying to change it. Plus a lot of his themes were gross, like Blood Feast, where everyone basically dressed like zombies, or Emergency Room. That one was actually sort of fun. Michael had a set designer build a makeshift hospital clubhouse. Armen, Richie Rich, and I dressed as sexy nurses (I already had the costume). We'd go up to hot guys and ask if they were feeling ill. If they were, we'd give them a checkup. Then Michael would come by and give them their "medicine," which was Rohypnol with a vodka chaser.

My favorite parties were when Michael would get a celebrity to show up. He sent out more than 200 letters to the stars of his favorite shows, inviting them to accept an award: the Nightlife Achievement Award.

By "award," Michael meant a cheap piece of plastic he would glue together and cover in glitter. It usually fell apart the second he handed it over to the poor celeb, who hopefully didn't put it too close to their clothing.

A bunch of people responded, which Michael did not expect. He'd run around saying, "What if Joyce DeWitt tells Florence Henderson that she won too? They'll know we made it all up!"

Barbara Eden, Nichelle Nichols, Snapple Lady, Mr. Ripple, and even the "Where's the Beef?" lady all received awards from Michael Alig. My favorite was Donna Douglas, aka Elly May Clampett from *The Beverly Hillbillies.* Michael covered the floors with hay and released a bunch of live chickens. I wore really cute capri jeans, just like she wore on the show. I loved finding a way to make the celeb's style fit into my own style. It was harder to do for Mr. Ripple. I ended up just wearing white.

These weren't A-listers showing up, which Michael preferred. "Club Kids are about soulless American consumerism, the emptiness of celebrity," he would say. "The B-listers are living proof of that!"

It was always awkward. These people were older by this point, and it was sort of disrespectful to get them to show up for no reason. You could see it in their faces when they realized the whole thing was a scam. They were mostly very gracious about it. Except the Snapple Lady. That girl was pissed. I tried not to focus on the bad side, though, and enjoyed the fact that I got to mingle with celebrities.

New York nightlife is a little incestuous. Once you start working at one bar, you start getting hired at all of them.

I was dancing at this club called the Building, around the block from Limelight.

The Building had a large staircase made of hollow, grated metal. I was walking fast, not holding on to the rail, and my heel got caught in the stairs. I fell forward into the railing, slamming my forehead really hard before falling down. My white dress was covered in blood.

I crawled back up the stairs to try to find help. The first person I saw was James St James, who said, "Amanda, great look!" and walked away. I kept trying to get someone to call me an ambulance but they all assumed I was putting on an act. Covering yourself in blood was very "in" at the time.

Richie Rich saw me, and luckily he had the same glam aesthetic I did and knew right away something was wrong. He took me to St. Vincent's Hospital, where the doctor told me I had several deep cuts on my face. I'd need a bunch of stitches and I'd definitely have a scar. Richie Rich started crying and so did I.

What was I going to do? My face was ruined. There would be a bandage on my head for months. I wouldn't be able to leave my house. After all the time and work I'd put into my look, now I'd have a scar? I was seriously suicidal.

Keni, Richie, and Armen gave me a sort of intervention, which was really just them helping me figure out how to wear my hair to cover the scar. I stopped bleaching and let my natural brown hair grow in (I couldn't risk breaking it again and not being able to cover my face), and I started wearing more ponytails and thick bangs over my forehead.

"Just get bigger breasts," Keni said. "Nobody will even notice a scar on your face if your tits are gigantic."

Maybe he was kidding but that made a lot of sense to me. The hot look at the time was Pam Anderson—no ass or hips, just implants. I saw Dr. Reinhorn and told him I was ready for my second breast enlargement; he wasn't surprised. "I had a feeling you'd want to go bigger," he said.

I went from a C to a D cup. While I was at it, I also asked him to make my lips as big as they could possibly be without looking bad. I knew that would draw attention away from the scar too. I did go a little overboard at first with the lips, but we fixed it.

People weren't doing lips like that back then. This was before Angelina Jolie. Guys went nuts. Nobody ever noticed my scar.

Drugs were always around, but Disco 2000 wasn't such a drug scene at the time. It was more about dressing up.

Michael was rebelling against the generation before, the celebutantes and the Studio 54 crowd. Cocaine was tacky and tired; Michael was too creative to be gacked out of his mind. He'd pretend to be high and act like he was doing cocaine just to fit into the scene, but the party itself was Michael's high. He didn't need help from a substance.

I never liked doing coke either, mostly because I

didn't want to mess up my nose job, but also because Mary Ellen's death was a real cautionary tale for me. Sure, I'd do a tootie every now and then, but whenever a drug dealer would hand me a "free sample" baggie I'd hand it over to Armen, like a cat presenting a mouse.

It comes as a surprise to many people that I can carry on a conversation and be as focused as I am, even in the midst of all the chaos that comes with a great party. It's not easy to do, but after many years in the club scene I developed a gift for it.

The big secret is a simple one: I am a preservationist.

Being a drunken, coked-out mess while wearing high heels is one surefire way to end up bruised and scarred. And if I have to make a choice between wearing fuck-me heels and getting drunk or high, I'm making the choice that is more visually appealing.

When I go out, if I want to drink, I'll order a glass

"What do you mean?" I asked. I took a nibble of a turkey sandwich, removed the lettuce from it, and tossed the rest away.

"Well, they have to worry about feeding themselves. In America we have the luxury of focusing on things that don't really matter. Like lip gloss."

"Lip gloss *does* matter, Michael."

"Yeah, but it's all satire, Mandy. We can afford to be helpless, act like children, carry lunch boxes and drink from baby bottles. We can create whatever character we want and be as big and extreme as we want."

"I don't play a character, Michael. This is who I am." I was wearing an Ungaro sweater, a head scarf, and large sunglasses, like an incognito movie star.

"We all play a character. Haven't you ever read Shakespeare?"

I got to see the "normal" side of Michael, which

I DIDN'T CARE ABOUT DOING THE COOLEST LOOK; I WAS DOING MY LOOK.

of champagne or a wine spritzer, and I'll nurse it all night. Usually I'll ask the bartender to serve me ginger ale in a champagne glass. That's a trick I stole from Dean Martin, who used to drink Coca-Cola out of a scotch glass. He always had a drink in his hand; it's part of the look. You seem out of place if you're in a club all night without a drink. But being sloppy hasn't been a good aesthetic since 1994, and I sincerely hope it's not coming back in style anytime soon.

"They could never have Club Kids in Ethiopia," Michael said to me one day. We were having a picnic in front of the Museum of Natural History on the Upper West Side.

no one else knew existed. It was like a split personality —the real Michael and the KING OF THE CLUB KIDS MICHAEL ALIG.

We didn't go to the museum. After he finished eating, we walked through Bed Bath & Beyond and discussed the surrealist political statement of the Club Kids. He got a kick out of seeing an entire store react to my day look with their mouths wide open.

"Doing drugs and living like a decadent mess is the ultimate freedom, but it always implodes eventually. It happened with the hippies in the sixties, then the disco coke fiends in the seventies. People have wised up, but now there are other drugs controlling everyone. Consumerism, capitalism, fame, celebrity . . . they're all a government conspiracy," Michael said.

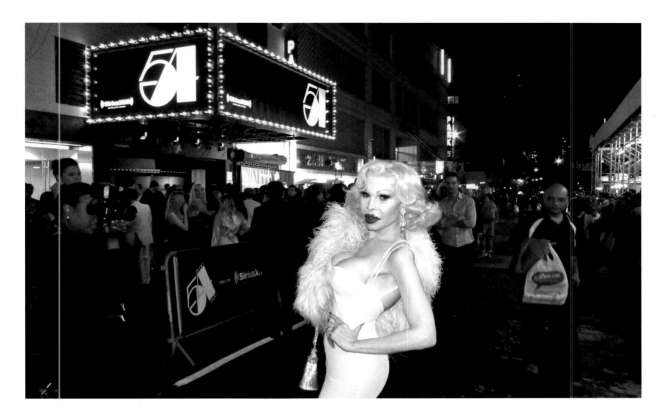

"Oh, okay. That makes sense," I said, while trying to pick out a shoe caddy. "You act even crazier than you really are on purpose, to force people to realize how absurd it is?"

"Personality is all that separates us from the animals," he said.

Michael's nightlife "character" may have been created deliberately, but it slowly started to take over his life, at about the same time he went from pretending to take drugs, to actually taking them. The environment demanded it. You can play a role for only so long before the role takes over.

Kate Moss was the big model of the time. Calvin Klein was making heroin chic the new thing, and Michael Alig was all about the next big thing.

It was easy to pretend to be tripping on E: just walk around like a hot mess and tell people you're seeing colors. But to convince people that he was shooting up, Michael started actually doing it. Michael, along with a large portion of the Club Kid crowd, picked up H like sheep jumping off a cliff.

Style changed along with the drugs. Grunge became a thing, and people stopped wearing bright colors and washing their hair. I kept on doing my Hollywood glamour look; people asked if I was from Texas, or California. But I didn't care about doing the coolest look; I was doing my look.

To even me out, Michael paired me with a new dancer from San Francisco, a fellow transsexual named Sophia Lamar. She had the style of Linda Perry and the body of Linda Evangelista.

"Sophia is so on trend it makes you look even more like a caricature!" Michael said to me.

"I'm not a caricature," I told him. I hated when he said that.

Sophia just rolled her eyes and said in her thick Cuban accent, "Honey! Why do you care what some

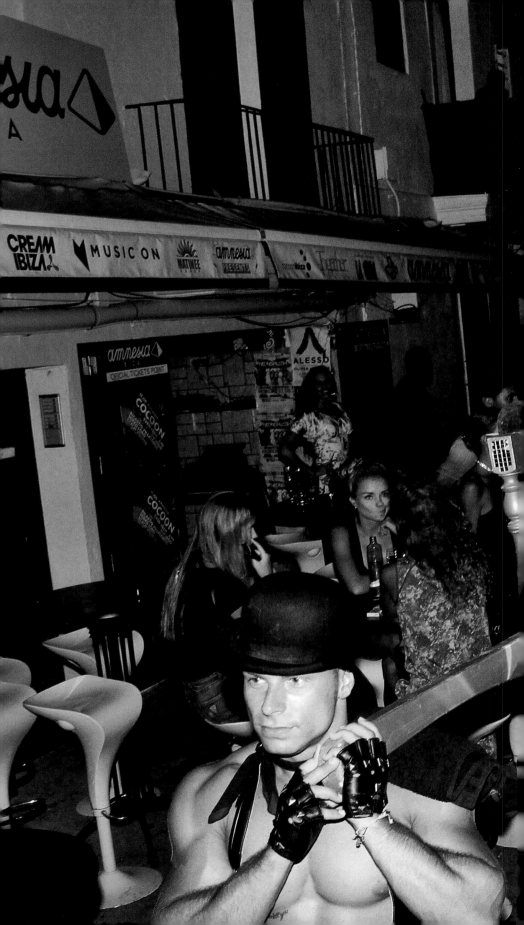

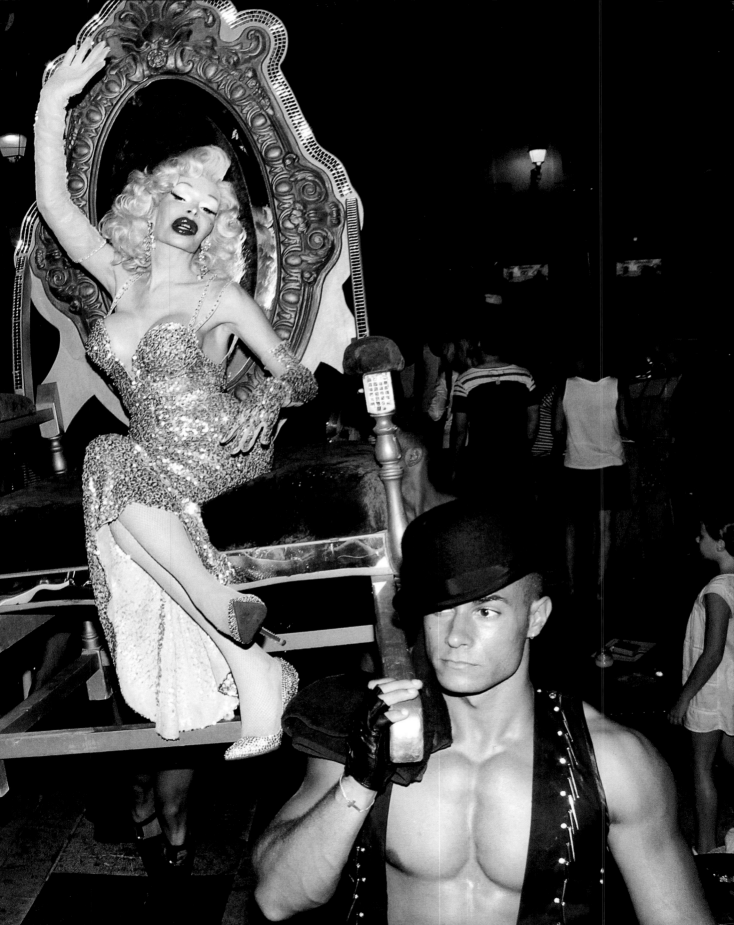

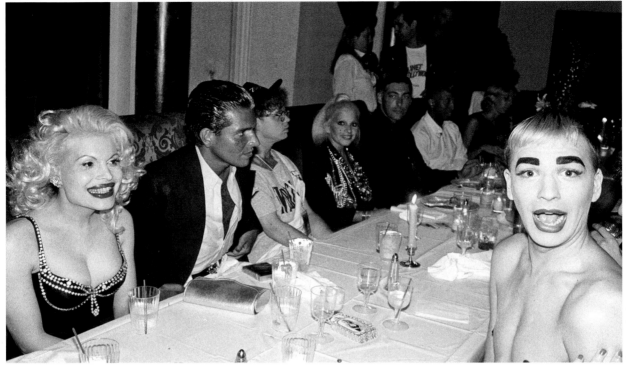

Photography by © Tina Paul 1989–2006 All Rights Reserved

sheety faggot says about what you are and what you are not?"

Michael cackled. "Is it true that you carried a live chicken with you on that raft from Cuba?" he asked. Sophia gave him the finger and off he went.

I had a great time dancing with Sophia that night; we looked great next to each other. "Did you really come here from Cuba?" I asked her.

"Yes, but there was no chicken. That's some racist bullshit."

Sophia was super smart. I actually saw her reading a newspaper behind the DJ booth one night. I asked Michael to start pairing me with her every time we worked.

While the drugs and fashion were changing, so was the music. It became darker and more aggressive. The Breeders and Blur were replaced by Marilyn Manson and Nine Inch Nails. Every time I heard that "fuck you like an animal" song I'd stop dancing and look around.

"What's wrong?" Sophia asked one night as Trent Reznor screamed over the speakers. The lighting was a bloodred, and the crowd danced with a hard-eyed intensity that stopped me cold.

"Why is everyone so angry?" I asked.

"It's the nineties," she said. "You'd be angry too if you paid attention to anything besides makeup." She kept dancing.

Maybe she was right. Maybe I was clueless. But I could feel it in the air. Something awful was about to happen.

I didn't fully realize something had changed in Michael Alig until he brought me to a private party Peter Gatien was having at the Four Seasons Hotel.

Michael had told me, "Peter wants pretty girls around, so you should go. Peter would love you." I didn't know Peter very well but I'd heard whispers

about these hotel parties. From what I'd heard it wouldn't be my scene, but I wanted to check out the Four Seasons; it sounded so nice.

When we arrived at the presidential suite, Peter was locked away in the bedroom and about ten sleazy-looking people were sitting around silently. Michael introduced me to a few of them, then disappeared into a giant tepee-shaped blanket fort in the middle of the living room. He'd come back out and introduce me when someone new showed up, and pick up a lamp or a pillow and say, "Isn't this nice, Amanda? Can you believe how fancy this is?" Then he'd disappear into the fort again. When a man is attempting to be extra attentive and failing miserably, it's a good sign he's up to no good.

Most of the girls at the party were dancers I knew, but none of them were very friendly. I sat down between a couple of guys, and they both put

Jenny was brand-new on the scene. Gorgeous. Even though she had shaved her head and pierced her cheeks, no one could deny she was a beauty. She was only fifteen, came from a rich Park Avenue family, had already modeled for Calvin Klein, and she loved getting into trouble with Michael.

The two of them hadn't even noticed me coming into the tent, so I backed right out the way I came in. I can talk about crystals and baubles for hours, but even I couldn't get sucked into a deep discussion on the wonders of cotton balls. I sat back down on the couch and tried not to look too out of place.

Around 8:30 in the morning I ordered ten steak-and-egg breakfasts from room service. I thought I could get all these people fed and on their way home, since this party was past its prime two days ago. Room service came (I put the $500 bill on the room), and nobody touched a thing.

SOMETHING AWFUL WAS ABOUT TO HAPPEN.

a hand on my bare legs right away. I excused myself and went to the bathroom. Unfortunately it was covered in vomit, so I ran right back out and sat down again.

A girl started screaming in one of the bedrooms. The door flew open, and Peter Gatien came running out, trying to open a little clutch purse, yelling, "I know you stole it, I know it's in here!" He was followed out by a naked girl who was trying to get the purse back from him. But Peter got it open, took out a baggie of powder, threw the purse on the floor, and locked himself back in the bedroom.

It seemed like a good time to go. I got on my knees to look inside the fort for Michael. There he was, talking to Jenny Talia about cotton balls versus Q-tips. I didn't even know she was at the party; she had been hiding in the fort the entire time.

Peter came out of the room again, saw all the food, and flipped out. I pretended I had no idea who ordered it. He'd left the bedroom door open, and inside I could see two naked women on their hands and knees by the side of the bed, each with an overflowing plate of cocaine resting on her back.

I crawled into the tent and told Michael it was time for me to go. His eyes were glazed, his focus was erratic, and he was sweating like a . . . well, like a crack addict. I asked if he wanted to come with me and sleep on my couch, but he told me he couldn't, everyone was getting ready to go to some after-hours club like Save the Robots.

During the cab ride home I thought about everything I'd just seen. I had just spent a sober night in the middle of a days-long drug party, and my good friend—the smartest guy I knew, the boy who was

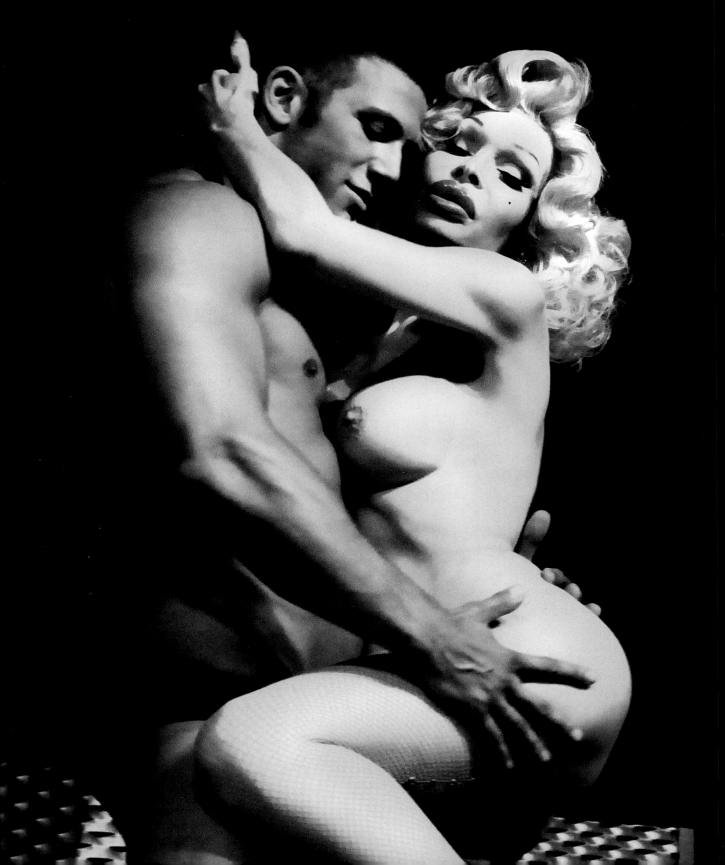

too busy changing the world to do drugs—was right in the thick of it.

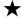

Michael had developed dual addictions to uppers and downers.

Since I wasn't doing drugs with him, he stopped hanging out with me as much. Jenny Talia took my place as his new It Girl. I compensated by finding a boyfriend to keep me busy and out of trouble—a grungy blond guitar player named Chris. His dick was perfect; we'd fuck three times a day, minimum.

Keni hated Chris because I screamed so loud when we were fucking. "How am I supposed to get any work done when I hear you moaning like a fucking poltergeist all day and night?" He'd taken on a new job compiling vintage clothes for designers. He was back on his feet and didn't need my help anymore, so I moved in with my walking hard-on of a boyfriend.

Chris worked a day job at a hotel that gave him a free room. It was close to where I'd lived with Rose, near the Key, and I thought it was so glamorous, living in a hotel. He was a good boyfriend; he proposed to me the first night I moved in with him. He was straitlaced, anti-drugs, and he hated that I was out at the clubs so much. And he hated it even more when I did a shift at the Key. Richie Rich, Sophia Lamar, and Armen Ra would come over and get ready to go out with me, and Chris would just mope around and try to keep me from leaving. It was sort of pathetic.

"Listen, Dick," Armen would say, "Amanda's a grown woman. She doesn't need you keeping a leash on her."

"My name's not Dick, it's Chris."

"I know what your name is."

I loved it.

I guess Chris was a little controlling, but it was good for me at the time. It gave me an excuse to leave the club early every night. Kept my nose clean.

Michael stopped showing up for work. I barely ever saw him anymore, except when he'd stop by the hotel to "borrow" $100 from me now and then. He looked terrible, and I knew he was using the money for drugs, but I couldn't say no to him.

Then came Michael Musto's "blind item" in the *Village Voice*.

Apparently rumors had been circulating that Michael Alig had murdered a drug dealer named Angel. I hadn't heard about it, probably because if someone says the word "murder" I'll beeline from the conversation, but once that column came out, there was no escaping the talk.

I didn't know Angel at all, except as a rude guy who always wore these huge-ass white wings that would hit people in the head as he walked by. He never said hello, he wasn't social like the rest of the Club Kids, and I thought he always seemed out of place, like he had just thrown on some wings to try to fit in. But one day Angel wasn't around anymore, and for some reason people were saying Michael had killed him.

I thought the whole thing was a publicity stunt. Peter Gatien was supposedly financing some Spanish film, and I was sure they were hiding Angel away, just to get the press. I forced myself to believe that to be the case. The alternative was too terrible to think about. The club was supposed to be a break from the realities of the world, and yet there I was, bombarded with the details of another murder in my midst.

This didn't stop people from partying. If anything, it made Disco 2000 more popular. People wanted to party at the place where it all went down. Michael showed up one night with the word GUILTY written on his forehead. The whole thing felt really gross.

The city and Mayor Giuliani were trying to shut down Peter and all the big nightclubs that were swarming with drugs. Limelight was on its last legs. I started taking on other jobs, go-go dancing five nights a week and even stripping at a titty bar in the Financial District (short-lived once my jealous

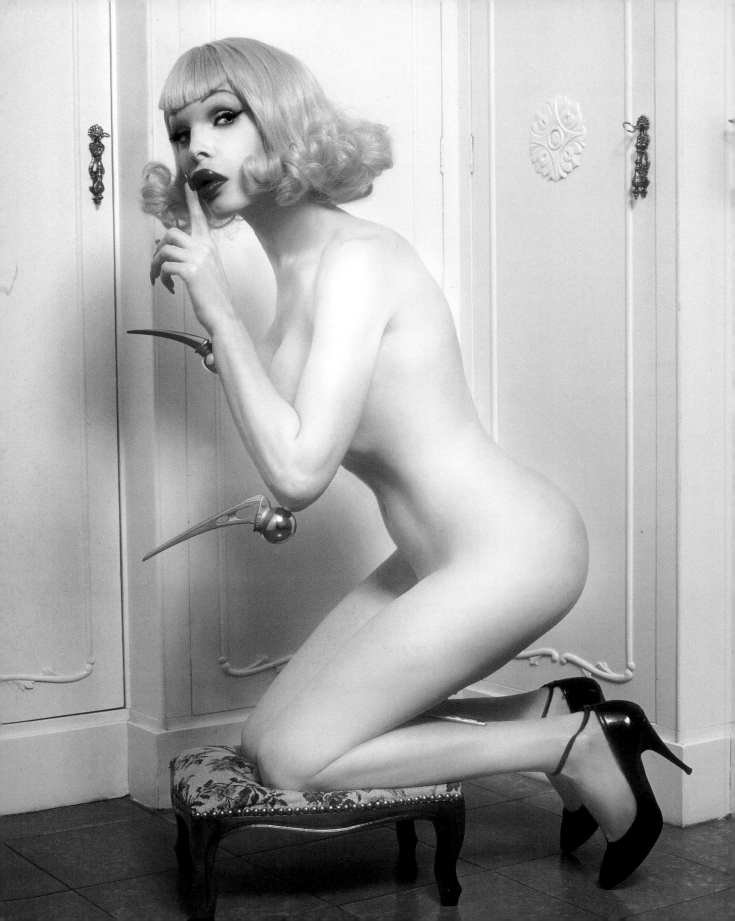

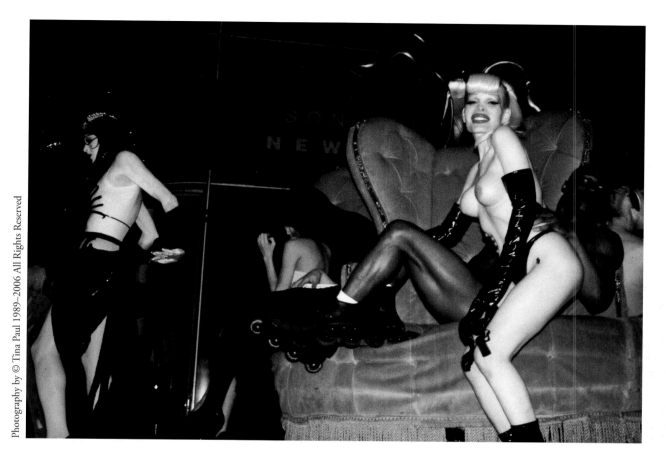

Photography by © Tina Paul 1989–2006 All Rights Reserved

coworkers found out I was transsexual and told all my clients).

Chris tried to take this opportunity to get me to stop working. "You shouldn't have to work so much," he said. "You're surrounded all night by losers and drug addicts; you need to get out of that life. Let me take care of you, and you just worry about looking good."

Guys always think they need to save me from my work.

"I can take care of myself," I told Chris. "If you really want to help me out, you can take me to YSL."

Always let a guy take you shopping, but never let him pay your bills.

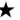

I was dancing at Twilo one night, shaking my ass onstage while I looked through the crowd for Sophia. There she was, in the DJ booth with Larry Tee. I waved to her and she waved back, beckoning me to her.

I climbed down and met her. "They found Angel's body," she said. "Michael really did kill him."

"Oh." I just stared at her and Larry Tee. They stared right back. I didn't know what to say. "Poor Michael."

"Yeah." Sophia hugged me and I started crying.

"And Angel, of course."

"Of course."

"Will Michael be arrested now?"

"Yep." Sophia held me close and we looked out at

Photography by © Tina Paul 1989–2006 All Rights Reserved

the crowd of oblivious dancers. "Guess the Club Kids will have to grow up after all."

In 1996 Michael Alig was charged with first-degree manslaughter. He gained even more fame when James St James wrote his memoir, *Disco Bloodbath,* which became the film *Party Monster*. I made a cameo appearance. I figured since I hadn't aged one bit since those days, I might as well.

I did my best to avoid the details of the murder, so I didn't get the whole story until I sat down and watched the movie. Apparently, Angel came to Michael's apartment to collect a drug debt, and ended up getting physical with him. Another drugged-out Club Kid named Freeze saw this and

hit Angel over the head with a hammer, cracking his skull.

If Michael had just called the police after that happened, I think I could wrap my head around the whole thing. Instead, they hit Angel in the head a few more times, suffocated him, then kept him in the bathtub for more than a week, blockading the bathroom and hosting parties in the apartment until the smell was too much to take. Then Michael cut Angel up into pieces and threw him over the pier near 28th Street. I didn't sleep for a week after watching that movie. I regretted having anything to do with it.

In the aftermath of the murder, the Club Kids scattered to the wind. Jenny Talia got clean, Armen Ra became a world-famous thereminist, James St James rode high on the success of his book, Richie Rich started the massively successful fashion line Heatherette, Kenny Kenny continued to reign as the top doorman in NYC, and Sophia Lamar and I kept dancing together and moved forward with the next wave of New York nightlife. Despite all that, we're all connected forever, like sister wives.

In 2014 Michael was released from prison, moved to Brooklyn, and joined Instagram. I hear he's writing a book and selling some lithographs with my face on them.

I ran into Michael at a club a few months back. It felt like the twilight zone. Kids are dressing up again like they used to, and there I was, chatting with Michael Alig at a Kenny Kenny party, as though nothing ever happened. When I got home that night, I couldn't fall asleep. I stayed up all night hot-gluing crystals to a new dress, trying not to think about the awful things that had happened.

I wish Michael the best, and considering how smart I know he is, I'm sure he'll be fine. I do hope he is able to do something with his life now that he's been given another chance. Not everyone is so lucky.

Photography by © Tina Paul 1989–2006 All Rights Reserved

Chapter 9

ALL
ABOUT
EVE

Limelight and the Key closed down around the same time. They'd both more than run their course; it felt good to move on.

I was living with grungy blond Chris rent-free. But then he got hooked on heroin, like everyone else it seemed. Even that I could put up with, but one night he asked me for some cash, I said no, and he smacked me in the face.

I flipped the fuck out, yelling and screaming so loud, half the hotel came to see what was up. I mean, what an asshole, getting hooked on junk after he had been so critical of all the other people doing it, and then hitting me? In the face? Fuck that.

The hotel manager gave me my own room to move in to, if I would "only stop screaming." I accepted, and all the doormen helped me move my clothes, shoes, handbags, and makeup down two flights, while Chris locked himself in the bathroom.

It was weird at first, living in the same hotel where my now-ex worked. But I made the best of it. I got my revenge on Chris by parading my new boys in front of him. I'd come home from a club with some 6'5" baseball player, or one of the cast of *The Outsiders* that I briefly dated, go to the front desk, pull down my top, and let all my tips from that night fall out.

"Can you change this into larger bills?" I'd say, and dry hump my new guy as the ex counted through my titty money.

Richie Rich moved into the room next to mine, Armen Ra took the room on the other side, and Sophia started sleeping over most nights. We were like sorority sisters; we'd spend all day getting ready to go out all night.

There was a pay phone right outside my door, which one of us was always on. It had a long cord, which was perfect because you could pull it into your room with you when you were having a "private conversation."

The phone rang one day, and this guy asked for Armand.

"Nope, wrong number," I said.

"You're not Armand?"

"Do I sound like Armand? I'm a girl, asshole." I hung up, and Armen was staring at me.

"What was that?" he asked.

"Oh, they were looking for someone named Armand. That used to be my name."

"Amanda, that used to be my name too. They were probably looking for me."

"You mean we've been friends all this time and never knew we were born with the same first name?"

"Guess we could stand to spend some more time together. You should come work with me!"

Armen was managing the makeup department at Patricia Field's on Eighth Street, and he offered me a position doing eyebrows and makeovers. Sophia and I still danced at a lot of parties, like Twilo, a monstrous warehouse of a techno club in Chelsea, as well as Bowery Bar and Plaid in the East Village. It wasn't enough to cover the extra income I'd gotten from the Key. I did need a day job.

Patricia Field was the lead costume designer on *Sex and the City,* so everyone knew who she was. Her

store was an extension of the nightlife scene. Her best customers were club personalities who weren't afraid of a strong look. It seemed like a perfect fit.

When I went in for my interview, wearing a leopard-print halter top, black cigarette pants, and nude Manolo Blahnik pumps, the store was packed. Armen was busy with a client, but he pointed me toward the back office. I quietly knocked on the door.

"WHADDYA WANT?" I heard a gravelly voiced old man scream from inside.

I cracked open the door and whispered, "Sorry, sir, I'm looking for Patricia?"

The door yanked fully open, and there stood Patricia Field, with her trademark manic red hair, a cigarette hanging out of her mouth (and another one lit in her hand), and no makeup on her face. Not even eyeliner.

"Oh, uh, sorry, Patricia. Armen told me to come in about a makeup job?"

She looked me up and down. "CAN YOU DO MAKEUP?" She was screaming so loud I turned around to see if she was talking to someone on the other side of the store.

"Um, yeah. I went to beauty school."

"PROVE IT."

She slammed her office door behind her and walked to the makeup counter, trailing smoke. I followed, eyeing a quick escape. Armen watched us walk toward him and rushed his customer out of her chair, which Pat plopped down in.

"WELL? LET'S GO."

I looked over at Armen; he was dressed like a chic deco lesbian witch. "You got this," he said, and set his makeup brushes down in front of me.

I picked up a foundation, tested it on the back of my hand, and approached Pat, who was still smoking her cigarette.

I worked on her face, and Pat stopped yelling everything she said and started asking me about my life, where I'd come from, what clubs I worked at, who my friends were. By the time I was done, she'd smoked six cigarettes and was offering to let me borrow outfits from the store for my nights at Twilo. And she also gave me the job.

I was able to wear the same clothes I wore at nightclubs, but instead of five-inch heels I'd wear three-inchers. More practical. Sometimes I'd show up in gowns with fur pieces, and Pat just loved it. It was the perfect job for me. The whole place was covered in mirrors, so when I didn't have a client I could stare at myself.

Since my counter was by the front door, my coworkers acted like it was my job to be security.

Kids would steal from us all the time; our code word for them was "Jenny." So if you thought someone was stealing, you'd yell out, "Hey, Jenny is here!" and everyone knew to watch out.

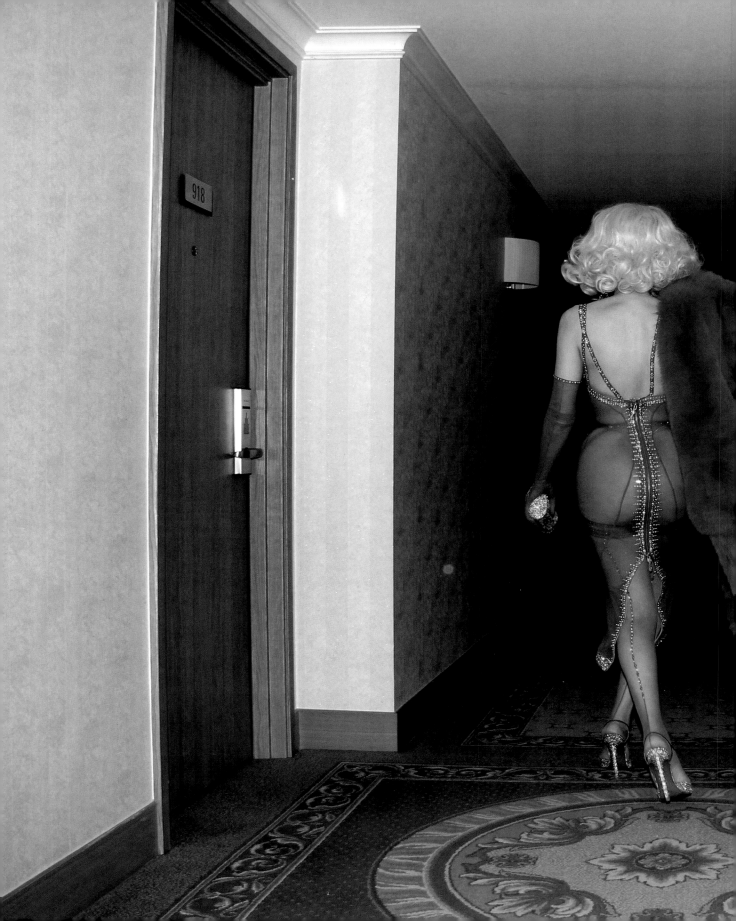

THE ART OF FLIRTATION

Flirting is an art form, not unlike origami, decoupage, and nipple torture.

STEP 1:
Eye Contact. So important. Pick out your guy, make direct eye contact, smile, then go about your business as though it never happened.

STEP 2:
Eye Contact. Double-check your work. If he doesn't pick up on it by now, he's not your guy. Move on.

STEP 3:
Make Your Presence Known. Laugh loudly at something your friend says. Make a sexually provocative body movement. The key is, make him look at you while you're preoccupied with something else.

STEP 4:
Expose and Ignore. Now that you have his attention, show him exactly where you want him to touch you. If you aced anatomy, I'm sure you'll have a few ideas. I suggest pulling your hair up to reveal the nape of your neck.

STEP 5:
Success! He walks over, leans in to say hello, and puts his hand on whatever spot you wanted him to. It always works!

Whenever I heard someone yell out about Jenny, I'd go hide in one of the closets. After I'd come out my coworkers would be all pissy with me. "Leave Amanda alone," Pat would say. "You know she lives in outer space."

Pat is a really special lady. She hired kids who couldn't get a job anywhere else—lots of transgender girls and homeless kids, people who had a hard time getting a start. She used to say she ran the only transsexual welfare system in the country. And she was right. Where else could a tranny get a job that didn't involve removing her clothes?

A lot of people think that I'm addicted to plastic surgery. But the truth is, if I'm addicted to anything, it's beauty. I suppose plastic surgery is part of that. My first psychiatrist said I was "body conscious." The reality is, the more work I put into my look, the more right I felt. The more loved I felt. Hormones, makeup, growing my nails, anything that increased my femininity. Even buying an eyelash curler gave me a sense of hope, happiness, and acceptance.

One day I was staring at myself in the mirror at work and noticed extra skin around my eyelids. I immediately made an appointment to see my surgeon.

Dr. Reinhorn and I talked about an eye lift. It was tricky; some girls had it done and looked uneven, and the procedure also leaves a scar on your forehead, which I did not want.

So I asked him if he could just cut along the line where I draw in my eyebrows; that way I would be able to trace the scars when I did my makeup. Two birds, one surgery. He thought it was a great idea and made a plan to take a triangle of skin out along with the muscle underneath, and lift my lids that way. In theory it would give me permanent Botox. The day of the surgery I drew my eyebrow line in blue Sharpie and told the doctor, "There's your scar."

It was an intense procedure and I was on a lot of pain pills, but the worst part was that I wasn't allowed to put makeup on my face for a full week after. Armen took care of me but I was driving him nuts; I was so high on pills I kept repeating myself, talking about the same nothing over and over.

After three days I'd had enough and needed to get out. Antony & the Johnsons were playing at Joe's Pub, and I really wanted to go, plus I wanted to see how lashes were going to look on my new lids.

Armen begged me, "Please don't fuck with the scars, it's too soon." But I didn't care. I put on a huge Farrah Fawcett–style wig that covered most of my forehead. Armen helped me do my makeup since I was too high to draw a straight line, and he also helped me into a black patent leather gown.

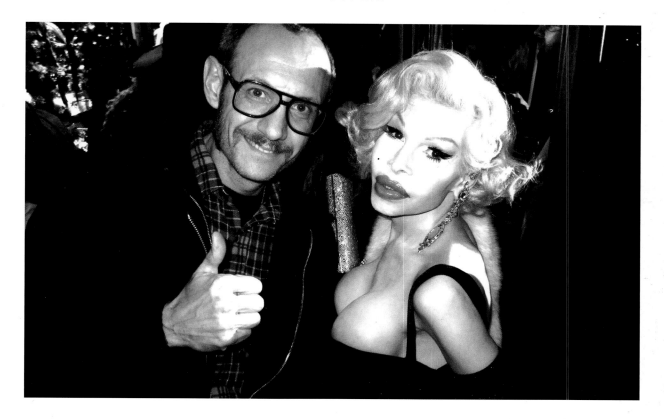

I didn't want to mess with the brow scars, so I left them exposed and taped pieces of black lace to my temples. It looked like my scars were part of the lace, rather than red gashes with little black stitched Xs.

Most people simply eyed my look, but when we saw Antony backstage, she got on her hands and knees to worship me. She said, "You're an even more extreme performance artist than Marina Abramović." It wasn't on purpose; I just really needed to get out.

A cute, dark Italian guy at the show started hitting on me. He seemed to know only three things to say in English: "Beautiful girl, beautiful hair, beautiful body." Isn't it always the case that you meet the cutest guys when you can't have sex? He was hitting on me like crazy, petting my hair and grabbing my ass, but I hadn't even pinned my wig on the right way, so I told him it wasn't going to happen. He kept begging me to bring him home, so I finally gave in and told him I was just getting over being sick so he had to be gentle with me.

First thing I did when we got to my place was turn the lights off and kick the wig head under the bed. We started fucking and he was very excited, loving it. Everything was going great until he pulled my hair, yanking the wig right off, so my scars were completely visible.

He turned white. "OH MY GOD, WHAT'S THAT? WHAT'S THAT?!" He was screaming. I told him to calm down, that I'd just had surgery, but he kept freaking out, his dick went down, and he ran out.

It was funny seeing a guy go from being in heaven to pure hell so quickly. I really should have pinned that wig.

I'd heard rumors about Sophia Lamar's life story, but she told me the whole thing one day during an aerobics class.

"I was in one of Castro's prison camps on my

fifteenth birthday," she nonchalantly said, as she jumped on and off a step, raising two-pound pink weights over her head.

"What for? What did you do?" I was out of breath, and not sure how serious she was.

"It was for reeducation, to turn me straight. I was lucky to get out of there. Some people were stuck there for most their lives." The other girls in class were giving us strange looks.

"How did you get out?"

"My mom was well connected."

Besides both of us being beautiful transsexuals, we had almost nothing in common, which helped us get

"Having a vagina doesn't make you a woman."

When we arrived at the club, it was just a typical dive bar. We walked in, me in a white corset and Sophia in red, and no one knew who we were. Patrons actually moved away from us, like we were diseased. We walked right back out and went back to our motel.

"It's so boring, to show up to these places with nothing to do," Sophia said as we lay in bed, filing our nails. "Maybe we should start coming up with an act. That way we could get hired as performers and make more money." We stayed up that night coming up with our plan.

Once back in New York, we went to the Abraca-

"DAVID LaCHAPELLE IS HERE, AND HE'S BEEN ASKING ABOUT YOU."

along well, like Jane Russell and Marilyn Monroe.

Club promoters all across the country wanted former Club Kids to host events with them, and Sophia and I used to travel together. We were hired by Camel Cigarettes to travel to Dallas for a party. They paid us a ton of money, way more than our usual rate.

On the plane ride there, Sophia told me she'd lived in Texas for some time. "My friend said to me, 'Americans will kill you if they find out you are a boy in a wig.' I was very careful; I wouldn't jump in a car with a stranger. Then one day a gorgeous long-haired boy asked if I needed a ride, and I said to myself, *He can kill me, I don't care.* He treated me so nice, I knew I would never have sex with a gay man again." That's when she decided to have a sex change.

"Sexuality is complex," she said. "I'm a woman when I'm in bed with a man, but otherwise I'm just Sophia."

"I'm just Amanda, but I'm definitely a woman."

dabra store on Twenty First Street. There was a cute guy at the counter.

"You have to teach us a magic trick," Sophia blurted out. No hello or anything. If I'm sugar and spice, Sophia is snips and snails.

I flirted with the guy (eye contact, touch and reveal) and told him what we were looking for. We didn't need anything too complicated, just something fun we could do on stage. It turned out he was a part-time clown and had lots of ideas.

"Maybe you could do something with balloons," he said.

I pulled out my tits and pinched my nipples. "Oh, I love balloons. What did you have in mind?"

My new clown friend showed me how to make a balloon dog and how to make it walk. Then he gave Sophia a top hat with a hidden compartment.

"We need a big finish," Sophia said.

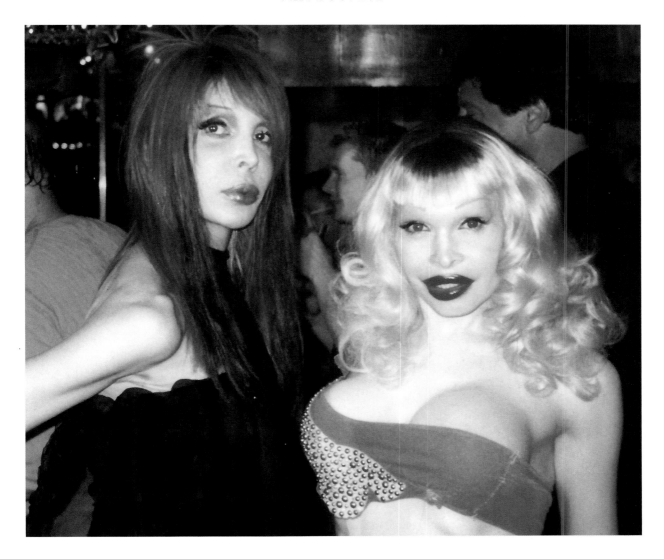

"You could do a paper coil and pull streamers out of your mouth. That's an easy one." The coil was a little plastic ball with tightly wound paper crammed inside. Sophia had a sinister grin on her face, which meant she had an idea.

I spent weeks getting my balloon animal down. I would pump and pump those balloons for a few hours every day until it was second nature. What's the point in doing something if you're not going to do it right?

The night of our magic premiere, Sophia and I showed up to a Susanne Bartsch party looking like magician's assistants just off a Parisian runway; red under-bust corsets, black bras, thigh-high fishnets with garter belts, black fishnet gloves, and top hats.

We walked on stage. I pulled out one of my pink balloons, blew it up real sexily, and tried to make my dog. It didn't work; I was too nervous, and my hands were shaking. My dog was disabled. I threw it down, winked to the audience, and picked out another balloon, this one yellow. The crowd was into it and super supportive, clapping and hollering, thank God.

This time my balloon dog was just right and I

STAGE
ENGAGEMENT

Find your light. I had a homing beacon implanted during my last eyelift that automatically takes me to the best light in any room. I suggest you do the same.

·

When you're lip-synching and you're not sure of the words, hold the microphone in front of your face so the audience can't see your lips moving. Bring your own handheld mic, just in case.

·

Never complain until you're rich and famous enough for people to listen. No one wants to hear it otherwise.

·

Confidence is contagious; you can't "fake" being confident. You have to create it.

·

Visuals are just as important as talent. Generally, even more so.

·

Work with people who know more than you do, always.

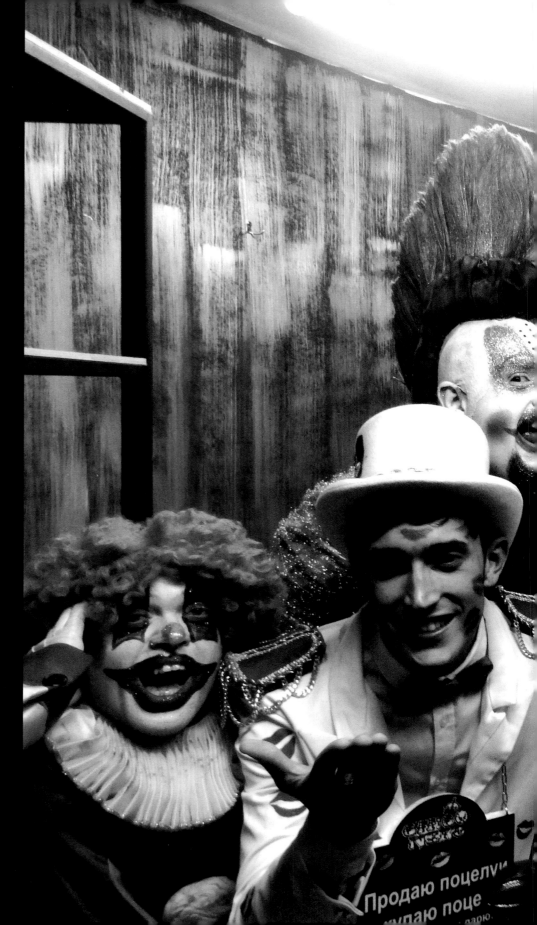

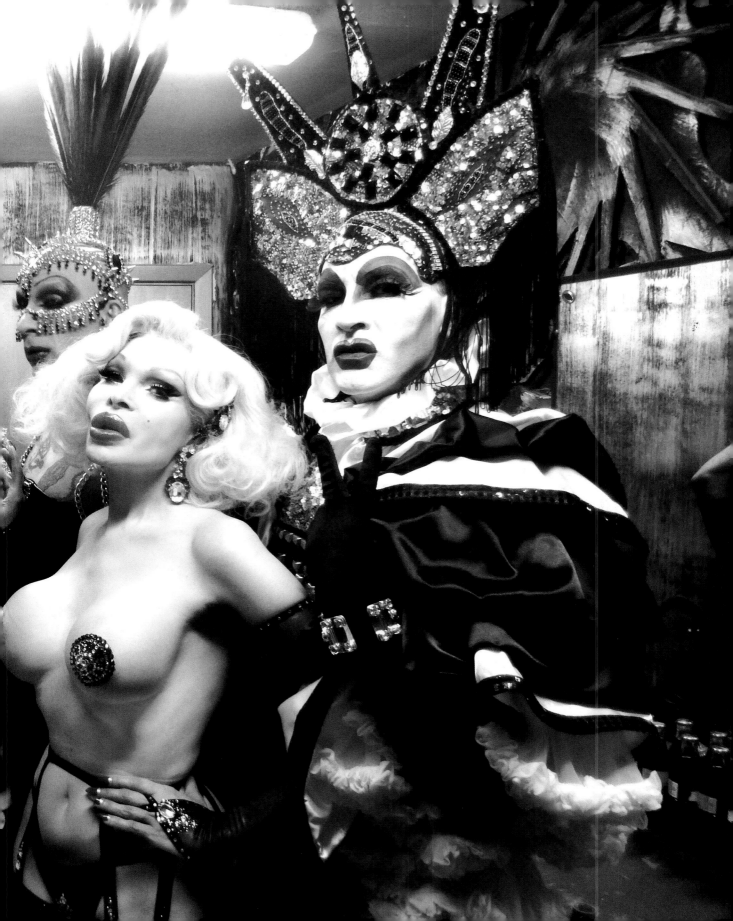

walked him across stage, letting people up front pet him. I picked up my yellow dog and squeezed him against my tits until he popped.

Sophia then did her trick, pulling a rabbit out of her top hat. The rabbit was plastic, but the audience didn't care. We looked great.

Afterward we did a "Let Me Entertain You" burlesque-style striptease. We peeled off our gloves, removed our bras, and snapped our panties off, exposing our pussies to thunderous applause.

Now it was time for the big finale: in perfect unison, we reached into our vaginas and tugged at the coiled string. Slowly, we pulled six feet of rainbow-colored coiled cloth out of our designer-made pussies.

The crowd went nuts, some guy bought my ribbon for $500, and we had a new act we could perform all over the country.

Sophia and I were hosting a party at Bowery Bar one night when Richie Rich came up to me. I hadn't seen him in weeks; he had been touring the world with a music single, modeling for Japanese beers, and working with Susanne Bartsch.

"David LaChapelle is here," he said, "and he's been asking about you." I looked around the room, trying to see him. David was the top photographer in the world. He'd just won Photographer of the Year at the VH1 Fashion Awards a few days before, and everyone was talking about him.

"What did he say?" I couldn't spot him anywhere. Sophia tapped me on the shoulder and gestured that she needed me.

"He said you looked intimidating and asked if you're a bitch or if you're nice." Richie was jumping up and down with excitement.

"What did you tell him?"

"I said you only had one mean bone in your body and you'd already had it removed."

Sophia gestured me toward some London kids who wanted to take a picture.

"What was that about?" Sophia asked as we posed.

"I'm not sure. I think David LaChapelle wants to meet me."

"What about me?" she asked. "You know I modeled for him once before. He's a tyrant, but he's the best."

I thanked the London kids for coming to our party and felt a big, manly hand fall on my shoulder. I turned around, and there he was.

"I think I *Weird Science*'d you into existence," David LaChapelle said in my ear. He was a hunk of a man—muscular, broad—and he smelled great.

"That would've been nice," I cooed. "And a lot easier on my body."

"Can I buy you a drink, Miss Hollywood?" he asked. Goose bumps covered my body. No one had called me that since Mom died.

I looked at Sophia, as though for permission. She seemed pissed but tried to play it cool. I said, "Okay," and went to sit down with him at a table on the outside patio.

I was nervous, and so caught off guard that I didn't know what to say. Luckily it didn't matter. David liked to talk.

"I worked the VIP room at Studio 54 when I was a teenager," he told me, "hanging out with Truman Capote, Liza Minnelli, and Bruce Jenner."

"What about high school?" I asked. We talked close, like lovers, the patio lights setting a romantic scene.

"I'd take the train in from Connecticut, then my dad would meet me at the train station in the morning. He'd take back the train pass from me and head in to work. If my eyes were too bloodshot, he'd tell me to go home. But if I looked half decent, he'd tell me to go to school."

Just like for me, high school had very little to offer David. On the rare occasion that he did show up, still wearing his disco attire from the night before, he would sit at his desk and fill his books with drawings of

Amanda Doodle, 1978 © David LaChapelle

a woman. The woman was all enormous cheekbones, eyelashes right off the eye, giant lips, and *gianter* hair. Her body was an hourglass, and her tits were always out. He'd draw this woman in every position, over and over, to the point where it became like his signature.

One day his teacher confiscated his book and asked him, "Why are you drawing this drag queen?" But it wasn't a drag queen; it was me.

"So you see, Miss Hollywood, I conjured you into existence."

"Why do you keep calling me that? My mom used to say that when I was a kid."

"I don't know," he said, and laughed. "Sounds like fate, doesn't it?"

The rest of the club had receded and Sophia was long gone, but we kept talking. He told me he had seen me around for a while but was always too intimidated to talk to me. Because my look was so severe, he assumed I was another bitchy party queen.

"I don't spend this much time looking beautiful just to ruin it with an ugly personality," I said. "I have no room in my life for rudeness."

"I guess that's the biggest difference between you and Sophia," he said, laughing.

"Oh, Sophia's not bad. She's tough but she's got a good heart."

As the bar was closing down and the overhead lights came on, David took my number, kissed me good-bye, and said I'd be hearing from him.

After he left, Richie came to get the gossip from me. I told him David was very nice and that I thought we'd become friends.

"Listen, space cadet," Richie said. "That man is going to make you famous."

"Don't be silly." I gathered my coat and purse and stepped into the bathroom. There were dozens of tea light candles lit. I left the fluorescent overhead off and let the excitement course through me.

I looked at myself in the mirror and thought about Mom, and what she would think of the woman I had become.

"I miss you, Mom," I said, and blew out all the candles.

"*I hate everyone but Amanda Lepore.*"

—MILEY CYRUS

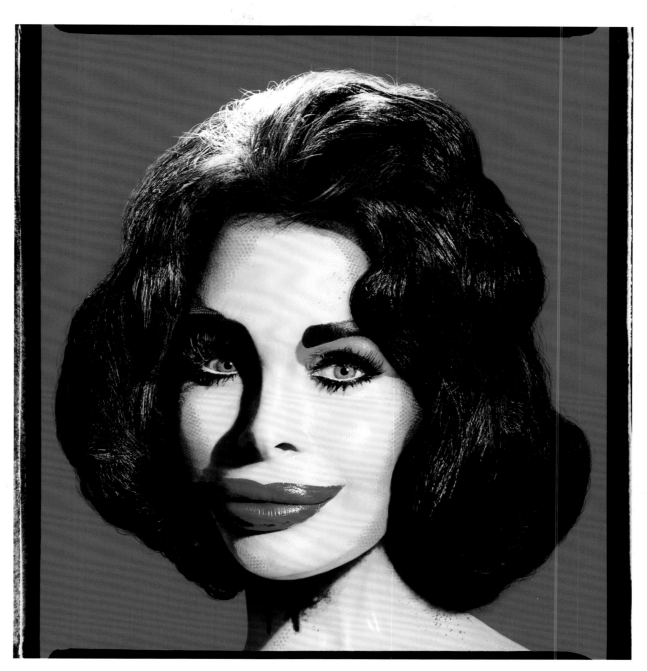

My Own Liz, 2007 Chromogenic Print © David LaChapelle

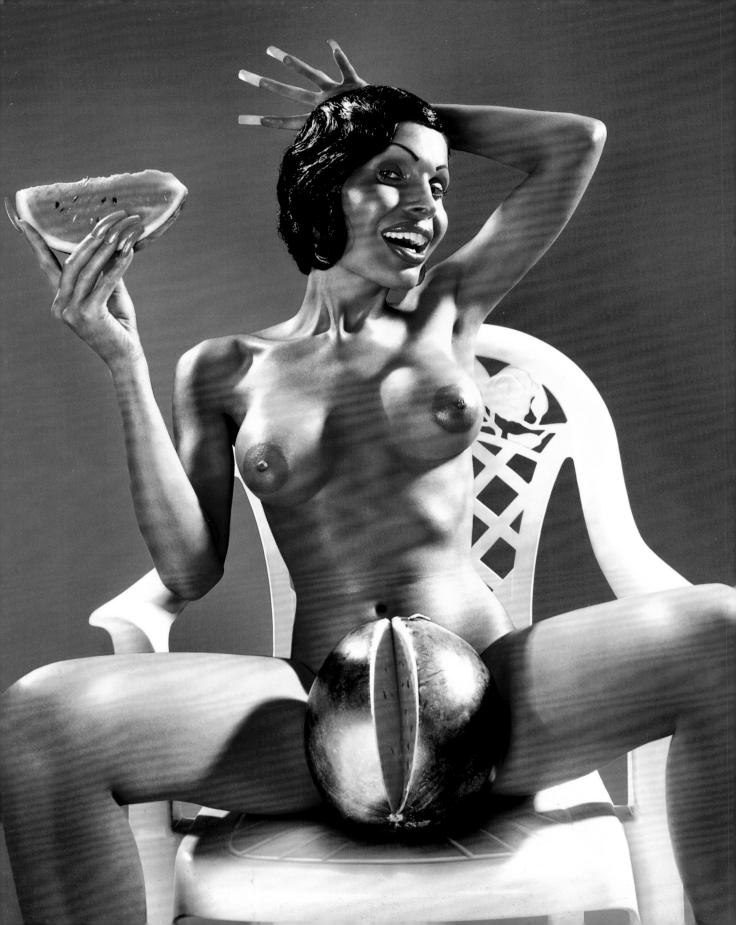

THE PRINCE AND THE SHOWGIRL

The next day I woke to the hallway phone ringing, and Richie Rich banging on my door. "It's him!" Richie was yelling. "Mandy, honey, get up! It's him!"

"Who? Michael?"

"Don't be so morbid! It's *LaChapelle!* It's your *future!*"

Indeed it was David's studio manager, Luis Nunez, calling to arrange a photo shoot with me at their Alphabet City studio that weekend. Richie was choking himself with the phone cord as I took down the details.

"What do they want you to *wear?*" he screamed when I hung up the phone.

"They didn't say."

"That probably means you'll be naked. Better stop eating now, girl."

"Oh, like I ever eat." I went inside and threw away the single strawberry I had been saving for breakfast.

Modeling had never really occurred to me. I don't have a model's measurements; I'm short and I'm curvy, with big tits and hips. My last boyfriend was Puerto Rican and obsessed with me having a big ass. I'd gotten the tiniest bit of silicone put in there—just enough to give it some pop. I loved it, and wanted to get more, but that's not what models were supposed to look like. Sophia was the model—tall, skinny, and moldable. I'd already molded myself into exactly what I wanted.

Never one to examine a gift horse's teeth, I showed up on time to my photo shoot. The studio was big—three stories—with colored glass windows. Luis, who was David's right-hand man, gave me a tour. Upstairs was a gothic-styled bedroom, "where," Luis told me, "David sleeps when things are busy." The room looked well lived-in.

The main floor was split into five separate, fully designed sets that we'd be using that weekend. David was running frantically between them, putting finishing touches on, moving lights around, and barking orders about the background colors and how the set pieces should be angled. He waved at me and yelled out, "Amanda! I'm sorry, I have one hundred thoughts in my head right now and if I stop I'll lose them all!" He didn't look up while he said any of this. "Go to hair and makeup and I'll be down in a minute to say hi!"

The basement had a makeup and hair station, and a large hangout room.

"Luis, I already did my makeup."

"We'll just do a light touch up," he said. "David likes everything a specific way. He's been working as a photographer since he was sixteen, taking photos for *Interview* magazine." Luis applied a thick layer of foundation as he told me this. "His work is meticulous, his sets are planned to the smallest detail. Nowadays people just Photoshop a background, but David makes a picture look like it was computer generated even though it is barely retouched. He is a genius in the truest sense."

"Does he pay you to say this, or what?" I asked.

Luis laughed. "You'll see what I mean soon enough." He applied another layer of foundation. I usually wear a very light foundation or tinted moisturizer, but this foundation was no joke.

David came down, unnecessarily apologetic and

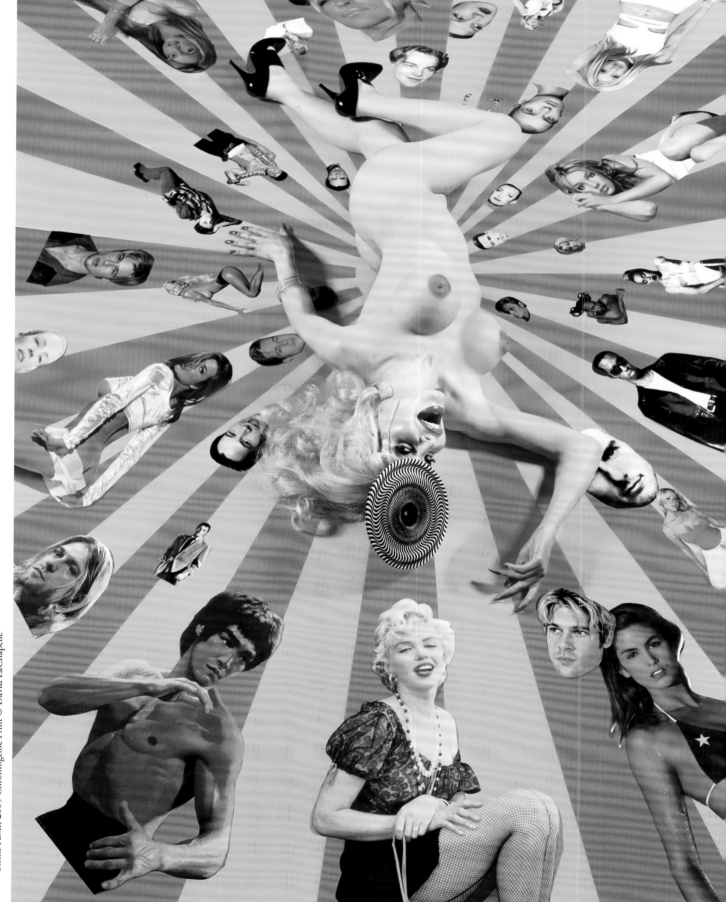

Useless Fame, 2005 Chromogenic Print © David LaChapelle

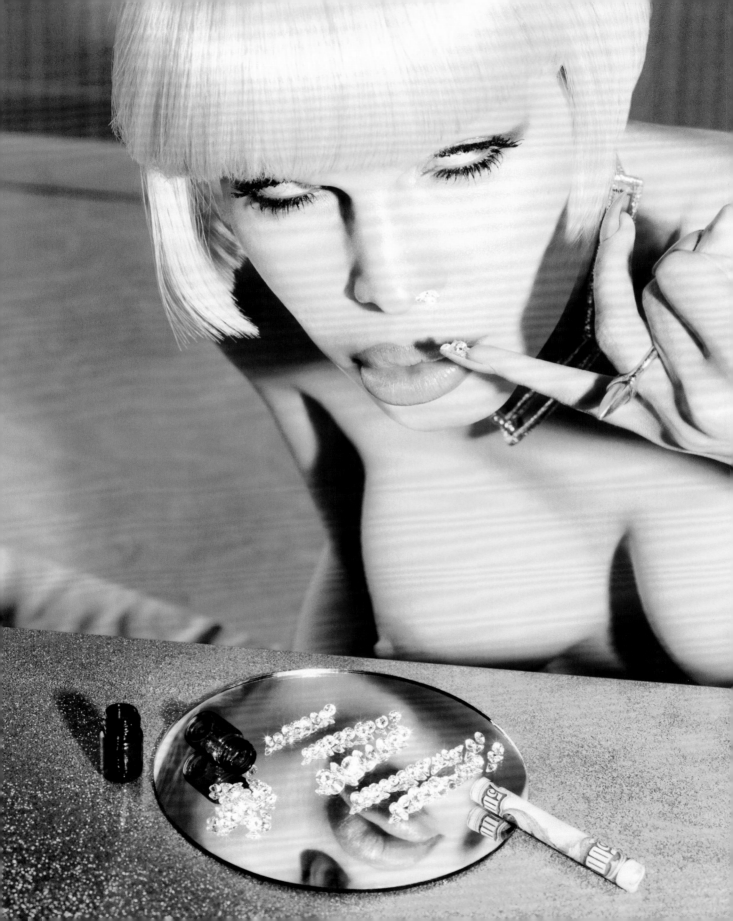

full of energy and excited to work with me, as though I was doing him a huge favor.

I got real quiet and shy.

"I'll do whatever you say," I told him. "This is a once-in-a-lifetime thing."

"Be careful telling me you'll do what I say. You might end up regretting it."

The first shoot we did was for *Visionaire*'s Diamond Issue. The idea was to portray an addiction to material possessions. It remains among my favorite photos David has ever taken of me, even though I think it looks nothing like me. There was no color on my eyelids and the lip color he had me wear was nude. My hair was straight and plain. It was a very

I wasn't sure what to do. Nobody told me anything, and David had run out already to work on another set. I didn't want to move; they'd spent a long time setting up the exact angles of all the lights, I didn't want to mess up anything. I was told to sit there with my finger on my nose, and I didn't plan on moving again until I was told otherwise.

Half an hour later, everyone came back with the new gold foam board and I was still sitting there, my finger to my nose, in the same position they had left me in. The lights came back on. David saw me still posed the way he had left me and yelled out, "This bitch is my girl!" Everyone on staff started clapping and hollering.

I was a much better model than I thought I would be. All those years of being what my mother needed, my marriage to Michael, followed by the scripted

HE BEGAN TELLING THE MEDIA THAT AMANDA LEPORE WAS HIS "MUSE."

big deal for me to let someone else control my look, after I'd spent so many years cultivating it, but that's what modeling is all about.

David set up a metallic blue table that was really just a piece of spray-painted foam board. On it he placed a circular mirror, a cocaine vial, a rolled-up bill, and diamonds lined up, as though they were a line of coke. He glued one of the diamonds to my nail and told me to position my finger as though I were about to snort it. I suggested gluing one to the inside of my nose, which David loved.

He shot several photos and then decided the blue table wasn't right. A gold table would look better with my skin tone. So the whole crew got up and left to get the new prop piece. The lights went out and the lighting guys left too.

interactions at the Key had taught me how to take direction and understand what people want. David would give me a direction and I would instinctively know exactly what to do. It was exhilarating. It also helped that I needed very little retouching. David says I've probably saved him a small fortune because he doesn't have to retouch me.

David is a perfectionist, and his setups and shoots take many long hours. When the bright lights went out, the music stopped (he'd played Whitney Houston's "I'm Every Woman" on repeat the entire day), and the adrenaline rush of the day started to float away, I pulled the diamond out of my nose and threw it behind me, happy to have it off my face. There was a loud gasp from everyone in the room.

"That was a real diamond!" Luis screamed. There

was a mad dash as everyone started searching for it. I thought it was only a rhinestone, but *Visionaire* had loaned real diamonds for the shoot. I couldn't believe they'd let me glue a real diamond inside my nose. Were these people nuts?

David handed me a glass of champagne and we clinked glasses and laughed while his staff frantically searched on their hands and knees for a diamond that had been in my nose.

"THAT WAS A REAL DIAMOND!"

That same weekend we did a plastic surgery photo shoot where a black model and a white one switched heads. We also did a photo of me with a crying baby.

I knew as we were shooting that the photos were going to be special, but I was still surprised and proud when they were published in various magazines. All my coworkers at Pat Field's were gagging, customers were asking for autographs, and everyone I knew was congratulating me . . . except Sophia.

"Tell him I'm the model," she said. "He needs to use both of us together."

"Oh, he asked about you the whole time," I lied. "If I see him again I'll tell him, but we did a lot of photos. I'm sure he's done with me."

Little did I know that David had other ideas. He began telling the media that Amanda Lepore was his "muse." He wanted me to be in as many photos as he could fit me into.

This really incensed Sophia. David had used her in a photo shoot before but had never called her a muse. I got him to use her for a few shoots, but she insisted I tell David he had to use her more often. What was I supposed to do? Every time I worked with him I was

sure it would be the last time. I couldn't start making demands for him to work with my friends.

"If you don't ask him, then I will," Sophia said. I hated when she got like this.

One night Sophia saw David in a bar and asked why he didn't use her instead of me.

"Amanda's got the look I want," he said.

"I'm a tranny too, you know. Just use me."

"I could give two shits that Amanda is a tranny."

Sophia didn't like that. She threw her glass on the floor and stormed out.

Shortly after I started working with David, Luis died suddenly and unexpectedly.

He was the most dependable, hardworking employee David ever had. The first two years Luis worked for David, he worked for no money. For payment, David let Luis live with him, rent-free. Luis didn't care; he always believed in David's work and knew it would be only a matter of time before LaChapelle Studio became a success. He didn't need the limelight, like so many of us do.

True to form, Luis had a heart attack in David's studio. He was so young, only thirty-four, and we were all shocked and devastated, but no one more than David. Luis was not only running LaChapelle Studio, he was David's closest friend.

David stopped coming to work, or even taking calls. When I did get him on the phone, I could sense something was deeply wrong. He was disconnected, like his brain had been broken. I thought about Mom, and about Michael Alig.

I showed up to David's room at the Mercer Hotel. I didn't have a plan; I just figured he could use the company. Most people don't know how to talk to

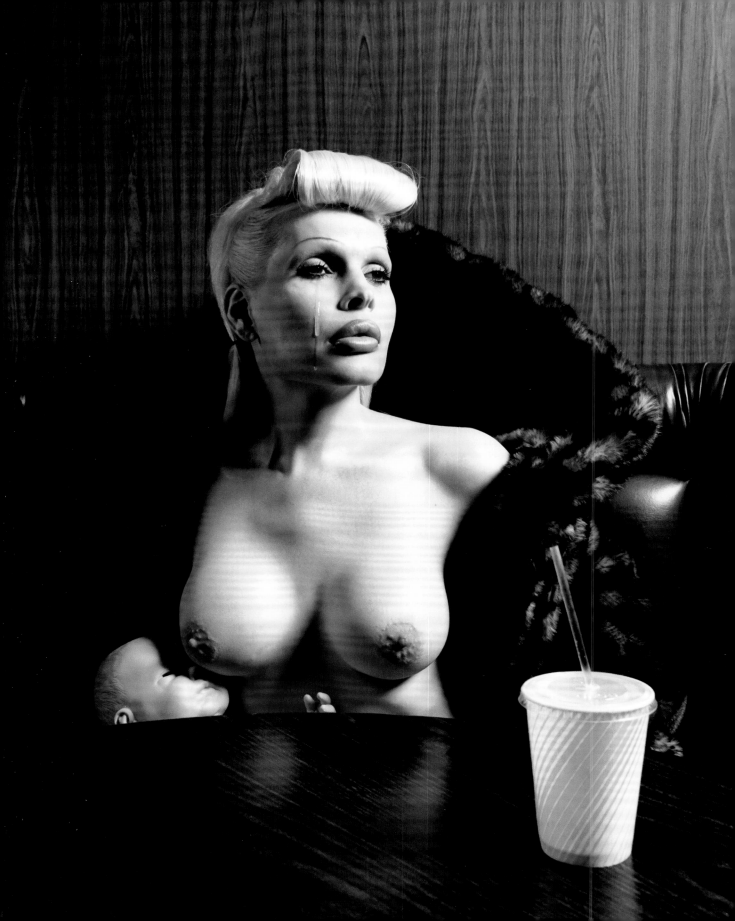

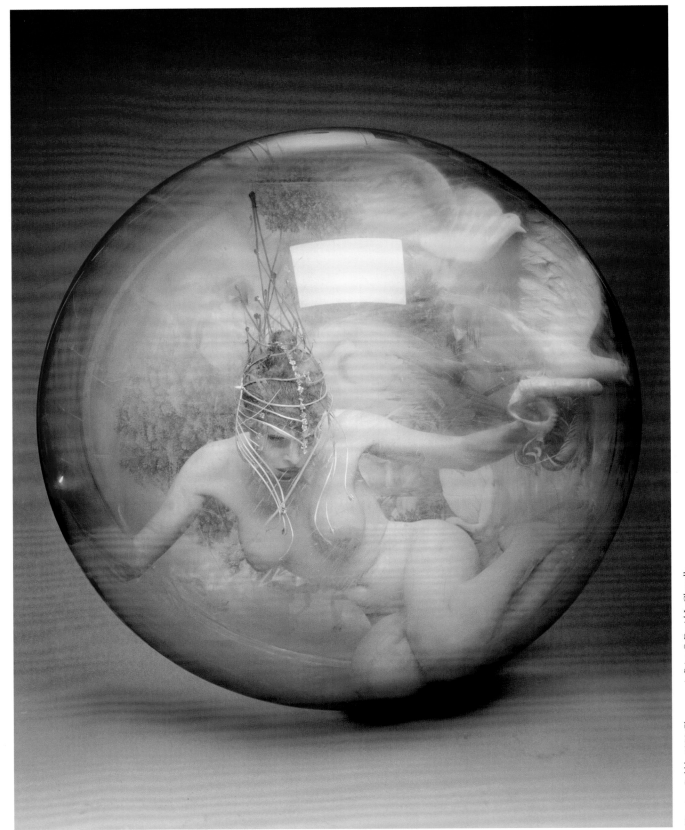

Time in a Bubble, 1998 Chromogenic Print © David LaChapelle

someone who is unwell, but it's something of a specialty for me.

When David opened the door I could tell right away he would be going off the deep end very shortly. His hair was standing straight up, his eyes were glazed and unfocused, and he was more jittery than usual.

He smiled when he saw me. "What are you doing here?" he asked, and started crying. I hugged him, and he held him tighter than any man has ever held me in my life.

We didn't talk about Luis, just watched television and bullshitted. Nothing serious. We ordered shrimp cocktails from room service and every time I took a bite he'd laugh and say, "You're eating MORE?" At night I went home, and in the morning I came back and sat with him all day again.

I quit Patricia Field's. It seemed like I could be sitting with David for a long time, and I wanted to keep my days free. I packed a bag and started spending nights with him as well. It was fun, like a slumber party.

"I sleep naked," he said.

"Oh please," I told him. "You wouldn't know what to do with a pussy anyway."

"I'm just glad I don't have one, I know I'd make an ugly girl. I'd be so jealous of you because you're so pretty."

"You're not the first gay guy to tell me that," I said.

I think a lot of gay guys dream of being women. Doesn't mean they're transgender, though.

"Let's do a makeover," I said. He let me beat his face with the same foundation he was always making me wear. When he looked in the mirror he was shocked. "Now you know what it's like to give over your look to someone else," I said.

After a week he started to look better, but we still hadn't talked about Luis. He needed a nudge.

"I've never told you about my mom," I said. He looked at me, scared of where this was going.

I told him everything. *Everything.* Things I'd never told anyone until I started writing this book. About Mom's illness and how I took care of her, and the

guilt I held inside me for abandoning her when she needed me most.

"If I hadn't worried so much about myself, I could have taken better care of her. She'd still be alive," I told David. He was crying; we both were.

"Ever since then, I've just been running on autopilot, distracting myself with wild parties so I don't have to think about how much I loved her and how much I miss her."

"You still miss her?" he asked.

"Sure. But it's different now, because I know she's here with me. Like a guardian angel. I think she was there the night I met you. Luis will be there for you too. He loved you so much, he will always watch out for you and make sure you live up to your potential."

I wasn't just telling David this; I was telling myself. I had gotten so used to playing a part: the supportive child, the sexual goddess, the good-time party girl, the flawless model. I had never gotten to know who I really was.

We spent the rest of the night remembering Luis, laughing and crying together. Once he opened up, David started to feel better, and he seemed to be ready to get back to society. He had *L-U-I-S* tattooed on the knuckles of his right hand, to honor his right-hand man. Then he got back to work.

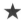

I thought I was going to have a nervous breakdown during the shoot for *Time in a Bubble*. Seriously. I was naked in a big bubble that was hung from the ceiling. The headpiece I was wearing was really heavy; it felt like a table. I had to sit completely still for hours, holding on to a giant dildo. The worst part was every time I exhaled it would fog up the bubble and they'd have to wipe it down. I had to hold my breath as long as I could.

When we finished, my entire body hurt. "That was more painful than my sex change," I said. I meant it.

Richie Rich was building a name for himself as a fantastic fashion designer.

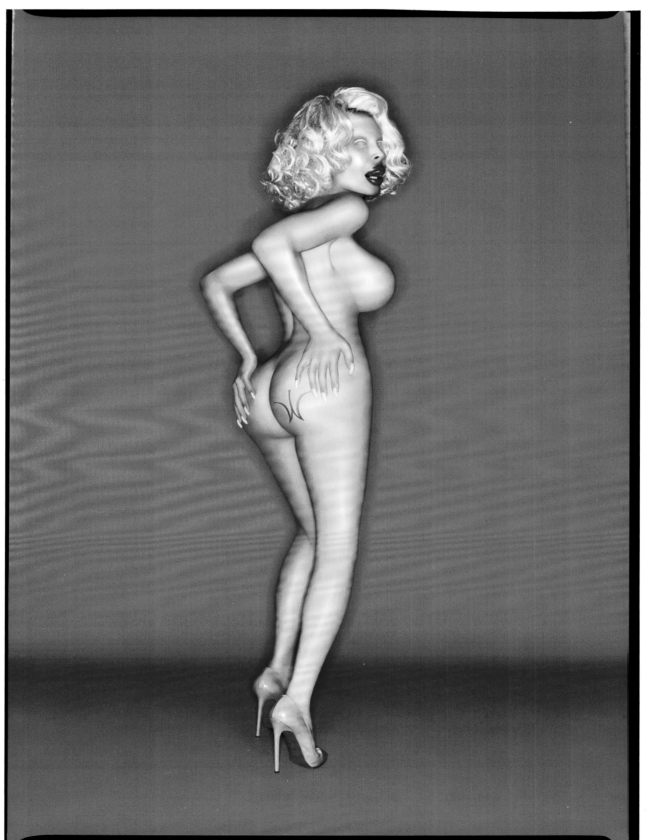

Untitled: (Picture of Jason Wu's Amanda Doll Full Back), 2005 Chromogenic Print © David LaChapelle

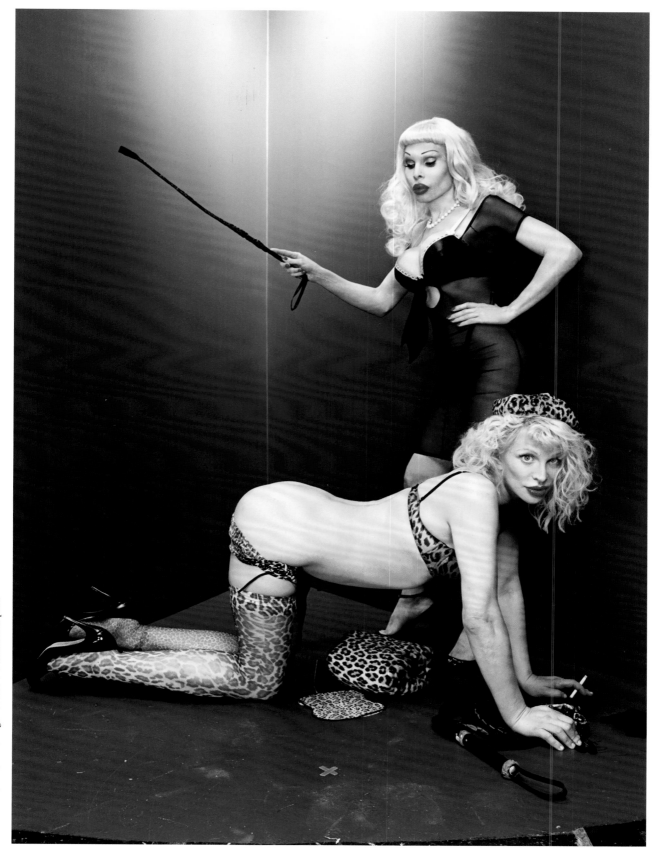

Charm School, 2003 Chromogenic Print © David LaChapelle

His personal style was so eye-catching; he'd taken the best of what the Club Kids did and put a high-fashion twist on it. Eight parts glam, two parts rock. Shake the hell out of it and add a few feathers, and you got Richie and his friend Traver's fashion line, Heatherette. Very East Village meets Bergdorf's.

Richie started making these T-shirts for celebrities he'd meet on his travels. He'd stencil their name, then hand paint, glitter, and Swarovski crystal the piece. Foxy Brown, Gwen Stefani, and the Backstreet Boys all ended up wearing those shirts. Pat Field even asked Richie to make a T-shirt that said CARRIE, for Sarah Jessica Parker to wear.

I introduced David to Richie and Traver and said he should keep them on set, they were great at making magic out of nothing.

"Karolina Kurkova will be here tomorrow for a *Vanity Fair* shoot," David said. "Make a dress for her to wear and we'll see how it looks." This was a big deal; Karolina had just been on the cover of *Vogue* and she was only seventeen. Richie and Traver stayed up all night making a signature dress out of purple fishnet and torn silk stenciled with the words LOOK AT ME.

The next morning Richie and Traver were waiting, dress in hand, when David and I arrived at the studio. David looked disgusted. He threw up his hands and yelled, "Go back to your studio and get all your supplies, stencils, fabrics . . . and come back here. I have a few shoots I want you on today. This dress is fucking fantastic." He was tricky like that.

That day Heatherette styled Steven Tyler and Mariah Carey. While they were styling Mariah, Pat Field called and said the Carrie shirt would be part of the season two ad campaign for *Sex and the City*. It was magical, seeing how things come together like that.

Afterward Heatherette was on David's set even more than I was. We were like a big happy family, like Andy Warhol's Factory, just as David had always wanted.

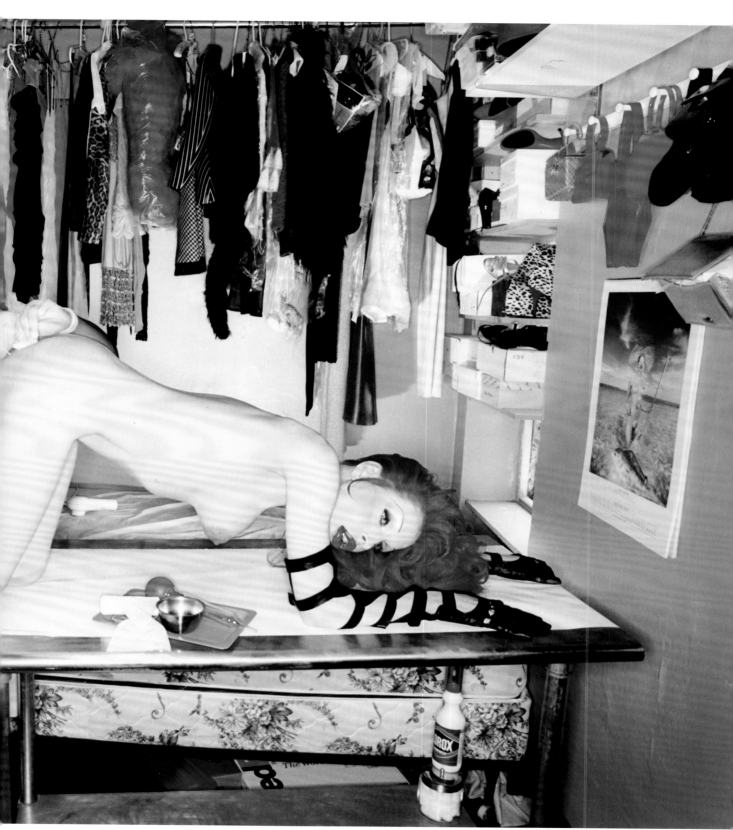

Silicone Injection in Amanda's Apartment, 1998 Chromogenic Print © David LaChapelle

I was always curvy.

It wasn't the "in" look, but it was my look. Then Jennifer Lopez came around and big asses became the big thing. Sophia thought I was crazy, but I started finding out about how I could enhance my shape even more.

I won't mince words: I became obsessed with achieving an hourglass figure. It's all I could talk about. I was driving Sophia and David nuts.

"Just get it done already," Sophia said. "If I have to hear you talking about it anymore I'm going to throw myself into traffic."

There were a lot of shitty silicone jobs out there, and the only thing worse than not doing it at all would be doing it wrong. At a party one night I met a girl who had a fantastic shape, exactly what I was looking for. I asked what she had done, and she told me about a woman who ran a private practice. I begged for the number and immediately called for a consultation.

The appointment was at a residence in Harlem with a nurse named Kimmy. I was nervous going in. There's a lot that can go wrong when you start playing with body shape, but I'd seen what this woman could do, and I had to find out more.

I recognized Kimmy as soon as I saw her; she had worked for Dr. Reinhorn. In fact, she was the nurse who had shown me how to dilate my pussy.

We hugged and made small talk, she asked me how my pussy was and I said good. She told me Dr. Reinhorn had passed away, and a lot of his patients had been coming to see her directly. It was shocking to hear; Dr. Reinhorn had been such an important part of my life. But he was an old man, so it wasn't out of nowhere or anything.

Seeing Nurse Kimmy felt like fate and I immediately trusted her.

The first thing she told me was we could only use top-of-the-line silicone. Then she said it would take a long time; girls made the mistake of doing too much at one time, and that made it come out uneven. We made a plan for me to go once a month and do a small amount in my hips one month, and a small amount in my ass the next.

Everything was going great. I was really happy with the results and started to get even more attention from guys than ever before, but there was a problem with having my hips and butt enlarged: it made my boobs look smaller by comparison. I had one more breast enlargement, going up to a double D.

There was one more thing I needed to do to get the exact proportion I was looking for. My tits and ass were large, but I wanted the hourglass to be more extreme.

I had to have my ribs broken.

David was always supportive of my injections, but he was *not* happy about this one. He staged an intervention with Richie.

"Mandy, honey, honey," Richie said. "It's too much. You're taking it too far."

"I can't have you dying on me too," David said.

"Oh, boys, I'll be fine. They're going to remove my bottom two ribs, and I'll have them gold plated and sold at Christie's."

"It's illegal, you know," Richie said.

"Yes, that's why I'm going to Mexico. If Cher and Raquel Welch can do it, then so can I." (Those are rumors I'd heard; please don't sue, ladies!)

"You'll look like you're wearing a corset even when you're naked," David said. He was starting to get into it. I could see the wheels spinning in his head.

"Yes, that's exactly the point."

Sophia graciously volunteered to come to Mexico to take care of me while I healed.

"If you die," she said, "I'm getting all your shoes."

"Sophia, my feet are so tiny you could never fit into them."

People don't quite understand what the procedure is; they think you get a rib removed, but that's not it. At least that's not what I did. To have the rib removed, they have to cut you open, and it leaves a very large

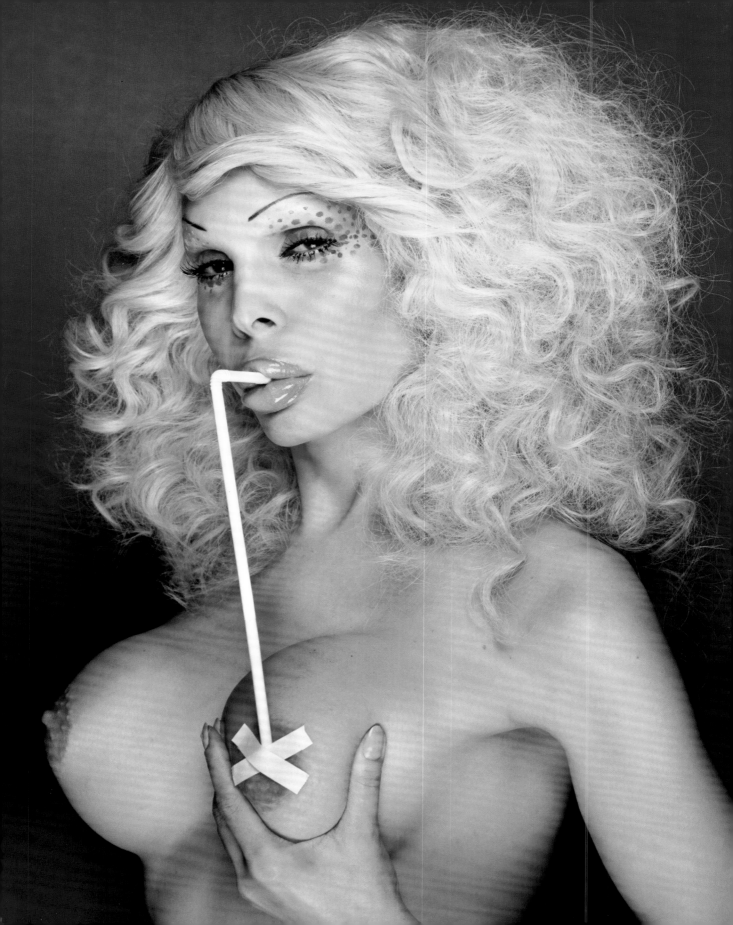

scar. They didn't cut me open at all. Your bottom two ribs are considered "floating ribs," they are only connected to your back, not to the front of the rib cage. If you corset train, you are pushing those ribs in to make your waist smaller.

My surgeon basically took a hammer, cracked the bottom ribs, and pushed them in, then put a cast over my midsection to hold them in place.

While he had me under, my surgeon also gave me a forehead reduction without even telling me he was going to. I woke up after the operation and couldn't understand why my face hurt so much. The nurse told me they gave me a lift and a hairline reduction, too.

Maybe other people would be pissed off about something like that, but I had to appreciate the fact that my doctor knew I'd be happy to save myself another trip down. And it looked great; it made my face heart-shaped and much more feminine.

The rib procedure was by far the most painful thing I've ever experienced. I wasn't even able to lie down afterward; while I was waiting to heal in Mexico, all I could do was walk around the doctor's parking lot with Sophia until I was tired, and then I'd fall asleep in a sitting position. I couldn't lie down for six months.

I left Mexico and headed back to New York, happy to have Sophia along to take care of me. My head was covered in sheer plastic held on with blue surgical tape. Large red gashes and black stitches were clearly visible. I had no makeup on, not even my eyebrows. My stomach was covered by an enormous belt. I looked like I'd gone to Mexico for a wrestling match, got the shit kicked out of me, and was wearing the title belt. The stewardess gasped when she saw me.

"Are you okay?"

"Yeah. Can I get a Diet Coke?" She seemed flustered and not sure what to do.

"Just get the poor girl a Diet Coke and stop gawking like a child," Sophia snapped.

David was waiting for me in New York. He was supposed to be at the MTV Video Music Awards that night but he wasn't feeling up to going.

"Just come stay with me," he said. "I'll take care of you, and we can watch the show together."

Walking into the Mercer Hotel, I knew what Frankenstein's monster must have felt like. Parents shielded their children, grown men fainted, women held up rosaries to ward me off. I was in such intense pain from my ribs that I didn't care at all.

David answered his hotel door holding a six-month-old baby. He'd given his award show tickets to a friend of his, who left her child to be watched by him. I took off my clothes to show him the training belt, and there was a knock on the door.

"Go answer it," he said. He handed me the baby and hid in the bathroom.

It was room service. I answered the door completely naked (except for heels), holding a newborn baby that was trying to breast-feed off me, with a sinister-looking corset belt, bandages around my head, and huge stitches across my face.

The poor old Dominican man almost fell backward, he was so freaked out. He handed me a bottle of water and went running down the hall.

David came out of the bathroom, laughing hysterically, and picked up the phone. "Yeah, hi, can you send me up a toothbrush?" Same thing, different guy at the door. Ten minutes later, "Yeah, hi, can I get some ice, please?" "Can we have chamomile tea?" He kept calling, and they kept sending different guys. They must have been down there like, "You have to see this."

We locked ourselves in that hotel room for a week. I heal really fast . . . alien fast. It's a miracle that with all the work I've had done I haven't had anything go wrong.

I still wear that cincher belt. I put it on when I'm

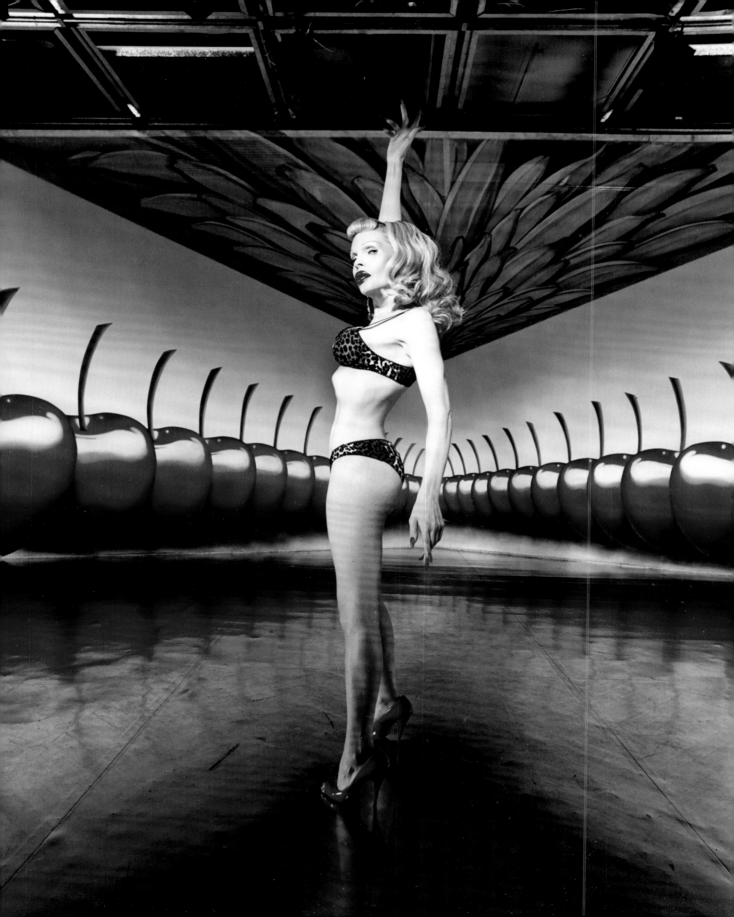

getting ready to go out. It sets the bone and makes it feel better. Before I would always get blisters when I wore corsets, and I don't get them anymore. My waist got smaller and smaller. For a while I was down to eighteen inches when I was completely naked, with no corset on. My body just stays like that.

I drove people crazy with my proportions after I did my ribs. So many other girls went to Mexico but the doctors are very particular about who can have it done. Supposedly you can't do it when you're older than twenty-six, but I was older than that and my doctor didn't know. And there are certain body types that it doesn't work on; it'll make you look bigger. So if you have a long torso, or if you're tall, it won't look right. You have to be short with a long stomach and a small rib cage.

The cinched-waist look isn't so popular in America, and it's gotten me a fair share of criticism. I have my own ideas about what beauty is. I look exactly the way I want to look.

Heatherette was doing their first fashion show since investors came on board, and MAC Cosmetics was partnering with them. They hired David to direct a video introduction for the show and he came up with this idea of having me paint my entire body with pink lipstick.

We went to Los Angeles for the shoot. My hair was yellow at the time and I hated it, but David told me I'd wear a blonde wig, so I didn't wash it or bring extensions or anything. But in typical LaChapelle fashion, when he saw me after makeup and in the turquoise room we shot in, he liked the yellow hair and wanted to use it. It was filthy, and I was upset. I didn't look good and did not want anyone seeing me like that.

"This is your big acting moment," David pleaded. "Charlize Theron is filming *Monster* right now and they made her look bad. This is your chance to do the same thing. Besides, your body looks great."

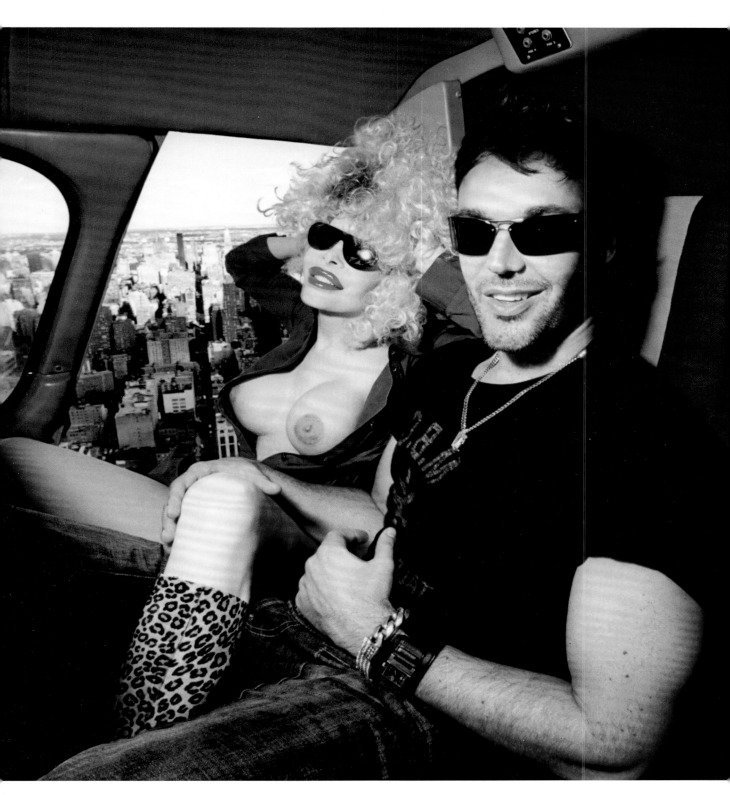

Publicity Portrait of David LaChapelle and Amanda Lepore in Helicopter, 2002 Published in *Complex Magazine*

All the guys on set agreed that my body looked hot. One of the lighting crew said, "I'll fuck you right now if it'll make you feel better." I said no, but it helped. I got on board.

When we started shooting I had to draw on my body with pink lipstick in an aggressive way. I started lightly, and after several minutes the tube was almost gone. Richie handed me another. "More, Amanda. Paint it like you mean it!" David screamed at me.

I tried to go faster and harder, but the lipsticks would break. "More!" David yelled. "More, MORE, MORE!" I was scared he was going to hit me. The lipstick would break and I'd just pretend I was still doing it, scraping the metal tubing against my skin until Richie handed me another one.

By the time I was done I had scratches all over my body. I cried as Richie helped clean me off; it didn't hurt, but I was scared I might scar.

That night I went to bed angry at David, but also angry at myself for getting so upset. I'd been given the chance to model. Who was I to give my photographer a hard time?

The next day we met at the Los Angeles studio and David and his assistants were packing bags.

"Where are we going?" I asked

"Yeah, aren't we done?" asked Richie.

"We're going to the desert," David said.

"Oh no. Do I have to be pink again?"

We drove halfway between Los Angeles and Las Vegas. I was painted pink and was not happy about it. David was pushing me to my breaking point.

It was dusk, and there was a sharp wind in the air. I was naked besides high heels and a layer of pink body paint. "What do I have to do?" I asked.

David handed me a Tiffany-blue suitcase. "Just run down the freeway." Cars were slowing down to gawk at me as they drove by.

I was about to cry. David could see the emotion on my face.

"Listen," he said to me. "You're Amanda Fucking Lepore. You can do anything. You've done everything. Just pretend your ex-husband is chasing after you, and get fucking moving. And don't cry, you'll fuck up your makeup."

I started running while an assistant slowly followed behind me in a station wagon. I was tired, my feet hurt, I was freezing, but I was in the zone. In my mind, Michael was in that car and I wasn't stopping until I'd gotten free.

A minivan drove by as I was running. As it passed me the driver rolled down his window and called out, "Are you okay, Miss? Do you need help?"

I didn't look at him. "I'M ACTING!" I screamed, and he drove off.

The next morning David had flowers sent to my room with a note: *Charlize has nothing on you. Love always, David.*

Sophia and I were both supposed to walk in the first Heatherette fashion show, but David told Richie not to put us in: "The brand will be more respected if you use professional runway models," he said. Richie agreed, and I wasn't mad about it; David was absolutely right. Besides, my video would be playing, so I'd still be in it in a way.

The day of the show, Richie and David came to my hotel. "Amanda, we had a great fucking idea. You're going to be in the show," David said.

"Oh, great! Sophia too?"

"Don't worry about Sophia, just get ready to go."

Nobody told me I had to be pink again until I was naked and the paint was already on the brushes. I should have seen it coming.

"It makes sense that you're here," Richie said as he painted me. "Heatherette wouldn't exist without you." We air-kissed. It was an exciting night; Paris Hilton was walking, and the New York fashion insiders had really come out in support of Heatherette.

DOLL PARTS

The lights went down, and our video started playing—me in my turquoise room, painting myself with lipstick like a crazy person. It wasn't as feminine as I'd have liked, but it was punk and I looked young.

The video changed, and there I was, running down the desert highway carrying my Tiffany-blue suitcase while Tiffany's "I Think We're Alone Now" played. As the video faded out, I ran out on the catwalk, carrying the same suitcase, wearing the same pink body paint, smiling and blowing kisses to the audience. The applause was thunderous and so vindicating. All the work had truly paid off. I sat down in the audience and watched the rest of the show.

All our lives changed after that. It was so exciting, being part of something that people had such a positive reaction to. There was only one problem: Sophia Lamar.

She showed up at my hotel the next day, out of breath and totally pissed, accusing me of stealing the spotlight. I was apologetic; Richie really should have told her I was going to be in the show. I kept saying, "I'm sorry, I'm sorry, I'm sorry," over and over, trying to calm her down, but nothing worked. She kept calling me a stupid whore and making fun of the way I looked.

I understood why she was upset, but I hate conflict. No matter what she said, I just apologized, hoping it would end.

"It should've been *me* in that video," she said. "*I'm* the model, *not* you." She left after her voice gave out, but went on to bad-mouth me all around town and to all our friends. New York ate it up with a spoon. People I'd never met before started having opinions about who was right and wrong in my "beef" with Sophia.

Our feud started to become notorious, and the gay magazines all talked about how much we hated each other. The whole thing was so silly, and I think Sophia mostly played into it to ruffle my feathers. If I was going to be the sweet one, then she had to play the bad girl, the ultimate fashion bitch. She created

- 170 -

Elegance Blasé, 2000 Chromogenic Print © David LaChapelle

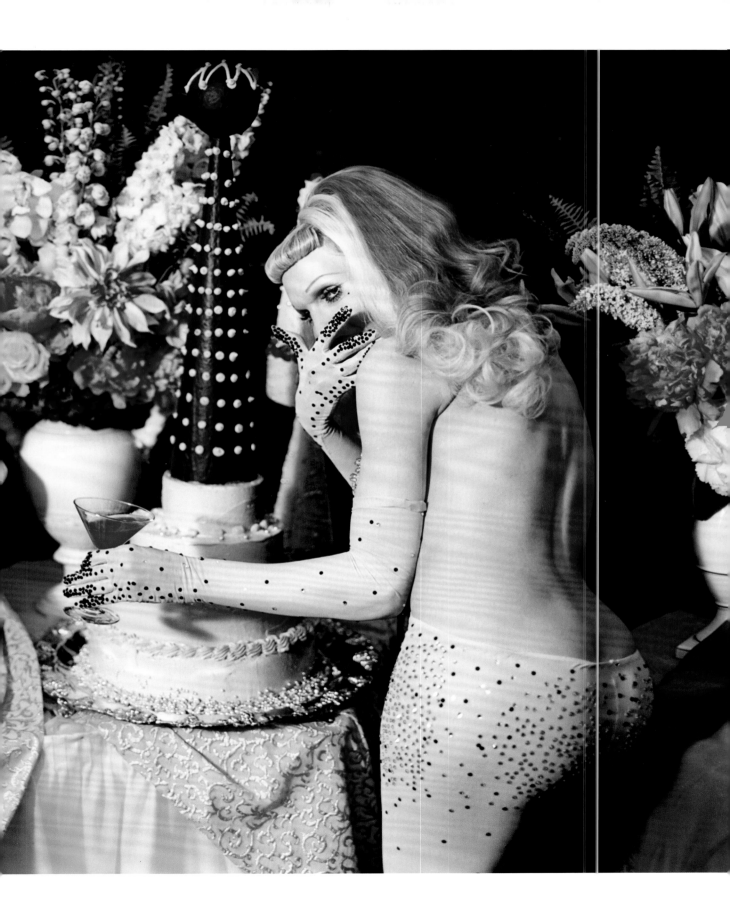

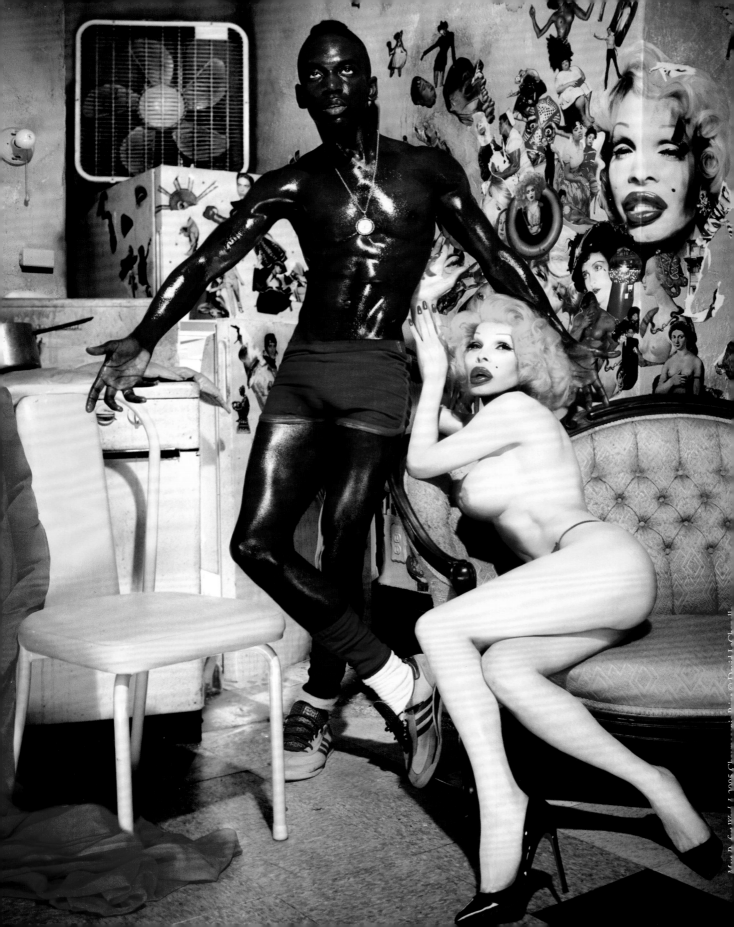

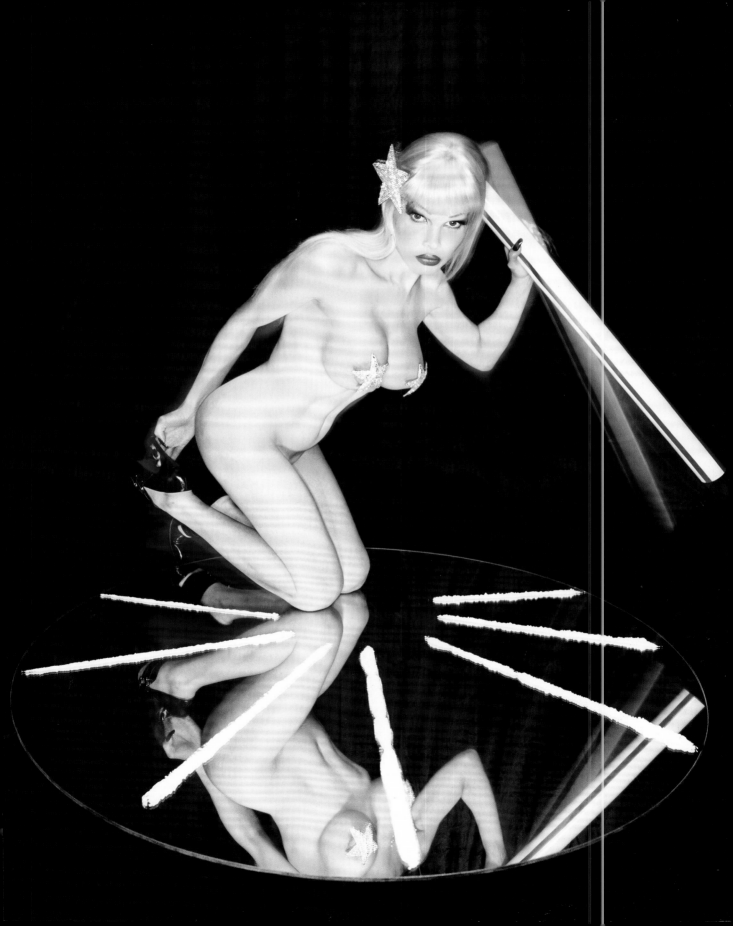

an entertaining story line, but every time I saw her in a club I'd beeline to the other side of the room.

She stopped talking to Richie too, which was sad because they had known each other in San Francisco, before either of them moved to New York. But Richie and I were too busy being on top of the world to worry so much about Sophia Lamar trying to knock us down.

Everyone wanted a piece of David, and he had an inability to say no to work back then; it was my job to help him find the fun in what he was doing. I loved it.

Marky Mark was just breaking into acting but was already a big deal, so his publicist was on set. This poor brunette had the job of keeping all the "funny shit" out of Mark's picture.

By this point I was showing up to David's studio every day, and he would try to throw me into whatever he was doing. Apparently the publicist had been warned that I'm always up for the funny shit because when she saw me she started freaking out.

David assured her she had nothing to worry about, that I was just dropping something off. Then he hid me in his upstairs bedroom and had a hairstylist put a ponytail on me that came down to my ass.

The brunette publicist stepped out to take a call (you never have to wait too long for a publicist to pick up a phone) and I came downstairs, walked up to wide-eyed Mark, and said, "Hi, Marky Mark. I'm Amanda. I like your outfit." He was dressed like a pizza delivery boy. I was in fishnets, a patent leather corset, and my tits were exposed. We shook hands and he blushed.

Production assistants lowered a heavy Lucite slab onto my back and we knocked out some great shots in less than five minutes. One of the PAs waited in the doorway, and when the publicist was heading back he yelled out, "That table has to get off the set." They lifted the slab and I returned to the bedroom for a quick change, while David and Marky Mark

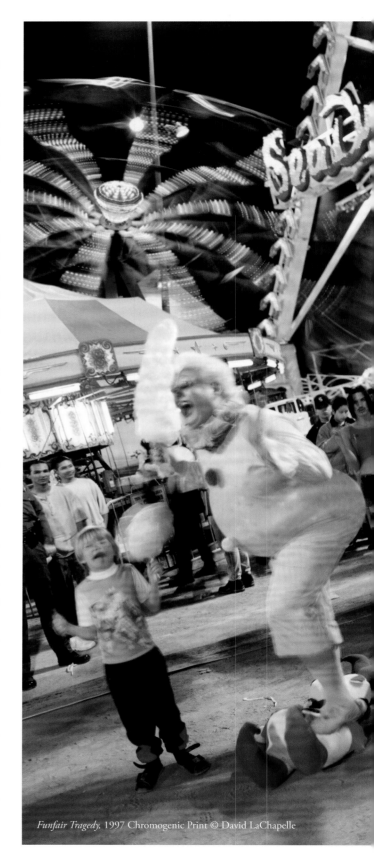

Funfair Tragedy, 1997 Chromogenic Print © David LaChapelle

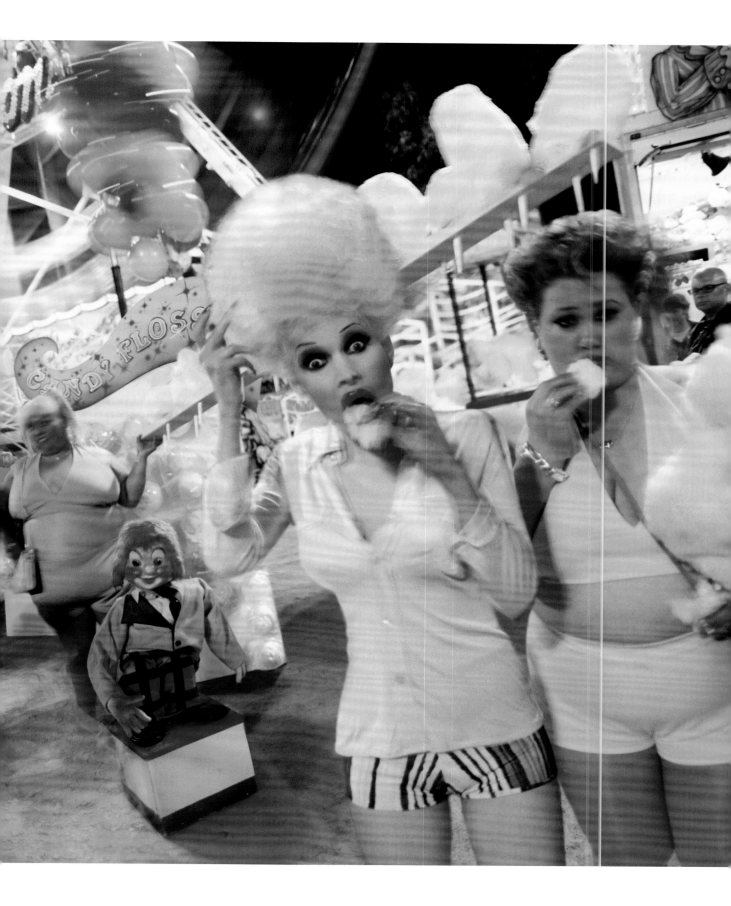

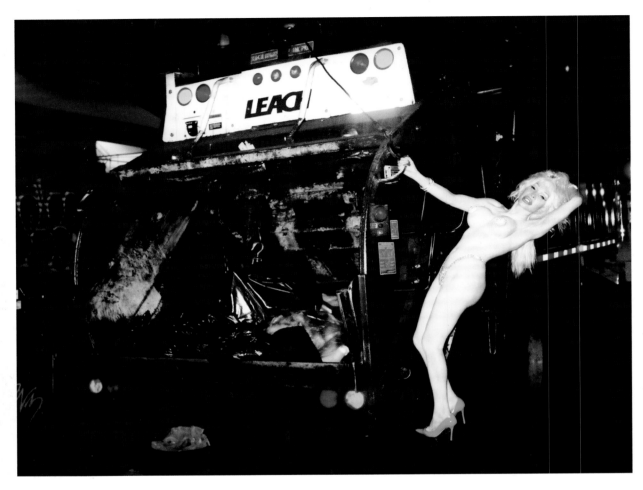

moved on to the next set. When the publicist went back outside for another call, I ran back down and we got our next shot in. As David positioned us, Mark said to me, "You know, I used to be a painter."

"Oh, that's great," I said.

"Maybe I could do your portrait?" I winked at him and held my position. David snapped away and I made another swift exit.

"Bye, Marky Mark, it was so nice meeting you," I said as I ran off.

He never painted me, but our photo came out great, don't you think? Mark was a sweet guy and he liked me, especially my boobs.

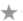

After I moved out of grungy Chris's hotel room, I tried not to take boys too seriously.

I did have this college boy named Ricky who moved in with me for a few years. He looked like a Spanish Johnny Depp. Dark black hair and very masculine—a great contrast with me, which I always love. I met him at Pat Field's and would see him around all the time but didn't take him seriously until I brought him home one day and saw his disturbingly large, uncut cock. He moved in soon after.

Ricky didn't like me going out naked and could be really possessive, like most men. I got him a job bartending at one of my weekly parties, which was a great gig—those bartenders made a ton of money—but he

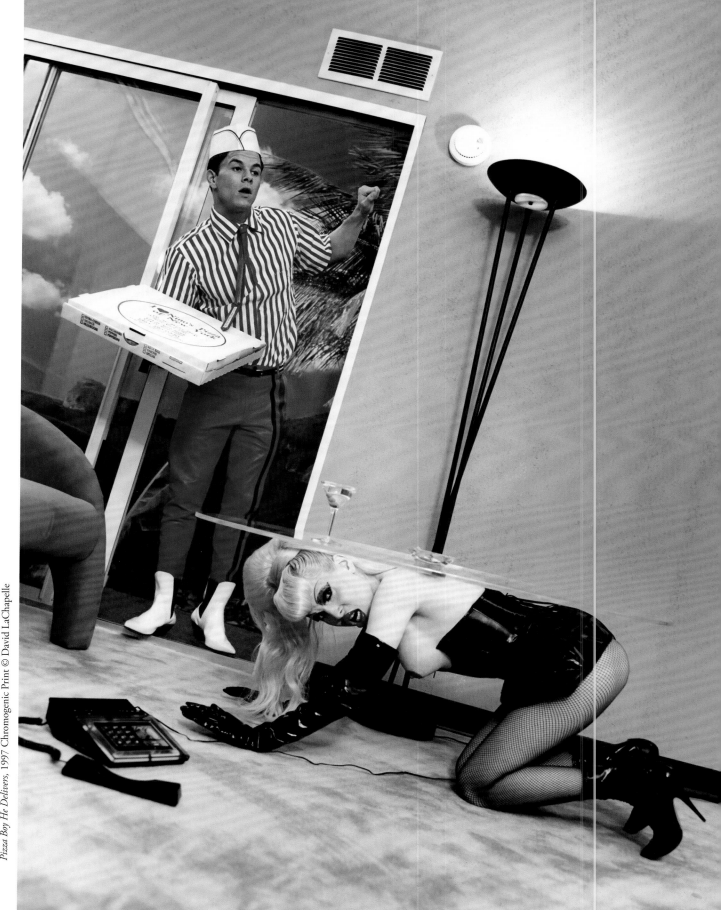

Pizza Boy He Delivers, 1997 Chromogenic Print © David LaChapelle

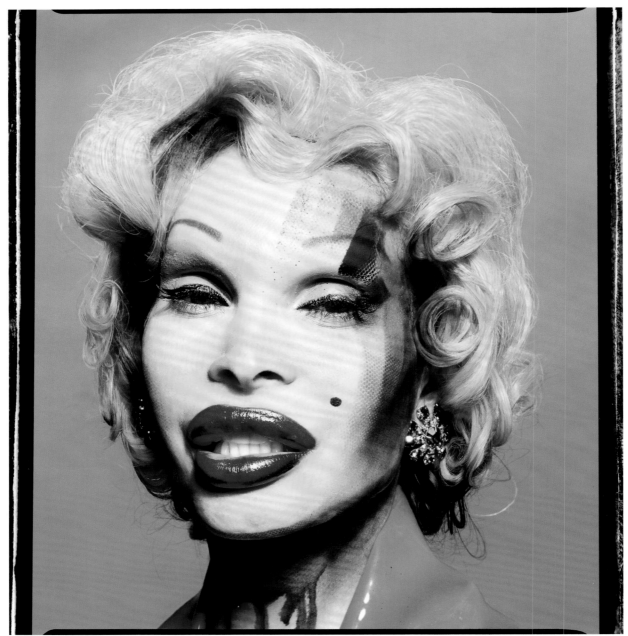

My Own Marilyn 2002 Chromogenic Print © David LaChapelle

just wanted to be there so he could keep an eye on me.

The Insider had just done a segment on me (they called me "one of the most extreme plastic surgery cases *The Insider* has ever uncovered"), so I was getting recognized more than usual on the street, which Ricky didn't handle well. He didn't want to share me

with the public. I had to get rid of him.

It wasn't an easy breakup, I had gotten dickmatized and I do love having a boyfriend. But I had to go to San Francisco for a Heatherette event, and I told Ricky he should move out while I was gone. He was livid and I was crying; I'd be alone, again.

- 178 -

I called Michael Formika Jones when I arrived at my super-fancy hotel in San Fran. Michael was my boss who had reluctantly hired my boyfriend to make me happy, and now I had to tell him I couldn't work with Ricky anymore.

"Amanda," he said, "this is why I don't hire boyfriends."

"I know, I'm sorry. If you need to fire me instead, I understand, but one of us has to go."

Michael decided to keep me. I felt bad putting him in that position.

I needed to do something to clear my head in San Francisco, so I went down to the hotel gym. It was around midnight, and no one else was there. I was wearing a tube top and had bangs and heels; I hadn't packed any other shoes.

My goal at the gym has always been to burn four hundred calories. I put the treadmill on a low speed and the steepest possible incline.

Two hundred calories in, I saw a well-built, good-looking black guy walk in. I didn't get a good look, but he seemed familiar and I could tell he was looking at me. I assumed he'd seen me on *The Insider,* but I was focusing on getting to four hundred calories, so I didn't pay him much attention.

He came up to me and said hi, and I said hi back, then he started trying to talk me up, and asked if I wanted to go up to his room. I said, "Well, I have to burn these 400 calories before I get off," and kept on climbing.

I think he was surprised that I wasn't throwing myself at him. He said to me, "You're really young, what are you, twenty-four?"

"Yes," I said. Now he was starting to get my attention.

"I got a girl up in my room but I can get rid of her if you want to come up."

"That sounds nice, but I still have to burn these 400 calories." I thought he'd move on but he kept staring at me, like he was in shock. It occurred to me that if this guy was so confident, he might have

a really big dick, which was exactly what I needed to move on from the ex-boyfriend. So I told him to hold on a minute.

I finished my workout, then I walked into the gym's cleaning room, and he followed me in. I took out his cock and got on my knees.

While I was sucking his dick, he kept saying to me, "Do you know whose dick you're sucking?" I didn't know how to answer that because I really didn't, but I was smart enough to realize I was supposed to. But then I looked up at him and noticed his chin was a little weird, and I knew I'd seen him before, and then I realized that yes, I did know whose dick I was sucking. He was a very famous rapper, they were playing his new song in the clubs constantly.

I never saw him again after that, but when he got married I couldn't help but think that his wife had a similar body type to me.

Giorgio Armani invited David and me to Milan for a fashion show. Our Armani Jeans commercial featuring Ryan Phillippe would be premiering.

Working with Heatherette had made me a fashion commodity, but I was still an outsider, and some fashion executives could never get past the whole tranny thing. David had to really fight for me to be in that commercial. In the end he told them I'd be playing an evil blonde bitch à la Donatella Versace, and that won the Armani execs over.

For a young girl from Jersey, flying to Milan at the request of Giorgio Armani was the height of success.

The night before we were to leave, David threw an after-party at Chateau Marmont for the opening of a Los Angeles art gallery. He called the party Elegance Blasé, and the idea was very sixties retro, very fitting with the Chateau. Picture one of the sets of *Mad Men.* Punch fountains, Roman statues, fondue, and cigarettes in gold bowls on the coffee table. There

was also to be a performance/demonstration, by me.

While David and his crew set up the party, I went to work on my dress. It was sheer white and backless, and I'd already spent hours hand stitching black Swarovski crystals on it, but there was still more to do.

All of David's inner circle and most of his celebrity friends showed up. Jaid Barrymore, Drew's mother, overheard me talking about my pussy surgery with

McGowan?" He was having none of it. "Who asked you, anyway?"

Rose was twenty percent terrified, and eighty percent irritated. She started walking away.

"Where do you think you're going? What's wrong with Mariah? You tell me!" Armen and Drea chased Rose around the party, both of them yelling out, "What did Mariah ever do to you?" until Rose made

WHO NEEDS SLEEP WHEN ARMANI HIMSELF IS WAITING FOR YOU?

Armen Ra, who had just recently moved to the City of Angels himself. Jaid came in mid-conversation and blurted out, "Oh, you had the vaginal surgery? I've been thinking about getting it as well."

"Oh, it's great," I said. "You should do it; you'll never miss your dick."

She gave me a lemon face and walked brusquely away.

"Amanda, she thought you were talking about vaginal rejuvenation!"

"I know what she thought."

The DJ put on "Fantasy," by Mariah Carey. Armen and I hightailed it to the mini dance floor, where we were met by Drea de Matteo, aka Adriana from *The Sopranos*. Armen loves Mariah, and apparently so does Drea, because they were really getting into it—dancing, singing, not a care in the world.

Their fun was ruined by the raven-haired beauty, Rose McGowan, who was famously dating Marilyn Manson at the time. She walked up to the DJ and blurted out, "Can you turn this crap off?"

Rose didn't know it but she had stepped on a beehive of Armenian fury named Armen Ra. He tapped Rose on the shoulder, hand on hip, heel tapping furiously while Drea giggled like a schoolgirl behind him.

"And what is *wrong* with Mariah Carey, *Miss* Rose

a swift exit. I didn't get a chance to ask her about Manson's supposed rib removal.

There was a buffet of food laid out—elaborate three-tiered cakes and sumptuous multi-colored pastries that resembled an *Alice in Wonderland* tea party.

But this being Los Angeles, David knew no one was going to eat anything. So all the food had been made by one of his set designers out of frosting-covered Styrofoam.

At the height of the party, David told me it was time for the show. I took off all my clothes, walked over to the buffet, and quietly started knocking things over. Not angrily or forcefully, but methodically.

Most of the partygoers barely even watched. These were LA scenesters; they'd seen the biggest rock stars in the world destroy hotel rooms, throw televisions out windows, and streak down Sunset Boulevard. My antics didn't impress them much, but I thought it was clever. It was meant to be an anti-eating, anti-food demonstration.

As the party wound down and the bulk of the guests left, David and I smoked a little pot, something we rarely do. Quentin Tarantino was there; I'd never heard of him, but David assured me it was a big deal, and so we both wanted to be extra fun for him.

It sort of backfired. I ended up changing into my negligee and brushing out hairpieces by the crackling fireplace as David and Quentin spaced out and stared at my tits.

One of the logs in the fireplace rolled out onto the carpet, sending thick clouds of smoke into the air. Stoned and unsure of what to do, David and I fumbled our way to the back patio and watched as the room got cloudier and cloudier, like a fish-bowl filling with smoke.

Eventually Quentin had the good sense to get the log off the shag carpeting, but the room was a disaster. Soot covered everything, and the smell was overpowering. David and I stayed up all night wiping black dust from brick walls with white bath towels.

Realizing we would never be able to fix the mess, David called the hotel manager, who came as we were packing up to catch our early-morning flight to Milan. We were both crying and apologizing, but the manager barely blinked. He looked around and laughed at our sad attempts to clean up.

"Well, Mr. LaChapelle," the manager said, "I'm afraid you will no longer be allowed to have a room with a fireplace."

That was it. They didn't charge David a single cent for the damages. They were very cool about it.

We got on our plane to Milan, exhausted, but I was too excited to care. Who needs sleep when Armani himself is waiting for you?

David sat across the aisle from me, and my seatmate was a little old lady—very Park Avenue proper, in a Chanel suit and wearing a large golden brooch. I was a little embarrassed by my look; my hair was dirty, and I'm sure I smelled like I'd just come back from two weeks at a Girl Scout camp jamboree.

"What are you doing in Milan?" she asked.

"Oh, I'm modeling."

She hesitated. "What for?"

I gave my best Marilyn impression: "For Armani. He's going to have me in his show. Isn't it wonderful?"

"That's nice, dear." She picked up a book. I don't think she believed me.

Our first night in Milan was the Armani fashion show and the premiere of our commercial.

Armani had flown in some of the biggest stars in the world for the show; that's what all the designers do. So it didn't even occur to me anyone would notice I was there. But they did. I don't know if it was my lips or my tits or the fact that I was wearing a see-through dress, but cameras followed me the whole night.

We sat front row at the show, which I'm sure was lovely, but I could barely pay attention I was so excited to be there. As we left, it seemed every camera in Milan was pointed at me. *I . . . loved . . . it. LOVED. IT.* I ate it up, all of it.

The next day, on the front page of the Italian newspapers? La Silicona At Armani and a picture of me in my see-through dress. That was the best day of my life.

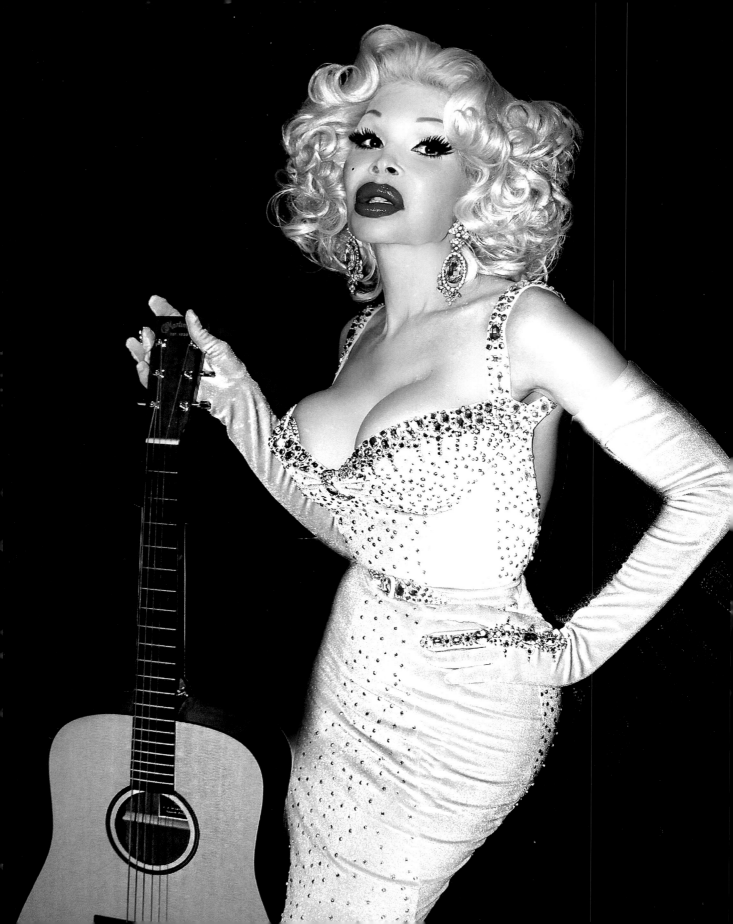

AS YOUNG AS YOU FEEL

Maybe the most famous photo David took of me is Amanda Lepore as Andy Warhol's *Marilyn*. David worships Andy, and I worship Marilyn. She was a pioneer in plastic surgery; she had her nose and chin done, and she had electrolysis on her hairline and silicone injections in her breasts. I even heard she had her eyelids done. That's a lot of work for those days. She was self-made, like a transsexual in a lot of ways.

The makeup that people are doing today, all the contouring, Marilyn did all that. She would use glycerin and Vaseline to contour and highlight her features, stuff cotton balls between her lips and teeth to make them pout, and even made her own lip gloss. Everyone else had matte lips. Marilyn invented beauty techniques that were well beyond her times. She wasn't a perfect beauty, but she had created this persona of perfection; she worked at it.

When I dyed my hair yellow I really hated it, but the color looked very similar to Andy's silk screen of Marilyn. I suggested to David that we do a remake of the image before I dyed my hair back. He loved the idea and told me to come to the studio the next day to shoot it. I thought we would be able to do a pretty picture; David had something completely different in mind.

I showed up with my hair and makeup already styled like the original picture, and earrings that matched what Marilyn had worn. David was alone in the studio. It was quiet. No lighting and makeup people running all over the place, no stream of celebrities coming for photo shoots. It was just David and me. He had a very specific idea of how he wanted to do this, and he wanted to do it all himself.

He had studied the original publicity photo from *Niagara* that Andy had made his silk screen on in order to match the lighting. He also made a blue vinyl collar that matched our backdrop, same as what Marilyn had on. David vamped up my makeup and added a pink foundation onto my skin. Then he took a wired window screen and some knitting, and sprayed black ink on my face and neck, to give a similar effect to the silk screen. He unscrewed the spray bottle and dripped the black coloring onto me as well. The hardest part to get right was the lips, and he spent a while trying to get them perfect.

Usually David has a monitor and I can see his photos right away, but I didn't see the Marilyn image until the prints. It came out kind of punk, I thought. Different from anything else I'd ever seen. It was in *i-D* magazine, and Montblanc used the image on its bags. It was even on a statue, in Central Park over by Bergdorf Goodman. Then it became really successful and the image was seen all over the world. Other people started trying to copy the look. Even Kate Moss did it once, but I never thought it looked as good as the one David and I did.

I've done the Warhol Marilyn look a couple of times since then, for parties. It's a lot of fun but messy. People ask me to redo it all the time, but where's the art in doing something you've already done?

David loves when I take my clothes off in public.

We were at an Italian restaurant one night that had a brick oven, and the room was extraordinarily hot. I was seated next to one of the cast members from *Jackass,* whom I found extraordinarily sexy.

"I heard you have a big dick," I told him. He responded by whipping it out, already rock hard.

I started jerking him off under the table. Nobody noticed at first, but when David saw me he yelled out, "Amanda, what are you DOING?"

"Oh, it's so hot in here, I'm just fanning my pussy under the table."

"If you're so hot, then take off your damn dress."

I did, and continued jerking the guy off until he came.

After that night, any time David says to me, "Amanda, it's really hot, don't you think?" no matter where we are, I take off my clothes.

Once we were on the street in the East Village when a trash truck stopped right in front of us. David said to me, "Amanda, can you believe how hot out it is?"

I looked at him to make sure he wasn't kidding, which of course he wasn't. I slipped my dress over my head, took off my panties as he unclipped my bra, and waved down the truck as it was about to drive away.

"Excuse me! Sir! I have something to give you!" I yelled out to one of the beefy men riding on the back. He banged on the side of the truck and it came to a stop.

David grabbed my clothes from me and one of his friends took out a camera.

"She'll give you a kiss if you let her climb up there," he said.

The trashman said yes, I jumped on his perch, and we got a great picture. They helped me down, and I gave the man his kiss. I'm sure I'm the only girl in New York who has ever been on the back of a trash truck wearing nothing but Manolo Blahniks.

My most memorable naked outing occurred later that year, when David was invited to a party celebrating Azzedine Alaïa's exhibition opening at the Guggenheim in SoHo.

Before the party David wanted to go to his favorite sushi restaurant in Tribeca, Nobu. We went with a few of the kids who worked at LaChapelle Studio and this sexy hip-hop music video director I'd never met before named Little X.

All David could talk about was his new favorite drink, a White Rabbit, which is sake mixed with sour yogurt. I didn't want to drink, but everyone else seemed to love these things and David was practically forcing one down my throat, so I drank one and it was okay. Not too sweet but really strong. I was buzzed right away.

The food looked extravagant; I say "looked" because David wouldn't let me eat any of it. When the waiter brought me my first course, David picked it up and handed it back to the man and requested a clean plate. The waiter brought one over, and David reached into his pocket and pulled out a diet pill, which he placed in the center of the plate. While the entire restaurant was digging into their ungodly expensive Japanese cuisine, I rolled my pill around the plate with my spoon before I picked it up with chopsticks and slowly ate it.

When the next course came out, David again gave the waiter my plate and gave me a vitamin to chew on. For the next course he allowed me to have a single caviar egg from his own meal. "Great, now you're going to be bloated," he said as I swallowed it. The waiter stopped bringing me food.

We were all having a good time, and I was flirting with Little X, when David leaned over to me and whispered, "It's really hot in here, don't you think?"

"No, I think it's fine."

"It's really fucking hot in here, Amanda."

"Really, David, it's fine. I'm kind of cold actually."

"Amanda! It's like a furnace in here!" He tried to give me a menacing look but was laughing too hard.

That White Rabbit must have been stronger than I thought because I stood up, unzipped my bedazzled red dress, and handed it to David. I wasn't wearing a bra or panties. David and Little X lifted me onto the table and the entire restaurant turned around to stare at us; even the raw fish in the kitchen were gagging. I was sure my left tit was bouncing because my heart was beating so fast. Then, the entire restaurant started clapping for me! I smiled and blew kisses to everyone. A few women came over to the table, flashed their tits, and had their picture taken with me.

The kitchen sent out a plate of ice cream in the shape of boobs, with cherries for nipples. It was really cute, and such a relief. I'd never taken off my clothes in such a fancy place before.

When I got off the table, David had hidden my dress and wouldn't give it back. He rushed me out the door to a waiting limo. It was a cold night, snow was on the ground, all I had on were my heels, and we were heading to one of the biggest social events of the year.

As soon as we walked into the Guggenheim I saw Azzedine having his picture taken with Linda Evangelista, Naomi Campbell, Stephanie Seymour, and the rest of the supermodels. Every single one of them looked up and noticed my naked body at the same time, and when they looked, the line of photographers turned toward me as well.

The whole room gasped, the photogs, followed by Azzedine, Stephanie, and Naomi, swarmed toward us. I grabbed on tight to David.

"Oh my God, you're naked!" Naomi screamed.

David said to me, "I'll be right back," and took off with her, leaving me alone, surrounded by cameras and about to receive Azzedine Alaïa and Stephanie

Seymour, two of the biggest names in fashion. I wanted to chase after David but did *not* want to run in front of these people. It felt too tacky.

A journalist asked me why I was naked. What should I say, that David LaChapelle thought it was funny to leave me naked and stranded? "Oh, I didn't have time to borrow a dress from Alaïa, and I'd rather be naked than wear anything else." Azzedine and Stephanie laughed, thank God. I could breathe again!

Azzedine had shown his approval, and on cue, the rest of the crowd really started going nuts for me. I took a spot next to the wall and started talking to a journalist from *W* magazine, while photographers snapped my picture. I leaned against the wall, with my hand behind my head and proclaimed, "Alaïa celebrates the female form, and so do I!" which I thought was great.

But I heard a man shout out, "No! Stop!" It was Peter Brandt, the well-known art collector. *It's over,* I thought. *I'm about to be thrown out on the street, naked, by Peter Brandt.*

"Get off the wall!" he yelled. "You're leaning on the art!" I turned around. I had put my elbows right onto a huge pink camouflage Warhol painting. I thought it was just the wall. Peter was actually very nice about it; luckily my elbows are tiny.

Eventually David found me and apologized for taking off. He'd been getting scolded by Naomi. I told him it was fine, that everything had actually gone really well.

That night, there had been a shift in the fashion and art world's perception of me. I went from being a spectacle to getting respect. People seemed to have a better understanding of me. Major national brands started calling me about ad campaigns. Other top photographers started hitting me up. Even Terry Richardson hired me to grab the cocks of these sexy Brazilian twins for a photo shoot. Swatch made a limited-edition watch with my face on it (it was called Tranny Watch but I guess they'll have to go

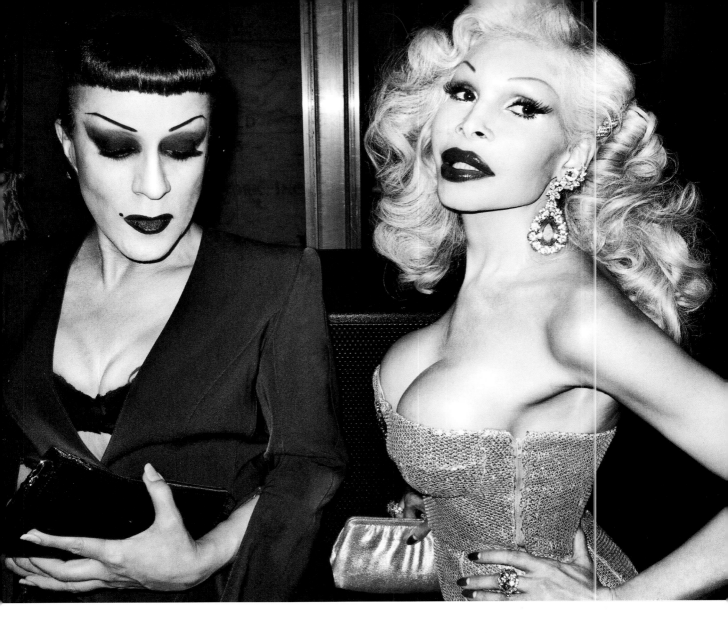

back and change it to Transgender Watch). A perfumer made a signature Amanda Lepore fragrance, which sold out in minutes. Each bottle was covered in 1,000 Swarovski crystals. Jason Wu made an Amanda Lepore doll, which would be my favorite doll even if it didn't look like me. He started with a prototype that I thought looked more like Brigitte Nielsen than me, so he made the nose and jaw smaller and the cheekbones higher. Then he increased the size of the boobs, ass and hips, and also made my doll anatomically correct. Jason is an expert at making dolls; he started when he was sixteen. I was blown away by the quality of his work. We released my doll exclusively at Jeffreys and it sold out right away. All the money went to AIDS charities.

The whole world opened up for me, and all I had to do was show up naked.

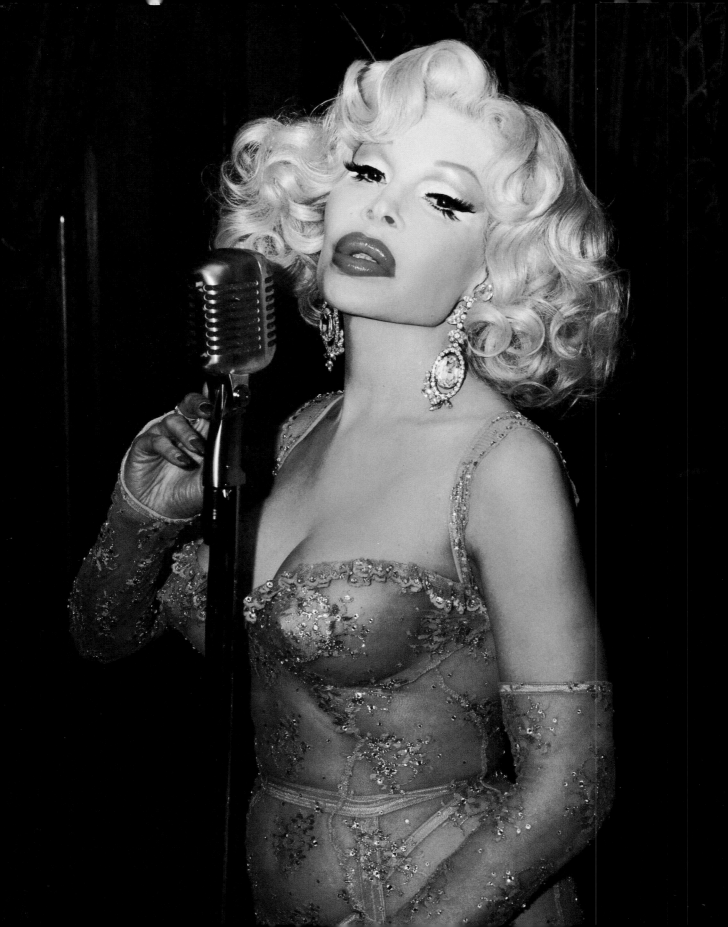

THERE'S NO BUSINESS LIKE SHOW BUSINESS

"When you're onstage and your look is on point, you can get away with things that other people can't." That's what Cazwell told me as he tried persuading me to musically collaborate with him. He had just performed at my birthday party at Spa, a club on Thirteeth Street. I was sitting on a banquette with my new meathead boyfriend Billy, sipping on champagne.

Cazwell had been making a real name for himself in the club scene. His whole style was so unique: a sexy gay rapper with a shaved head and piercing blue eyes, who would show up to the clubs shirtless, in bedazzled gym shorts and an oversized gold chain. To top it all off, he was a talented performer. Boys worshipped him.

"She'll do it," Billy said. "But I'm her manager."

Cazwell ignored him. "We're both so over-the-top, we'll look great onstage together."

"I can't sing," I said. "My self-confidence can only go so far."

"I'll take care of you," he said. "Just trust me. I already have an idea for the first song. It's called 'Champagne.'"

The next week I broke up with Billy. Some guys think my fame is something more than it is, and that it'll do something for their lives. Fame doesn't work like that, though. I was still sad, he was a nice guy and we did look hot together. He would carry me around clubs on his back, or like a baby in his arms. I hated the thought of being single again, but I have to take care of myself first. I'd come this far on my own; I wasn't about to let a man start bossing me around.

I called Cazwell and told him I wouldn't be able to do anything until I got over the breakup.

"Use the pain," Cazwell told me. "It'll make you a better singer."

"I don't want to look stupid on stage, though," I told him.

"You're Amanda Lepore; you could get up there and say your ABCs and people will go nuts."

I am used to people looking at me and sometimes having a negative reaction. I don't really care, because I'm confident in my look, so it doesn't matter what they think. No one ever sees me when I'm not looking good. If I don't have the time I need to get ready, then I don't go out. Singing on stage felt like building myself up all over again. It was going to take time to get as comfortable as I'd need to be in order to do this.

I called Armen Ra to ask his advice, since I knew he was a great singer. "You can do whatever you set your mind to," he told me. "Just treat it like everything else you do and practice your ass off!"

I called Cazwell right after and agreed to start working with him. He sent me a copy of the track to start practicing with.

A week before our first performance I went to Moscow for a massive Heatherette show. Four thousand people crammed into an event space just to see me walk in feathered pasties and a rhinestoned G-string. Backstage I asked Richie, "Do you really think I should start singing? Isn't this enough?"

"Mandy," he said, "you know better than anyone you can't stagnate. Keep on truckin', pumpkin." He was right. When I walked the runway that night, I felt it. I wanted to do something more.

After the runway show we were met by a young Russian boy who was to be our interpreter, guide, and driver while we were in the city. Richie, his team, and I crammed into a limo, headed for the after-party. I hadn't eaten for two days to prep for the show; I was starving.

"Let's skip the party," I said. "I just have to eat something."

"You cannot venture out on your own," the Russian driver said. "You have all been in the newspapers,

and you will get abducted." He drove off, but traffic was awful; we were going nowhere.

"If I don't eat something right now, I'm going to pass out," I said.

I never eat. If I say I need to, then I mean it. "Come on, Mister," Richie said. "Our star needs sustenance!"

"You are hungry? Give me rubles, I will get you food."

We were in the middle of a freeway. There were no buildings even close by. He pulled to the side of the road and jumped out with all our cash.

Fifteen minutes passed. Richie was freaking out, sure we had been abandoned. Finally our guy returned and handed me a large brown bag. I didn't even care what was inside; I was so hungry I'd eat anything. I opened it up and was about to stick my hand in when I felt the bag move. It was filled with live lobsters. Never in my life have I screamed so loud. The driver was laughing, but I was livid. I threw them out on the road. "Why would you do that?" I yelled.

"I'm Club Kid," he said. "It's funny, right?" I didn't think it was funny.

The after-party was equally awful, but I did find some berries to stave off death. A drag queen called Hitler Marilyn followed me around all night. She was dressed as Marilyn with a Hitler mustache, and wore an elephant-sized beaver fur coat that she swore was mink. I'm pretty sure that coat had teeth.

The rest of the week I was supposed to make appearances with Richie, but I'd had enough of Moscow already, so I locked myself in my hotel room and hammered Cazwell's song into my head. The song moved fast and the lyrics were a little complicated, so I needed to go over them until it came as easily as using liquid liner.

By the time I got back to New York, I had the song down cold.

Cazwell and I showed up at Spa—I wore sequined pasties and a white G-string, he was covered in bedazzled Smurfs.

"You're so quiet," he said.

"I want to get this right."

I sat backstage and looked out into the crowd. All the friends and family I had made after twenty-some years in the New York nightlife scene had come out to support me.

Keni Valenti, who had started me on my journey of glamour.

Rose, the man-hating thorned Rose, who taught me how tough a woman could be.

Armen, who taught me there was a deeper meaning to all of this.

Richie Rich, who stayed true to himself and kept his heart pure, no matter what life threw at him.

Sophia, the smartest person I've ever met. Forever my sister.

And David, dear sweet David, who offered me the world and his heart, and showed me what a work ethic is all about.

James St James tapped me on the shoulder, bringing me back to reality. "You'll be great," he said. "I wrote Michael and told him you're performing. He's here in spirit!"

I knew that to be true. I owed Michael so much; he had taught me that art is all that survives, and all that matters.

I thought about the twins and the Louises, and Tina too, who each taught me to take pleasure in being the fairer sex. I carry them with me wherever I go.

And, of course, I thought about Mom. The woman pulling strings behind the curtain, who I knew was with me, watching out for me, and loving me as she always did.

Cazwell came up beside me. "You ready to do this?" he asked.

I gave one last look in the mirror. Everything was perfect.

We walked out onstage and the band launched into our song. I opened my mouth, and started to sing.

Acknowledgments

AMANDA

Thank You to: Aimee Phillips, Alexander Legaspi, Alan Hererq, Alexander Dymek, Andi Oakes, AnnMarie Regan, Arhlene Ayalin, Armen Ra, Artware Editions, Bec Stupak, Brandon Voss, Brian Buenaventura, Carol Currie, Cazwell, Chi Chi Valenti, Daniel Nardicio, Chris and Amy Bracco, Christian Louboutin, Christophe Laudamiel, Christopher Barrette, Danilo Dixon, Danny Nguyen, David Mason, Diana Coney, Dianne Brill, Dita Von Teese, Domonique Echeverria, Doris Borhi, Duo Raw, Eric Currie, Erich Conrad, Esteban Martinez, François Nars, Garo Sparo, Gery Keszler, GoodandEvil, Heatherette, Henry Ruiz, Hunter Woodham, James St. James, Jimmy Floyd, Jason Wu, Jayne Mansfield, Jean Paul Gaultier, Jen Gapay, Jimmy Helvin, Jodie Harsh, Joey Arias, Johnny Dynell, Jonathan Mendelsohn, Jordan Traxler, Kayvon and Anna Zand, Kenny Kenny, Keni Valenti, Kyle Farmery, Ladyfag, Lady Gaga, Laurant Philippon, Larry Tee, Life Ball, Leo Herrera, Lorenzo Diaz, Louie Laborde, Lynn Verlayne, MAC Cosmetics, Madonna, Mao and Roger Padilha, Marilyn Monroe, Mark Sifuentes, Matthew Dailey, Matt Gorny, May Day, Megan Vice, Michael Alig, Michael Formika Jones, Michael Musto, Milkshake Festival, Mim & Liv Nervo, Michael Benedetti, Mighty Real Agency (Carmen Cacciatore & Martha Tang), Mike Killmon, Mike Skinner (R.I.P.), Miley Cyrus, Miss Mya, Naomi Yasuda, NEXT Magazine, Patricia Field, Perez Hilton, Pinup Girl Clothing, Project Publicity (Len Evans & Jeff Dorta), RedTop, Rene Garza, Richie Rich, Risqué, Robert Sorrell, Roxy Cottontail, Sophia Lamar, Sharon Needles, Steven Perfidia Kirkham, Steven Pranica, Susanne Bartsch, Steven Klein, Swarovski, Ted Ottaviano (Book of Love), The Blonds, The Ones, Trey Cornwall, Viv Farmery, World Of Wonder (Randy Barbato, Fenton Bailey, Thairin Smothers), Yadim Carranza.

Thank you, Thomas Flannery for your vision, diligence, hours of candid conversation and of course, your invaluable assistance in getting the ball rolling to tell a story of this international blonde bombshell!

Thank you, David Vigliano and Vigliano Associates for your support, wealth of knowledge and belief in this project from the beginning.

Thank you, Regan Arts: Judith Regan, Alexis Gargagliano, Mia Abrahams, Catherine Casalino, Richard Ljoenes, and Lynne Ciccaglione. Thanks to 'Team Regan' for your belief and continuous excitement in this project and for sharing your editorial and design expertise. It's a pleasure and honor to be the newest member of the Regan Arts family!

Thank you, to my management team at Peace Bisquit: Bill Coleman, Angelo "Pepe" Skordos, Michele Ruiz and Mike Borhi for your continuous support, love, guidance, creative input and going way beyond the call of duty to ensure that my memoirs were the absolute best they could be - we did it!

Very Special Thanks to:

David LaChapelle & DLC Studios: Amanda Crommett, Kumi Tanimura, Reid Welsh. Thank you, David, for your generous contributions, love and friendship.

Marco Ovando, for providing so many of your amazing photos, and for all of our wonderful adventures across the globe.

Rob Lebow, for making the cover of my first book so gorgeous!

A Huge Thank you, to the many photographers who contributed their images to my story:
Alvaro Villarubia, Andrew Werner, Angie Bankhead, Davey Mitchell, David Nguyen, Franz Szony, Gazelle Paulo, Jeff Eason, Joakim Palm Karlsson, Joey Falsetta, Josef Jasso, Karl Giant, Luca Pizzaroni, Marco Cerrone, Marcus Ohllson, Michael Fazakerley, Nico Iliev, Pierre et Gilles, Pieter Henket, Richard Machado, Roxanne Lowit, Scott Ewalt, Sequoia Emmanuelle, Spiros Ferentinos, Terry Richardson, Tina Paul, Victoria Janashvili, Vijat Mohindra, Xavier Muntane.

And last but not least, red lipstick kisses to all of my fans around the globe! I love you all! xo

THOMAS

Amanda, for letting me in, being so honest, and showing me your world. It was an honor.

David Vigliano, my mentor, my friend, and the best agent in the biz.

Bill Coleman, Michele Ruiz, Angelo Skordos, Mike Borhi, and the rest of Peace Bisquit, for your commitment to artistic expression, beauty, and putting in the hours.

Judith Regan, Alexis Gargagliano, Mia Abrahams, Catherine Casalino, and everyone at Regan Arts for keeping the faith.

David LaChapelle and LaChapelle Studio, for going above and beyond.

Caryn Liz Fauerbach for keeping me organized.

Keni Valenti, Armen Ra, Sophia Lamar, Kenny Kenny, Cazwell, Aimee Phillips, Richie Rich, Michael Alig, Lorenzo Diaz, Esteban Martinez, James St James, Mao Padilha, DJ Keoki, Tom Shanahan, Stephen Sumner, Sharon Needles, David Charpentier, Peter McQuaid, Michael Musto, and Javier Figueroa, for sharing their stories and their time.

Maryellen Foley Nyce, Rhonda Browning, Patricia Holmes, Jazmine Bernard, Teal Warner, Ruben Zambrano, David Ritz, Diane Reverand, Larry Amoros, Ruth Ondarza, Paula Breen, Oscar Hernandez, DJ Adam, for their assistance and support.

Photographers

Cover: © ROB LEBOW The Gorgeous Project
Back Cover: Untitled: (Picture of Jason Wu's Amanda Doll Full Back), 2005 Chromogenic Print ©David LaChapelle
Page II & III: Joey Falsetta
Page IV: © ROB LEBOW The Gorgeous Project
Page VIII: Xavier Muntane

Introduction: Let's Make Love
Page XI: Sequoia Emmanuelle
Page XIII: Terry Richardson

Chapter 1: Gentlemen Prefer Blondes
Page XIV: Josef Jasso Photography
Page 3: Joakim Palm Karlsson (jfkphoto)
Page 5: Pieter Henket
Page 6 & 7: David Nguyen
Page 9: Josef Jasso Photography
Page 10: Jeff Eason
Page 11: Josef Jasso Photography

Chapter 2: Hometown Story
Page 12: Photo by © Michael Fazakerley
Page 16 & 17: Joey Falsetta
Page 19: Marco Ovando
Page 22 & 23: Angie Bankhead

Page 26 & 27: Marco Ovando
Page 30 & 31: Marco Ovando

Chapter 3: Some Like It Hot
Page 32: Sequoia Emmanuelle
Page 35: Sequoia Emmanuelle
Page 36 & 37: Marco Ovando
Page 38: S.A. Ferentinos 1991, 1992
Page 40: Marco Ovando
Page 42 & 43: Marco Ovando
Page 44: Alvaro Villarubia
Page 45: Marco Ovando
Page 48 & 49: Photography by © Nico Iliev, Style by Rowshana Jackson
Page 51: Photography by © Nico Iliev, Art Direction by Tory Jones

Chapter 4: How To Marry A Millionaire
Page 52: Forever Yours, 2011 Chromogenic Print © Elias Wessel
Page 55: Photo Courtesy of Andrew Werner
Page 56 & 57: Photographed by Vijat Mohindra
Page 58: Jeff Eason
Page 60 & 61: Marco Ovando
Page 64: Photographed by Vijat Mohindra
Page 65: Jeff Eason
Page 66 & 67: Scott Ewalt
Page 68: Kareem Black

Page 70 & 71: Photography by © Nico Iliev for Artware Editions, Makeup by Yadim

Page 73: Scott Ewalt

Page 74 & 75: Pierre et Gilles "Dream Girl" 2001

Page 76 & 77: Courtesy of Amanda Lepore & David LaChapelle (Personal Collection)

Page 79: Joey Falsetta

Page 80 & 81: Courtesy of Amanda Lepore (Personal Collection)

Page 82: Amanda Lepore (Jessica Rabbit) by Richard Machado for Gazelland Magazine

Page 84: Marco Ovando

Chapter 5: River Of No Return

Page 86: Victoria Janashvili Photography LLC

Page 89: Private Collection of Armen Ra

Page 93: Marco Ovando

Chapter 6: Something's Got To Give

Page 94: Josef Jasso Photography

Page 97: Marco Ovando

Chapter 7: Monkey Business

Page 100: Roxanne Lowit ©

Chapter 8: The Misfits

Page 108: Photo by © Michael Fazakerley

Page 111: Photography by © Tina Paul 1989-2006 All Rights Reserved

Page 113: Marco Ovando

Page 116 & 117: Karl Giant

Page 118: Photography by © Tina Paul 1989-2006 All Rights Reserved

Page 121: Marco Ovando

Page 122 & 123: Marco Ovando

Page 124: Photography by © Tina Paul 1989-2006 All Rights Reserved

Page 126: Marco Ovando

Page 128: Alvaro Villarubia

Page 129: Photography by © Tina Paul 1989-2006 All Rights Reserved

Page 130: Photography by © Tina Paul 1989-2006 All Rights Reserved

Page 131: Photography by © Tina Paul 1989-2006 All Rights Reserved

Chapter 9: All About Eve

Page 132: Marcus Ohllson

Page 135: Marco Ovando

Page 136 & 137: Marco Ovando

Page 139: Marco Ovando

Page 141: Courtesy of Amanda Lepore (Personal Collection)

Page 142 & 143: Marco Ovando

Page 145: Amanda Doodle, 1978 ©David LaChapelle

Page 147: My Own Liz, 2007 Chromogenic Print ©David LaChapelle

Chapter 10: The Prince and The Showgirl

Page 148: Any Way You Slice It, 1998 Chromogenic Print ©David LaChapelle

Page 151: Useless Fame, 2005 Chromogenic Print ©David LaChapelle

Page 152: Addicted to Diamonds, 1997 Chromogenic Print ©David LaChapelle

Page 155: Only Real Tears, 1997 Chromogenic Print ©David LaChapelle

Page 156: Time in A Bubble, 1998 Chromogenic Print ©David LaChapelle

Page 158: Untitled: (Picture of Jason Wu's Amanda Doll Full Back), 2005 Chromogenic Print ©David LaChapelle

Page 159: Charm School, 2003 Chromogenic Print ©David LaChapelle

Page 160 & 161: Silicone Injection in Amanda's Apartment, 1998 Chromogenic Print ©David LaChapelle

Page 163: Breast Feeding, 2003 Chromogenic Print ©David LaChapelle

Page 165: Cherry Bomb, 1999 Chromogenic Print ©David LaChapelle

Page 166 & 167: Publicity Portrait of David LaChapelle and Amanda Lepore in Helicopter, 2002 Published in Complex Magazine

Page 168: Screenshots of Heatherette M.A.C Cosmetics In-Store Video Starring Amanda Lepore Directed By David LaChapelle

Page 170 & 171: Elegance Blasé, 2000 Chromogenic Print ©David LaChapelle

Page 172: Most Perfect Work I, 2005 Chromogenic Print ©David LaChapelle

Page 173: Mirror Image, 2001 Chromogenic Print ©David LaChapelle

Page 174 & 175: Funfair Tragedy, 1997 Chromogenic Print ©David LaChapelle

Page 176: "New York's Strongest" by Luca Pizzaroni

Page 177: Pizza Boy He Delivers, 1997 Chromogenic Print ©David LaChapelle

Page 178: My Own Marilyn, 2002 Chromogenic Print ©David LaChapelle

Chapter 11: As Young As You Feel

Page 182: Marco Cerrone

Page 187: Roxanne Lowit ©

Chapter 12: There's No Business Like Show Business

Page 188: Photo Courtesy of Andrew Werner

Back Cover: Untitled: (Picture of Jason Wu's Amanda Doll Full Back), 2005 Chromogenic Print ©David LaChapelle

Photo Research, Archive Production and Editorial Collaboration: Bill Coleman and Michele Ruiz for Peace Bisquit